HOW TO
SURVIVE 2012

Other Books by Patrick Geryl:

THE ORION PROPHECY

THE WORLD CATACLYSM IN 2012

HOW TO
SURVIVE 2012

Patrick Geryl

Adventures Unlimited Press
Kempton, Illinois
Enhuizen, Netherlands

How to Survive 2012

First Printing
March 2007

ISBN: 1-931882-68-1
ISBN 13: 978-1-931882-68-2

Published by:
Adventures Unlimited Press
One Adventure Place
Kempton, Illinois 60946 USA
auphq@frontiernet.net

www.adventuresunlimitedpress.com
www.adventuresunlimited.nl
www.wexclub.com/aup

10 9 8 7 6 5

HOW TO
SURVIVE 2012

CONTENTS

FOREWORD 9

PART I SECRETS FROM A DISTANT PAST

1. The Riddle of the Magnetic Field Solved 13
2. Why the North Becomes South 26
3. The Inner Core of the Earth 34
4. A Super Spectacular Double Code! 41
5. The Maya Sunspot Cycle: Theory and Reality 47

PART II THE DESTRUCTION AFTER
THE CATASTROPHE

6. A Religious Warning of the
 Forthcoming Apocalypse? 61
7. The Destruction 67
8. Hurricanes and Tornadoes 74
9. Sunstorms and Cosmic Radiation 79
10. Volcanic Areas 85
11. Glacial Areas 93

PART III THE REBUILDING

12. A Relevant Geographic Place 101
13. The Rebuilding 106
14. Essential Fruits, Vegetables and Grains 110
15. The Library for a New World 125
16. Rudimentary Medicine 130

PART IV POSSIBLE SURVIVAL PLACES

17. The Behavior of the Tidal Wave 135
18. Unsinkable Boats 138
19. The Problem of Determining Location 143
20. Where Do We Gather After the Continental Shift? 153

21. The Rising and Sinking of Mountains 157
22. Places with the Best Chance for Survival 166
23. The End of Times 172
24. A New Golden Age 182

PART V ASTRONOMICAL AND
 MATHEMATICAL PROOF

25. Mathematical Proof 191
 •Super Numbers Predict the Catastrophe
 •Code Numbers that Confirm the Countdown
 to the End of Times in 2012
 •The Sunspot Cycle Theoretically Calculated
 •The Magnetic Field Reversal with an
 Orbit Speed of 360 Days
 •Another Calculation of the Period of the
 Reversal of the Magnetic Field of the Sun
 •The Turning Point on Bit 16,071
 •Mathematical Correlations Between the
 Sunspot Cycle and the Shifting of the Zodiac
 •How Did They Encode the Orbit Period
 of the Earth?

APPENDIX 209

FOREWORD

In this book, *How to Survive 2012*, I reveal details about the immense cataclysm that is going to torment the earth in the near future. Presently, most people, including the scientific community at large, think that the rotation of the Earth is stable; however, as I have discussed at length in my previous works, this is not the case. The gruesome reports left to us by survivors of previous catastrophes should, hopefully, prove this point quite clearly.

The historical exploration of cosmology I undertook in my previous books was founded on the translation of hieroglyphs, cracking of codes, unveiling of the magnetic reversal of the sun, study of old maps, decoding of astronomical clues, geological research, and the discovery of the most exciting archaeological find in modern times.

After poring over all of this evidence, I came to the following conclusions:

1. *Sudden reversals and pole shifts are natural to the earth, and occur with clock-like regularity, The result is worldwide destruction, which is supported by paleo-magnetic evidence and early manuscripts.*
2. *The reversal of the poles is attributable to the harmonic cycle of the magnetic fields of the sun.*
3. *Polar reversals can be calculated precisely on the basis of the sunspot cycle theory or the magnetic field theory, which the Maya and the Old Egyptians were privy to. These secrets are contained in the Labyrinth of Hawara, a huge complex consisting of three thousand rooms.*

It is understandable that, through the evidence from my discoveries I have convinced you to make the decision to survive the forthcoming pole shift in 2012. You would want to save your life and/or that of your descendants, your family or friends. This is a good starting point. Surviving and then rebuilding, that is what it ultimately comes down to. And, not surprisingly, it is here that we stumble upon the first of our problems: are you really aware of what is awaiting you? Do you know what horrible chaos will terrorize your life for the foreseeable future? Let me give you an idea: there are no adventure movies or fairy tales in this totally destroyed "new antediluvian" world. Hopefully you already understood this after reading my previous books, which contain an exact description of what happened the last time and what is awaiting us in 2012.

I clearly explained that life after a polar reversal is nothing but horror, pure unimaginable horror. All securities you presently have at hand such as food, transportation and medicine will disappear in one big blow, as will our entire civilization, dissolved into nothingness. It cannot be more horrifying than this; worse than the worst nightmare. More destructive than a nuclear war in which the entire global arsenal of nuclear weapons has been deployed. Are you grasping the facts?

The earth will be subjected to total destruction. It will be many times worse than my description. You will know terrible hunger, cold and pain without the hope of a quick recovery; all knowledge and resources will have been completely destroyed. This will be the reality of your daily life after the forthcoming polar reversal. This is the scenario you will have to fight your way through in order to survive.

At first there will be great panic and despair among those that remain. Yet, due to our foresight, we will be able to quickly resume using our highly-evolved standard of technology. We will have a small minority of well-organized people with a vision: to rebuild our lost civilization. Technicians, scientists, mathematicians, doctors and many more will try to save as much as possible. Even if we do not succeed in motivating all of these people, a tiny group with sufficient knowledge and perseverance will be able to create a climate of resurrection; something to benefit our future generations. Just as we built up our civilization based on the knowledge we inherited from the Old Egyptians, our children will pass on their inherited knowledge to their descendants, and they to theirs, and so on. Within a few thousand years, a new and hopefully more peaceful, less polluted civilization will inhabit the earth, after which the cycle of destruction and resurrection will start again. But that is another story…

PART I

SECRETS FROM A DISTANT PAST

1.
THE RIDDLE OF THE
MAGNETIC FIELD SOLVED

At present, the mechanism that generates the magnetic field of the earth remains, for the most part, a mystery, and this is more than frightening. Without doubt, our continued existence depends upon this information. Thousands of years ago our ancestors knew that when this magnetic field tilts, destruction takes place all over the entire globe. Presently, geologists, astronomers and physicists know little about this. And because of their lack of knowledge, we are running headlong towards our end without a single acknowledgement from official sources.

So, what do our professors know? In short, they know next to nothing. The scenario is as follows: a solid central core rotates in the center of the earth. It is surrounded by a liquid iron-like layer, on top of which the earth's crust is continuously drifting. This whole structure therefore appears to be a huge rotating dynamo. In addition, the liquid layer rotates in the electrostatic field of the sun, recharging itself.

However, this is not at all efficient: more electrical potential is lost than gained. Just like a battery that is almost empty, it is difficult to recharge and it becomes exhausted quickly and easily. Because of this, the force of the magnetic field has diminished by almost 60% over the last two thousand years. At this rate there will not be much energy left within a couple of decades! Then, in addition to this, one can expect a reversal of the poles. But no one living knows what this will be like. In contrast, the Maya and the Old Egyptians knew the terrible consequences only too well. Everything about their way of life from their science to their religion was completely based on this knowledge. As a result, they encoded their knowledge within their Holy Numbers and in their architecture.

I took it as my task to rediscover the lost knowledge of these brilliant scientists. Almost from the beginning of my search I discovered astronomical numbers and mathematical series that correlated with each other. Esoteric symbols complemented this connection. They formed codes impossible to crack for non-insiders, yet I persisted in finishing my task, unraveling code after code. I needed days, weeks, months and years to follow their carefully applied clues and decode them. After an exasperatingly long search, I found out that these codes were connected with the catastrophic events on earth that were the results of pole

shifts. Some of the codes were terribly complicated, although not incomprehensible. Once you have figured out the cipher, you are able to decipher the different levels of their scientific language. Then you can literally peel away layer after layer until you reach the ultimate result: the naked scientific figures regarding the background of these catastrophes.

Although I am already quite experienced at this, there are still questions that have not been answered. The answers I seek lie hidden in the legendary Labyrinth buried beneath the sands at Hawara. This labyrinth holds revelations that will astonish even me. I still do not have permission to start digging, so I am continuously thinking about the theories of our ancestors. I studied carefully the crucial knowledge stored in their numbers. While doing this, my mind bridged the gap and led me into the depths of my prehistoric ancestors' way of thinking. Many questions were answered by this means, like: What knowledge did they have? Were they more advanced in some important areas than we? What did they know exactly? Should we take their warnings seriously?

Unknown Sunspot Cycle Theory Gives the Answer

The answers to these questions are alarming and devastating. All of the deciphering I have done reveals a complex and ingenious science. Let me explain. When you, as a scientist, stumble upon results pointing to things that the present astronomers do not know about, you have, without doubt, stumbled upon something terribly important, and this is exactly what I have done. I have discovered an echo of a long-lost technological terminology; a majestic building with immensely sophisticated keys. Many numbers, or keys, were based on the sunspot cycle, which these old civilizations had discovered—a theory that is irrefutably correct and not known by our physicists! This cannot be more alarming!

The sunspot theory, in turn, correlates with the periodic polar reversals of the earth. I succeeded in cracking the whole puzzle and a large-scale structure appeared. Its development was such that the mathematical matrix ends on the day of the next polar reversal! Just like the way we count down to the launching of a rocket, they counted down to the End of Times. On the last day of the calendar the magnetic north of the earth will change into the south. And this will mean the end of the whole civilized world!

These discoveries convey a serious message from a lost science. Because their code numbers covered quite complex theories, they were not always easy to understand. After my deciphering, which was sometimes pages long, these numbers fit

together logically and revealed the whole. I deciphered theory after theory and unveiled clear, mutual connections. Along with this, the precession, or the period of the ages of the zodiac, played an important role. Nowadays everybody knows that the Age of Pisces is coming to an end, and that the Age of Aquarius will start. But, is this true? Will there not be a hitch? In the past, interruptions of the ages happened more than once as they passed into another zodiacal sign! And this was directly related with the polar reversal of the earth!

On the basis of what the Old Egyptians left us, we know that some long-lost ages correlated with the rise of civilizations. The civilization of Atlantis, for example, was founded in the year 35,712 BC, and knew a first period bloom of 864 years in the sign of Libra. Thereafter, the sign of Virgo passed without any problems over a period of 2,592 years. According to scientists of old this couldn't continue. With the passing of time the Celestial Machine was winding up, like a mainspring. Springs can only be wound up to a certain extent, then they start to resist; they either break or unwind in the opposite direction. On a cosmological scale, the celestial machinery will either break or unwind. Consequently, the first blooming period of Atlantis ended in the sign of Leo. Only 5,904 years had passed since its foundation. The end of the first Atlantean civilization was accompanied by terrifying cosmic phenomena, as well as horrifying events on our planet: a gigantic tidal wave, mountains rising as well as crashing down, furious volcanoes—in short, the catastrophic end of the environment.

Thereafter a new earth was created. After this reversal, the earth started to rotate in the opposite direction and the continents shifted thousands of kilometers. The view from earth of heavenly bodies in the sky changed drastically. The sun switched horizons. Before this catastrophe, it rose in the east, but afterward in the west. Stars seemed to move the other way in this celestial mechanism set adrift. Many myths are based on this and were the raw material for my deciphering.

Thousands of years later, another catastrophe took place in 21,312 BC. At that time the earth shifted seventy-two degrees in less than half an hour. It wasn't a total reversal, but indeed a quick glide of the axis of the earth, through which its zodiacal "age" changed drastically. The survivors of this tragic event decided to build a "Circle of Gold" in which all astronomical observations would be kept. They also assigned their priests a mission: to calculate the next cataclysm on the basis of all relevant information. They invested thousands and thousands of years into intense research until the moment of their success! Through their discoveries dealing with the behavior of the magnetic fields

of the sun, they were able to calculate with an amazing degree of accuracy the coming of the catastrophic event that was to destroy their civilization. You can read about this in my previous books. An even more devastating discovery for me, was the fact that *their* descendants, the Maya and the Old Egyptians, did the same for us. In the year 2012 a new polar reversal awaits us!

Several Past Locations of the Poles

Geologic evidence shows that the poles have diminished in strength and have changed positions many times. Geologists know that after volcanic eruptions, lava remains magnetic during the process of coagulation. The polarity of magnetization, however, depends on the orientation of the magnetic field of the earth. Because of the minor tendency of magnetization in the magnetic field of the earth, magnetization of the lava remains constant after cooling. On this basis, it is possible to determine the orientation of the magnetic field of the earth at that point in history. Every incident of lava found having reversed polarity shows that—even recently—the magnetic poles were in opposition to their current locations. During each

Figure 1.
The Path of the Pole.

pole reversal lava flows were very active. One finds proof of this worldwide.

However, this does not seem enough evidence to convince the scientific community. They continue to assume that the magnetic field of the earth has reversed many times without a clear reason and that the consequences of future reversals will not be so bad. Unbelievable, because their own data flagrantly contradict this! Time and time again one stumbles upon a worldwide extinction of past animal species, together with reversed poles and thousands of volcanic eruptions. A mountain of books and numerous journals have been devoted to this subject, yet nobody has reached the right conclusions!

In order to understand the implications you have to look at the geomagnetic field of the earth. The terrestrial magnetic field is similar to that of a magnet between two poles: a North Pole on top and a South Pole at the bottom. At the moment of reversal, the

earth starts to turn in the opposite direction and the earth's crust shifts. While the crust is shifting, the rock is subjected to magnetic fields with different orientations. When you draw lines from these points you can locate the positions of the previous poles. Figure 1 clarifies this phenomenon. It's not that difficult to understand.

Figure 1 shows some of the different pole positions determined from Mesozoic European rocks. The list of locations is incomplete because the determination involves a difficult and slow process. To date, hundreds of different pole locations have been determined. Geologists do not currently have an explanation for this phenomenon. In practice, it can only be explained by a reversal of the poles, together with a shift in the earth's crust. Just imagine the pole in a fixed location, when suddenly the earth's crust shifts thousands of kilometers: while the position of the pole was, for example, 90 degrees north or south of the Equator, the shift of the earth's crust has moved it. Now another point on the earth's surface has become the pole, which will record this magnetic marker. This is the only convincing explanation for the retrieval of many previous terrestrial pole positions.

Stories about the Polar Reversal

All three holy books of the Mexicans-—the Manuscript *Troano*, the *Popol-Vuh* and the manuscript *Cakchiquel*-—describe that during the change of the compass directions, the mountains swelled by the pressure of melted lava, new ridges and volcanoes rose and streams of lava surged from huge, newly-opened voids.

In the old Chinese encyclopedia *Sing-li-ta-tsiuen-chou* we also find a clue to this catastrophe. It tells that "in a general convulsion of nature, the sea is lifted from its bed, rivers change course, mountains rise from the earth, people and their goods are completely ruined and the old traces erased." The Chinese count a total of ten lost worlds, since the beginning up until the age of Confucius.

When we compile all historic reports into one whole, we learn a great deal about this terrifying phenomenon of nature: a reversal makes the earth moan, makes its layers shift one over the other, pours its oceans onto the lands, lifts up its mountains, makes its rivers run upstream, its mountains collapse, the winds change direction and more. But what is the real cause? What chaos theory is hiding here? What were the Maya and Old Egyptians telling us about this? Can traditions help us to survive?

According to a legend of the Hopi Indians, the present civilization is not the first of our world. There were three other "worlds" before this one, each of which disappeared in a global catastrophe. They call our present world the "Fourth World," and

claim that this one, just like the rest, will end on a pre-determined day. The Hopi wise men say that the end will be marked by an appearance of Saquasohuh, the spirit of the Blue Star. This is not the only story to tie the End of Days catastrophes with events in the sky. According to Albert Slosman's hieroglyphic interpretations, on July 26th, 9792 BC, the day just before the previous catastrophe, the hearts of many must have skipped a beat. With increasing fear they saw the sun surrounded and overpowered by "new stars," which rushed in the direction of the earth and set everything on fire. In H.H. Bancroft's 1875 book, *The Native Races of the Pacific States of America*, we read the following about a man who, while tending his llamas, was surprised by a similar phenomenon.

One day a shepherd noticed that all his animals were staring in the direction of the sun. He put his hand over his eyes to have a look himself, and saw a huge number of stars that seemed to surround the sun, even in plain daylight. Then the llama told him that this was the sign for worldwide destruction by a tidal wave. The herdsman led his family and animals to the top of a mountain and, just as they arrived there, the waters of the sea overflowed the land in one big destructive wave.

This is one of several myths; there are many others. In Atlantis, mankind was struck by a clear diffuse light, through which they could no longer see the sun. This was probably because they lived at the North Pole at that time, and they would have been viewing the phenomenon through the resulting diffuse light or auroras. In the mythological *Popol-Vuh* of the Maya it says that: "Together with the tidal wave, a huge fire raged in the skies." This catastrophe connects the Guatemalan myth with the ancient Greek story about Phaeton: thanks to his mistake, celestial fires burned half of the earth, after which it drowned in a tidal wave. Interestingly, the word "Phaeton" means "The Flaming One."

This Greek legend tells that the young Phaeton, who claimed to be a son of the sun, tried to drive the sun chariot one fateful day. Phaeton however wasn't able to fight "against the whirling of the poles," and "their fast ashes" made him fade away. Ovid writes (in *The Metamorphoses*, Book 11), "The earth burst into flames, the higher parts first. The greens are burned to white ashes, the trees drop green leaves and cities with their walls fall into ruins and the raging fire turned whole nations to ashes." Furthermore, "The Etna vomits fire irrepressibly, as well as the double-peaked Parnassus; the Caucasus is burning, and the sky-piercing Alps. Phaeton sees the earth in flames. "He cannot stand the ashes and the whirling sparks any longer. He is completely blinded by thick hot smoke. In this pitch-black darkness he can no longer orientate himself."

According to Plato, as written in his dialogue *Timaeus*, Solon presented this story about the world tidal wave to the local priests during his visit to Egypt. One of the priests, an old man, said: "There have already been many destructions of humanity and more will follow. Actually, this story is told in your country [Greece] as well as in ours. It tells how Phaeton, the son of Helios, once hitched the horses to his father's sun chariot. But because he wasn't able to lead it along the path that his father used to follow, everything on earth was burned, and he himself was killed by a bolt of lightning. This story, told in the form of legend, is in fact the occurrence of a shift of the celestial bodies that are moving around the earth, and the destruction of all earthly things by a huge fire, an event which repeats itself between long pauses."

The Egyptian priests revealed to Solon that the scriptures of scientists from many civilizations were destroyed during such catastrophes; therefore the Greeks were like children because they did not know the true horror of the past. Let us be clear: these testimonies describe the consequences of a reversal in the magnetic field of the sun. In other words, these myths confirm the scientific theory about the magnetic fields of the sun, which the Maya knew. During a polar reversal the sun's force increases exponentially, giving it a sharp, fierce countenance. When the magnetic field (exemplified by the Van Allen belts) that protects the earth from solar radiation is diminished, the earth is bombarded by a toxic solar wind of cosmic radiation, which causes mutation, cancer and worldwide destruction.

"Solar Lightning" causes the Polar Reversal

From legends and the sunspot cycle theory of the Maya, we can piece together the things that cause a polar reversal. It has long been known that when a beam of lightning strikes a magnet, a reversal of the magnetic poles takes place. Let's apply this principle on a broader scale. Our earth is a huge magnet, with its own North and South Poles. A short-circuit with another external "flash of lightning," or magnet, can end in a catastrophic polar reversal. This means that the magnetic North Pole changes place with the magnetic South Pole. But what sort of external beam can cause this? What force is powerful enough to stop the rotation of the earth and then reverse it?

Only one object is powerful enough to do this: our sun. You know from my previous book, *The World Cataclysm in 2012*, that the magnetic field of the sun undergoes a drastic change every 11,500 to 12,000 years. Once a crucial point has been reached, it reverses instantaneously. Chaotic outbursts accompany this phenomenon and an immense cloud of plasma is catapulted into space. Then a

shock wave of particles reaches our planet and the polar reversal of our earth commences. Just like the flash of lightning that killed the mythical Phaeton, this "solar beam" puts an end to life on earth.

With unknown power this solar lightning strikes our planet and causes a gigantic short-circuit. That is the horrible truth behind a catastrophic polar reversal of the earth. But how can we ultimately explain this through science? What is the precise physical cause that produces this polar reversal?

I came upon the correct theory in the book *Earth under Fire*—more precisely, in the chapter entitled "Solar Storms and Geomagnetic Flips." The astronomer Paul La Violette writes, "Field flips have been accomplished experimentally, by shooting large quantities of loaded particles on a strong bipolar magnet. These particles are then caught in the magnetic fields and cause a 'ring-stream' in them. At a certain moment this stream speeds up to such an extent that the field of the magnet reverses completely."

In an equivalent scenario the field of the earth can reverse in just the same way. Astronomers know that the particles of a solar storm can compress the earth's magnetic field. The field fights back and temporarily ups its power. However, when the solar particles are caught in the geomagnetic field of the earth, they produce the opposite effect: a long-lasting decrease in the geomagnetic field force.

Figure 2.
Immense sun storms produce opposite electric currents around the earth's magnetic field. An electron current flows eastward, while a proton current goes westward. Together, they produce a "ring-current" opposite to the earth's magnetic field. When this "ring-current" exceeds a certain intensity, it pushes the interior of the earth in the opposite direction. In other words, instead of turning eastwards, our planet will start to turn westward! This is what caused the extinction of former civilizations. No matter how technologically advanced our civilization becomes, it will cause our disappearance as well.

In order to visualize the reversal process properly, you have to examine Figure 2 carefully. I am sure you want to know what is going to change your life completely, if not destroy it. When the solar particles reach our planet, the electromagnetically-loaded particles will move in a spiral along the magnetic lines: from the magnetic North Pole to the magnetic South Pole and back. While passing this north-south axis, they will move into the direction of the equator. When they arrive there, they will join into a super powerful "ring current."

This "ring current" generates an intense magnetic field that is opposite to the earth's magnetic field. In order to overpower the

earth's magnetic field, a solar flame a hundred times more forceful than the biggest one we have ever seen would be necessary. During the reversal of the sun's magnetic field, this degree of magnitude will certainly be reached.

From here on, my point of view deviates from that expressed by Paul La Violette. Not only will the poles reverse, but the earth will also begin to rotate in the opposite direction! This can only occur when the "ring current" pushes the inner core of the earth in the opposite direction.

Everybody knows that when you change the poles of an electric motor, it will start turning the other way. The same holds for the interior of the earth. When an external short circuit takes place, the core cannot do otherwise but start turning in the opposite direction!

Destruction and Renewed Life

This catastrophe will not only result in the massive destruction of life on earth, but also endanger its continued existence, however incomprehensible that may sound. Let me explain.

The magnetic field of the earth is not an accident of natural science. Its primary task is to protect us against cosmic and solar radiation. Without this field, life is practically impossible. Without this protection, life on our planet would be extinguished in a short time. An all-consuming, deadly radioactive radiation would rage across the earth's surface.

Despite the fact that overwhelming numbers of people, animals and plants will die, life will continue to exist because the exhausted battery of the earth will be reloaded by the enormous solar storm. For thousands of years following the pole reversal, the magnetic field of the earth will be empowered to remain stable, protecting the flora and fauna against the damaging radiation. While doing this job, the inner battery of the earth will run out again and another cycle of destruction followed by creation and mutation will start anew.

The Atmosphere of Venus in Flames

In his book, *The Civtate Dei*, St. Austin describes a universal tidal wave that tormented our planet in the age of Phoroneus, king of Pelasgi, in primordial times. During this catastrophe a horrible flaming phenomenon occurred in the skies. It was so strong that it influenced Venus. You can derive from the following text that Venus looked quite striking. This proves that a sun storm can severely change the face of a planet like Venus. It looked like a monstrous snake: "This snake has feathers, she is therefore called Quetzalcoatl. She appears at the moment the world starts

to resurrect from the chaos of the huge world disaster." The dress of feathers of the snake body "represented fierce flames." Logical thinking will help us to understand this. During the previous catastrophe, myriads of electromagnetic particles from the sun were spewed out. At that time our atmosphere was ablaze with the polar light that set the whole atmosphere "in flames." Just like the earth, the atmosphere of Venus was set aflame! Only the effect on Venus was much stronger—because it is so close to the sun the particles were much more concentrated when they reached that planet compared to when they reached the earth. As old scriptures testify, a "Second Sun" appeared in the sky. But there was more. When the sun storm reached Venus, its power had not diminished much. From the upper layers of Venus, gas-like substances were torn off and lit up like a "Celestial Bengal Hell-Fire": a magnificent, illuminating comet tail.

Ancient Mexican scriptures describe these phenomena. First, Quetzalcoatl, a snake-like celestial body, attacked the Sun who refused to shine, and for several days the world was robbed of her light. While the disaster took place on earth, countless human beings met their death. In his book *On the Eternity of the World*, written in the early frist century AD, Philo gives the following answer to the previous world fires: "Destructions of earthly matter were attributed to two main causes, the tremendous torments of fire and water. The fire, sent by heaven, causes a storm of fire on earth that spreads over the inhabited world."

Mars was also Ravaged

Even recently, photos of the surface of Mars coming from the *Mariner* and *Viking* satellites suggest that the sun has been active in shaping that planet. Planetary geologists have discovered that enormous canyons, all falling within a limit of forty degrees from the equator, have been deeply carved into the Martian surface. In order to create them, gigantic masses of water must have passed through them. Surely the necessary water must have come from several places on the planet's surface. Furthermore, these sprouted sources have passed long distances and shifted many areas of land.

The Martian channels are comparably larger than their earthly counterparts. It has been calculated that floods that transported one cubic kilometer of water per second created them! This correlates with ten thousand times the capacity of the Amazon River! Scientists do not currently have an explanation for this phenomenon. Normally there cannot be any water in liquid form on Mars, because there it freezes at sixty degrees Celsius. Therefore it must remain frozen in a layer of permafrost beneath the surface.

This information can be located on the NASA website, and has been documented in all the important scientific magazines.

We can easily reconstruct what happened twelve thousand years ago, during the previous catastrophe. When the magnetic field of the sun reversed, electromagnetic particles bombarded the surface of Mars, because, unlike the earth, it has practically no protective geomagnetic field. At the moment of impact, the frozen water melted and was shot under high pressure to the planet's surface. The equator suffered especially, because that is where cataclysm-like floods developed. The maps from the *Viking* satellite clearly show this. Ten thousand square meters of current patterns are evident on the planet's surface. And finally this also explains

Figure 3.
During the previous sun magnetic field reversal, Mars was hit by an enormous quantity of particles originating from the sun. The magnetic field of Mars is practically non-existent, so its surface was intensely bombarded and therefore heated up. In a short space of time, the underground frozen water must have been heated and pushed to the surface under great pressure. Then, during that short time period, cataclysmic floods must have ravaged the Martian surface.

why these cavities are relatively young. Their youth is illustrated by the fact that they cross through older terrain containing plenty of craters, while they themselves are free of them.

The Sun, the Waters and the Snake

Many cultures in the world have legends about a sun fire in the skies. The Ipurinas from northwestern Brazil tell of a hot flood coming from the sun that tormented the earth. The Australian aborigines have a similar myth about an old man who opened the door of the sun and a flood of fire poured out upon the earth. In Utah, the Ute Indians have a myth about their Sun God, Tavi, who once burned the world. One day, he came close to the earth and scorched the naked shoulder of Ta-Wats, the Hare God. Ta-Wats, who was furious, waited for the Sun God to appear again and then shot three arrows at him. The third hit Tavi in the face and he broke into thousands of fragments, which set the earth on fire. Ta-Wats fled because of the destruction he had caused, but the

burning earth consumed his body. Swollen by the heat, the eyes of the Hare God burst and his tears brought about a flood, which spread over the whole earth and extinguished the fire. Then the Sun God had to appear before a council of gods who sentenced him to follow the same path until the end of times.

In India there is a Hindu tradition about the end of previous worlds by a universally destructive force. The "Markandeya" saga tells about a world fire and a subsequent tidal wave: after a drought of several years, seven flaming suns appear, and they drink up all the waters. Then a fire, driven by a wind, ravages the earth, consuming everything, penetrating into the underworld where it destroys everything in the twinkling of an eye; the flames burn the whole universe. Multicolored lightning clouds appear in the sky. Scientifically, these traditions can be explained by a reversing solar magnetic field, which in turn makes the geomagnetic field of the earth reverse. This is accompanied by bright auroras in the sky, and followed by a huge tidal wave. Ancient scientists even incorporated these dramatic events in their architecture, but this is not always easy to understand.

In the dim light of the western entrance of Angkor Wat it is impossible to overlook the presence of the Naga snakes: with their stone bodies and raised heads they form an impressive coiling balustrade along the entranceway. Every corner of the roof of the temple is decorated with a seven-headed snake. In Indian mythology the Nagas are supernatural beings, cobra kings who rule on earth but belong to the gods; although they live in the material world and associate with humans, one does not doubt their true identity, consisting of celestial and cosmic forces. This obsession for snakes is not only to be found among Buddhists, but also among the Maya and the Old Egyptians. In all these cultures the snake functioned as a symbol for indescribable cosmic forces and as a metaphor for rebirth and spiritual innovation. Why, I wondered?

I found the answer to these pressing questions in *The Lost Continent of Mu* by James Churchward. The author writes that the Maya had chosen the snake because the movements of the body were an imitation of the waves of an ocean. Furthermore, the snake was connected with the Creator, our Sun. The Old Ones, however, appear to have been very deliberate in differentiating between the Godhead and the creating forces in nature, by crowning the snake that symbolizes the great Creator.

In Chichen Itza in northern Yucatan, Mexico stands the temple of Kukulkan. The geometry of the design was set with the precision of a Swiss watch according to a dramatic, as well as esoteric, goal: during the spring and autumn equinoxes, patterns

of light and shadow create the illusion of an enormous snake moving down the side of the pyramid. Here you can see a direct relation between our sun and a snake body!

All old scriptures indicate a relationship between the sun and the snake. In fact this symbolizes the catastrophe in all its simplicity: through their huge power the sun forces cause the reversal of the earth, and therefore bring "the waters into movement." In Egypt we find Horus, the symbol of the sun, who pierces the head of the snake Aphopsis (the waters) with a spear. In Greece, Apollo, who is there the symbol of the sun, fights with the snake Python, the symbol of the waters. In India, their highest god, Vishnu, lay sleeping with the snake Anatha, their symbol of the waters, before waking up and creating our present universe.

The Maya associate a cosmic snake with an old catastrophe. In chapter five of the *Chilam Balams* you can read the following: "This happened when the earth started to wake up. Nobody knew what was going to happen. A heavy rain streamed downwards and ashes fell down.

"The Big Snake of the heavens made rocks and trees crash on the ground and the Big Snake was torn apart in the sky, and skin and pieces of his bones fell upon the earth. Then the waters rose in a terrible flood." Just like in the story "Chicken Little," the sky fell.

2.
WHY THE NORTH BECOMES SOUTH

Years ago I started my quest, intending to discover why pole shifts take place. I found answers that put my imaginative powers heavily to the test. But through my persistent search, I found evidence to support the stories, telling of a highly advanced civilization that was exposed to three catastrophes. Each time, the movement of the earth's axis was severely disrupted and the whole earth was subjected to a gigantic cataclysm.

From this we can state the following: the graph of human evolution does not appear as a straight line. Towards the end it draws steeply upward, but after every disaster it slips quickly downward. Priests and scientists knew this, and intertwined their knowledge with religion in order to make everybody fully aware of it. Fourteen thousand years ago the priests knew how to decipher the secrets of polar reversals, but with the passage of time, the knowledge was lost.

At present nothing is left of this old wisdom. There isn't a single scientist in possession of this knowledge now, of a catastrophic downfall in the pre-primeval age. Hopefully as many people as possible will hear my warning before it is too late. But even if they do hear, will they neglect the messages from our distant past? The following text shows that in antiquity people were notified about the forthcoming end via *The Book of Enoch*: "Behold, destruction is coming, a great flood and it will destroy all living things." A great

Figure 4.

many codes hide in this short sentence, and they are relative to the forthcoming destruction—scientific knowledge having been interwoven with religion.

The Magnetic Field of the Earth Compared with that of a Dynamo

Everybody knows that the dynamo of a bicycle creates a magnetic field, and therefore electricity. As long as you keep cycling, the inner magnets keep turning around and electric power is generated. The earth has a somewhat similar, though more complicated, principle. Just like the bicycle dynamo, the magnetic field is generated in the earth's core, because the liquid upper layer rotates with a different speed in relation to the earth's core. There, the mechanical energy is transformed into magnetic energy, resulting in a North Pole and a South Pole.

Should you want to change the poles of a dynamo, you would have to change its direction of rotation!

Expanding this principle, the earth also has to change its direction when the North Pole becomes the South Pole! So here we find a scientific proof for polar reversals. It correlates completely with the statement of the Old Egyptians on this subject: after every pole reversal the sun rose from the opposite direction.

West became East

Because the earth's axis turns counter-clockwise, the sun rises in the east and sets in the west. These are the plain facts. But, was it always like this? Is this a constant law? When you look at Pluto, you see it rotating from the east to the west, so that the sun rises in the west there. Was this the same situation on earth in earlier days? Shockingly enough, it was!

When you examine the Old Egyptians' way of encoding, there is no other possible explanation. During their time, the earth underwent sudden drastic changes. Before the previous pole shift our sun rose in the west! From then on in the east, because the direction of rotation changed! When we apply this principle again, the sun will rise in the west after the forthcoming pole reversal.

As our present science is aware, our earth cannot continue its undisturbed rotations indefinitely, and will end its task as a chronometer; it first undergoes a deceleration and then acceleration in the opposite direction. The physical consequences of an abrupt deceleration are phenomenal: continuous earthquakes, cyclones, colossal tidal waves, scalding hot lava streams, etc., will wipe away the existing civilization of that time.

Of course it doesn't stop there. Not only does deceleration

Figure 5.
With the ending of a world age, the Milky Way will be "churned." In this Central Asian depiction, a turtle forms the base of a churn, which is being turned by a snake wrapped around it and pulled by attendants.

Figure 6.
The Maya Codex Tro-Cortesianus depicts the reversal in a way similar to Figure 5. This illustration is a bit more difficult to decipher, but one can see the turtle in the middle of the picture, atop a churn, which is being turned by attendants pulling a cord. It is a celestial metaphor for the awesome events that tormented our planet during the pole reversal. When the earth reverses its direction, the seas will be irreversibly churned around.

take place, but also a reversal. Instead of turning from west to east, the earth will start to turn from east to west. It cannot be more frightening, because it will bring along a destruction of immense proportions. Everything that took place beforehand will now happen again. The magical *Papyrus Harris* speaks of a colossal catastrophe of fire and water when "the North becomes the South." Plato wrote about this in *Politicus*: "In certain periods, the universe has its present rotating movement and in other periods it turns in the opposite direction…Of all the changes that take place in the sky, this reversal is the biggest and the most complete."

Read these words again, remember them forever and pass them on to your children. Only in this way will this terrible truth remain in existence. It is the only way to preserve the next civilization from total destruction. Because, without this knowledge, within twelve thousand years it will be thrown back into the Stone Age, just like ours will be very soon now.

It wasn't just the Old Egyptians who wrote about a change in the compass directions, the Hindus also have such myths. This change in the direction of the earth's rotation is described in the *Hahabarata* and *Ramayana*. This Hindu myth supports the belief of the continuous progression of eras. According to the story, the Milky Way is "churned" at specific moments. It is a symbolic image of the changing of the poles of the earth and the reversing of the movement.

The explanation lies in the fact that celestial mechanics are tossed upside down. The inner core of the earth starts to rotate in the opposite direction. Inescapably, the surrounding liquid magma has to follow this new direction of movement. Because the angle and the speed of the several layers of the earth are interrupted, they slide over one another, resulting in a phenomenal friction causing heat. Cracks and fissures appear and portions of rock sink away, while in other places mountain chains rise up. Or, in other old prophetic words: "The inside of the earth would tremble with fear and the upper layers of the earth would fall down."

Scientific Proof for a Reversal

The proof of previous events is found in the earth layers, the rocky crust of our planet. The lithosphere consists of igneous rocks like granite and basalt, topped by sedimentary rocks. The latter are formed on the igneous rocks, which form the original earth crust. One can regularly find places where the igneous rocks cover sedimentary rocks over large areas. Cuvier (1769-1832), the founder of the science of rib-skeletons was deeply impressed by the image they showed of successive earth layers. He was convinced that the bottom of the sea had repeatedly changed into mainland and

vice versa. From his studies he concluded that huge disasters had destroyed life in extensive areas. In *Essay on the Theory of Earth* he writes: "When the traveler moves through these fertile plains he will not have the slightest notion that nature has also had its inner wars, and that revolutions and catastrophes have tormented the terrestrial surface. But he will change his opinion when he starts digging in the ground that now looks so peaceful."

What he saw were the destructions caused by countless polar reversals. Doesn't a sudden deceleration and acceleration of the earth mean a complete destruction of civilizations? The end of billions of animal lives? The *Orphic Hymns* remind us of this only too well: "When the arch of heaven, the mighty Olympus, tremendously trembled ... and the earth was screaming terribly, the sea fumingly rose, tempestuous of purple waves."

For the survivors of the forthcoming catastrophe, the result of the next pole reversal will be more than overwhelming. The inhabitants of the earth will experience a very similar event to that of the old cultures, because all the stars and planets and even our own sun will now rise on a different horizon, and oceans will also rise. Those are the results of a magnetic field out of control.

Mountain-High Waves

The Choctaws from Oklahoma tell us the following: "In the north appeared mountain-high waves, quickly coming closer." The Indians of Oregon who lived near Mount Jefferson, which is three kilometers high, tell the following story: "A huge flood inundated the land. Then the water drew back. A second time a flood inundated the land and drew back. Afraid of a next and even bigger flood, they cut the biggest cedar tree they could find and made the biggest canoe they had ever seen. When the flood came for the third time, they chose the strongest and cleverest man and woman and placed them in the canoe, together with enough food for many days. Then a bigger and deeper flood engulfed all the land and all the people." There are facts to prove this. Sediments of the previous flood are found at great heights.

Huge layers of cobblestone sand, sometimes containing layers of clay and silt, can be found in Scotland on the slopes of valleys and hillsides. In Yorkshire, layers and displaced boulders were found at a height of 600 meters, indicating a total inundation. Similar terraces exist in North America, located in the White Mountains at a height of 750 meters. These and other loam-like and striated sediments were dropped there by a huge tidal wave. In other places, something different happened with the loam layers. They were baked in the twinkling of an eye. I will explain that phenomenon next.

Electrocution on a Planetary Scale

One hundred sixty years ago, the English physicist Michael Faraday discovered the laws of electricity. He built the first successful dynamo and proved that a fluctuating magnetic field generates electrical currents. If a dynamo can generate an electric current, doesn't it seem logical enough that the moment the magnetic field of the earth reverses, enormous electrical currents are produced? That a current surge of planetary magnitude sends billions of volts through the air and over the ground? What else could have baked layers of mud so quickly that they were changed into rock in the twinkling of an eye? So fast that the impacts of prehistoric raindrops are still visible, after billions of years! Yes indeed! In the rocks of the Grand Canyon you can admire the small indentations of these raindrops, as well as the footprints of dinosaurs. Imagine the raw power that must have raged through and around our planet to bake this mud so quickly.

Figure 7.
When the inside of the earth starts turning the other way, the magnetic field will change.

This is also the power from which most of the heat-formed rocks were created. Gigantic currents raged through the sediments, changing their composition instantly. Clay sediments metamorphose into slate at 100 to 200 degrees Celsius. At higher temperatures, they become liquid and can flood across hundreds of kilometers. Depending on the existing minerals in the clay layers, other sorts of rocks can form. With sufficient heat, limestone will crystallize into marble, while pure sandstone will change into quartz. Even granite is made of heated re-crystallized sediments. Something caused this heat. And that something is a changing magnetic field. Therefore, at the moment of the forthcoming pole reversal, masses of lightning will be seen raging in the sky.

At the same time, we find in this the explanation of the fact that the Atlanteans saw huge bolts of lightning striking the surface of the oceans just before the earth started to tilt (see my book *The Orion Prophecy*). This was the moment when the inner rotation of the earth changed and the magnetic field tilted. In 2012, dramatic lightshows will accompany the end of our civilization. Vivid yellow, purple and blue lightning bolts will torment our eyes, while above our heads continuous thunder will explode and roll over the astonished spectators.

Worldwide, but especially at the poles, gigantic lightning sheets will criss-cross the skies—the prelude to the complete downfall of our technical civilization. Together with the current surge, an immense electromagnetic pulse will "electrocute" all electronic connections; they will literally "burn" themselves out. Personally, I find this is the worst that can happen to us, because this will throw us back into the Stone Age.

A long time ago our ancestors gained scientific insight into the catastrophes that took place with a reversing magnetic field. To top that, they knew how to calculate this beforehand. We would now be building survival arks if wars hadn't caused the loss of this knowledge. But they have, and things are different. All knowledge predicting the cataclysm that awaits us has been dissolved in the mist of time.

And when the earth reverses its direction of movement, the seas will again gather into great tides, and planetary lightning will electrocute huge parts of the earth. Astonished spectators will start fighting a battle they will lose against this planetary violence of nature adrift, and almost all will perish in a horrible way.

3.
THE INNER CORE OF THE EARTH

One evening I was going through my previous calculations again. I had put some of them aside to have a better look at them later. One page immediately drew my attention. It had been two years since I had looked at it, since specifically marking it because I suspected that further decoding was possible. It concerned two simple calculations I had made based on a scientific article about the inner core of the earth. When I saw them again, I was stupefied. Why hadn't I seen it before? Since looking at it the first time, I had found these essential numbers appearing several times during the decoding of the Dresden Codex! What I suspected at that time was indeed true! Hereupon I started to read the article again: "The fixed inner core of the earth rotates somewhat quicker than the rest of the earth. The difference in rotation time is very slight, 0.8 seconds per day, but big enough to be important for the physics and chemistry of the earth."

I jumped up on seeing the number 0.8. That was it! In order to decipher the Dresden Codex I had needed to use the number 0.08, and the number eight in general. Here a similar code was mentioned! I quickly grabbed my calculator. In one day the aberration amounted to 0.8 seconds. Multiplying 0.8 by the days of one terrestrial year according to the several calendars of the Maya and the Egyptians, the following calculation appeared on the screen:

$$0.8 \times 360 = 288$$
$$0.8 \times 365 = 292$$
$$0.8 \times 365.25 = 292.2$$

I looked at these results with astonishment. I had calculated the same numbers in a totally different way. Before, I had found them in the decoding of the orbit time of Venus and the Earth around the sun! To do that, I had taken the words of the Maya literally: that five Venus years are equal to eight terrestrial years. When I made the figures behind the decimal point equal, I got the numbers I had just found! On this basis, I was able to completely decipher the calendar cycles of the Maya! You can find this information in my book *The World Cataclysm in 2012*.

As the Maya often describe different phenomena with one code, I knew I was on the track of something new. When I realized this, I could hardly breathe anymore. After all, when the inner core of the earth starts turning in the opposite direction in 2012, it will directly cause the biggest disaster ever in our civilization's

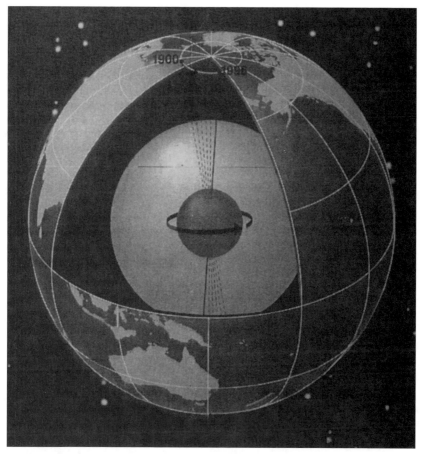

Figure 8.
Because the inner core turns faster than the rest of the earth, the axis around which
the inner core rotates shifts in relation to the north-south axis of the earth, with a
deviation of approximately 1.1 degrees per year to the east. The drawing shows
the shift since 1900.

history. This will happen as a result of a mega short circuit caused
by a sunstorm. With my mouth open wide, I continued reading
the article:

> The fixed inner core of the earth has a radius of 1,200
> kilometers and "drifts" in the liquid syrupy outer core,
> which has a radius of 3,500 kilometers. Both consist mainly
> of iron, but there are also lighter elements like sulfur and
> oxygen. The temperature of the inner core is higher than
> that of the outer core. One should expect therefore that the
> inner core too would be liquid, because there the pressure
> is higher than in the outer core, but this is not the case: the
> iron cannot melt.

Up to this point everything was clear and I hadn't found anything new. It just confirmed what I already knew. The dense inner core simply starts turning in the opposite direction, which forces the whole earth to do the same. It is as simple as that. No more, no less. But then if you have a look at the consequences, the shivers run down your whole body: in a few hours, continents can shift position by thousands of kilometers, some mountains rise, others sink, extreme earthquake and volcanic outbursts torment the earth, etc. Intrigued, I continued reading the article:

> The fixed inner core has grown since the earth came into existence, some 4.5 billion years ago. Because of a slow cooling down, crystallization takes place at the most interior border of the outer core, where solid iron is formed from the "iron syrup." The heat released during this process is the motor of convection currents in the outer core, which, in turn generate a magnetic field that sustains itself. The outer core is like a dynamo re-generating itself.

Here I had to think a bit. If the inner core keeps on growing, then it means that in a distant past, it must have been small. Therefore the polar reversals billions of years ago must have done relatively little planetary harm. And yet this is a theory, because in those days there wasn't much animal or plant life on our planet, so there wasn't much to destroy. However, for our future, this has even bigger catastrophic consequences in relation to those of the past: the bigger the fixed inner core, the more destructive the catastrophe that will accompany a polar reversal. You can bet your life on that. After all, the syrupy layer which somewhat absorbs the abrupt shock is becoming thinner and thinner. In fact it has the effect of an airbag. It is able to absorb the consequences of a collision. When you don't have the airbag, you may suffer fatal injuries when you hit your head on the steering wheel, or fly headfirst out of the window. So far, these were my reflections.

Impatiently I read further:

> Waves of earthquakes, which only travel through the outer core, travel somewhat slower than the waves that also move through the inner core. For this reason, seismic stations each time measure a tiny difference on the arrival times of "pairs" of waves that originate from the same, far away earthquake. This difference is constant for earthquakes that take place on earth at almost the same

place: the waves, after all, have followed almost the same course.

Xiaodong Song of the Lamont-Doherty Earth Observatory in Palisades, and Paul Richards of the Columbia University in New York, have recently found a systematic change in such pairs of wave—longitudinal (acoustic) waves with frequencies of between five and twenty kilometers. The difference in arrival time between the two sorts of waves appears to increase when the involved quakes—in the same area—have taken place with longer intervals between occurrences. But this increase only appears with waves that move in a rough north-south plane. For example the difference in earthquakes in the South Sandwich Islands (in Antarctica) registered in College (in Alaska) since the beginning of the measurements in 1967 have increased by approximately 0.4 seconds. However, there is no change in the wave patterns that move approximately in the plane of the equator, like the quakes in the Tonga area that were registered in Germany. The most likely reason is "that the inner core moves, probably through a sort of rotation," the researchers conclude.

World Shocking Discoveries

I have repeated this somewhat complicated explanation for a specific purpose. I am sure that the Old Egyptians and the Maya must have known about this. How? That is the question. The Egyptians as well as the Maya built architectural masterpieces, in which acoustics played an important role (Linda Goodman in her book *Star Signs*, Chapter *Forgotten Melodies*, talks of the power of sound in the building of the Great Pyramid of Giza). Were they in this way able to intercept the earthquake waves and reinforce their buildings? Who can tell? For the time being we can only guess at this. But that fact that they knew is certain. But before I show you what followed from the decodings I made two years ago, I will continue with the text of the article:

The changes are best explained by the fact that the inner core turns 1.1 degrees more per year than the mantle and the crust of the earth. This means that the inner core moves 0.8 seconds per day ahead, and that every day a shift of about seventy meters takes place at the junction of the outer and inner core. The rotational axis of the inner core forms an angle of approximately eleven degrees with the axis through the geographic poles, and the "North Pole" of this inner core axis is now located at 169 degrees eastern longitude, in other words north of the East Siberian Sea.

Here I needed to surface for air. In those few sentences three crucial codes were mentioned. I had already traced one of them back; it concerned the figures that were connected with 0.8 seconds. Now two others were left. The first remaining code involved the rotational axis of the inner core. It forms an angle of approximately 11 degrees with the axis through the geographic poles. Here I saw the number 11. Lights started to flash in my head while a bell was ringing. In my previous book I had included a relationship between the precession, or the shifting, of the zodiacal periods and the sunspot cycle: it takes eleven years for one cycle of sunspot activity, and this is equal to an essential number of the precession (=11.1111). There the number 11 showed up as an endless series. But, as seen in the forgoing text, it also shows up in essential findings regarding the inner core of the earth (1.1 degrees is also 11 when you leave out the decimal point). In several calculations, 11 therefore is an essential calculation unit.

Then I started to think about this. Was the next code hiding behind this? Where was my calculator? My brain was working at full speed. The inner nucleus turns 1.1 degree more than the mantle per year. I repeated the calculation of the proof I had found two years ago: one full circle consists of 360 degrees. When it turns 1.1 degrees faster per year, it will complete a full circle in the following time period: 360 / 1.1 = 327.272727 years. In practice, this means that after 327 years the inner core of the earth has completed one rotation more than the outer nucleus. Up to now everybody can surely follow this. But now it becomes more complicated.

Two years ago, when I made this simple calculation, I had not yet found any connections between the precession cycle and the sunspot cycle of the Maya. And in the meantime I had totally forgotten this calculation. If this had not happened, I would have immediately recognized the important code number 32.7272 in the calculation. It is identical to the number mentioned before, but with a unit ten times smaller. With the help of that number I had succeeded in finding a relationship between the precession and the sunspot cycle. For instance, the number 32.727272 points to several important similarities to the rotations of the magnetic fields of the sun. And there is another point of comparison: the equatorial field of the sun gets ahead of its polar field. After a certain time period the former runs 32.727272 degrees ahead of the latter.

The inner core of the earth does the same with its surrounding layer, only the relationship is different. In Chapter 25 of this book, I will explain more explicitly the proof for this, in the section called *Mathematical Correlations Between the Sunspot Cycle and the*

Shifting of the Zodiac. I found out that the Atlanteans of that time had also discovered this phenomenon and a relationship with the inner core of the earth. The mathematical chapter is of essential importance in understanding my point of view.

Once more this proves magnificently the Atlanteans' advanced scientific knowledge: they knew not only the sunspot cycle theory, of which our present astronomers still know very little, but also the theory about the inside of the earth, which only became known in 1996! The reason why they put this in codes is more than clear: when the sun changes its polarity it has a catastrophic influence on the inner core of the earth! Therefore they described this phenomenon with the same number. It cannot be more brilliantly expressed!

At once I started to trace back all my calculations. Before, I had calculated that, after 327.27 years, the inner core of the earth makes one rotation more than the outer core. Could I make another calculation with this? Of course. With the passing of years, the inner core has made more rotations than the outer core. After 25,920 years—a complete precession cycle—it amounts to the following number of rotations: $25,920 / 327.2727 = 79.2$. Look at this number and try to remember it a while. I also stumbled upon another strange relationship. In 72 years the earth moves up one degree in the Zodiac, an essential unit of the precession.

Because the inner core of the earth travels 1.1 degrees more per year than the outer core, after seventy-two years it has moved ahead 79.2 (72×1.1) degrees in relation to the outer core. Again you see the same number, which I asked you to remember for a while. Such combinations can't possibly be coincidental. It is the same principle of decoding that I found in my previous book: one code confirms the other. When you search further, you will stumble upon further revelations from these Ancient Scientists. Coincidentally or not, the number 792 shows up several times in the decoding of the Dresden Codex.

I show in my previous book that this number, in combination with other calculations, shows a relationship between the precession and the sunspot cycle. I am convinced that there are still more mutual relationships to be traced back. Their scientific thinking resulted in unique code combinations. To "break" them you need to have all the facts. It wasn't easy to decipher the codes on more than one occasion, because several theories are unknown by the present scientists! For the time being I have to restrict myself to the following conclusions:

- The Atlanteans knew about the movement of the inner core of the earth.

- Because they knew how to calculate its magnitude, they also knew that this core lay at the foundation of the reversal of the magnetic field. They knew that when the core started to rotate in the opposite direction, the North became the South.
- Their obsession with "The End of Times" must have been phenomenal; otherwise they could never have discovered this theory.

This theory confronts us with huge challenges. As you know from my previous book, the Atlanteans knew the speed of the polar field of the sun. From earth you cannot see the polar field and therefore it is impossible to determine its speed. And yet they knew it! Here we are confronted with similar questions: the speed of the inner core of the earth can only be determined with highly advanced equipment. So how were they able to determine this speed? Or were they using another method? Something simpler? Who knows the answer?

4.
A SUPER SPECTACULAR
DOUBLE CODE!

If you had calculated a forthcoming catastrophe, you'd naturally want to pass this on to your progeny. The Old Egyptians had a fantastic method for ensuring that this calculation could be passed on: they tied it to a circle-shaped retrograde movement of Venus above the Orion star constellation. With the help of this star code you can consistently determine the year of the next turning point, no matter what era you are living in. Then you can independently confirm that your predecessors' predictions were correct. That is how I rediscovered it, and possibly future generations will have to do the same. Other than using an escalating calendar like that of the Maya, retrograde movement may be the only way to accurately indicate the next catastrophic year. When wars or other disasters cause the calendar system you work with to disappear, this is the only certain method with which to determine the year of the next catastrophe.

Before the previous catastrophe which happened almost twelve thousand years ago, there was a striking relation between the code mentioned above and the constellation Orion: in 9792 BC, the year of the previous polar reversal, Venus made a retrograde loop above Orion. It is questionable whether this will be the same within the next twelve thousand years, because the code doesn't appear that regularly. Besides, it is possible that the Orion star constellation will undergo a fundamental change in the near future, but I will discuss this a little later.

Let me first try to answer the question why the pharaohs were so intrigued by Orion. Concentrate on the star in the middle of the three stars of Orion's belt. When you examine it closely, you will notice that this star appears to be a hazy object. Seen through a telescope it looks like an illuminated mist of gas and dust through which several stars are filtering their light. We know that it has a diameter of about thirty light years and it is situated at a distance of approximately sixteen hundred light years from Earth. Compared to terrestrial values, the cloud is extremely rare, thinner than the best vacuum one can make on earth. However, due to its huge volume, there are still enough dust particles in the field of observation to hide some stars. Furthermore, it is a breeding ground for new stars. In the mist, for example, the formation of hot and young stars requires strong stellar winds. When these stellar winds blow through the surrounding mist,

they push away the gas and dust resulting in a somewhat higher local density. The gravitational field becomes stronger and finally a star is born. The pyramid scriptures tell that, after their death, the pharaohs expected to ascend to Orion. Was this the reason why they wanted their soul to go there, because it is a breeding ground for new stars? And was it not their aim to be reborn as a star? Or was there another mystical or esoteric reason for why they wanted to be reborn?

Figure 9.
In 2012, Venus will make a retrograde loop above Orion. According to the Old Egyptians, this circle-shaped movement expressed the reversal of the magnetic field of the earth. Venus describes an angle of 360 degrees. After the polar reversal, the earth will do the same. It will start turning in the opposite direction!

A Super Spectacular Code

With respect to the forthcoming change in the Orion star constellation, we can now discuss Betelgeuse, one of the two stars forming Orion's shoulders. Betelgeuse is the star on the left-hand

side, while Bellatrix forms the right shoulder. I had seen on the computer simulation that Venus makes its retrograde movement slightly to the right-hand side above Orion. But, was that true? Wasn't the screen giving an unclear image? I therefore decided to go to Urania, an observatory and planetarium near my home. On an "open day" they simulated planetary movements, and I asked them to plot the movement of Venus in 2012. It was projected onto an immense screen where you could clearly see the planet's circle-shaped movement. Some adjustments relating to the angle of the earth in relation to Venus were made, in such a way that Betelgeuse and Bellatrix came to lie aligned beneath Venus. The outcome was sensational!

In 2012 Venus will stand still directly above Betelgeuse, a red super giant, and will make its retrograde loop. But this is not all. Venus will then come to stand still above Bellatrix, after which it will continue its loop! You cannot imagine a more spectacular code than this one! Because of this, and for other reasons, am I very convinced of the fact that 2012 is the year of the next cataclysm.

The Last Code?

Betelgeuse is one of the biggest stars we know. Red giants and super giants have enormous magnitudes, with diameters up to hundreds of times greater than our sun. This means that the gravitational force at their surface is reasonably weak. A lot of matter is therefore being released. Betelgeuse has a stellar wind that is presumably a billion times stronger than that of our sun. This means that every year, approximately 1/100,000th of its mass is blown away into space. This is equivalent to the mass of our moon being lost every day and a half. Although the mass of Betelgeuse is sixteen times the size of our sun, at its present speed, its entire mass will be burnt up and blown away in approximately one million years. Our sun, on the other hand, can easily last five billion years.

For several reasons, Betelgeuse is a good candidate for going super nova. Due to its enormous stellar winds, a "peel" of gas surrounds it. According to recent research, it contains abnormally few carbon nuclei. Such a carbon shortage is probably accompanied by a high content of nitrogen nuclei, which has also been found in some super nova remnants. The moment Betelgeuse ultimately collapses (and no force of nature can prevent this), it will happen so quickly that the surrounding temperature and pressure will increase tremendously. The result will be an immense nuclear explosion, like that of hyper-hydrogen bomb. This explosion will be seen from the earth as a Type II super nova. In astronomical time, this event will not take long, however, "not long" in this

case means in one thousand or even ten thousand years.

Because Betelgeuse is approximately 500 light years away, it is possible that it went super nova five hundred years ago, and that the light from it will reach us tomorrow. When Betelgeuse explodes, it will be clearer than any other super nova that has blazed up during the existence of man, due to its relatively close proximity to earth. At its zenith, Betelgeuse could become as clear as the full moon. You can look directly at the light of the moon, but when Betelgeuse goes super nova, all the light will be concentrated in one little point. Therefore, it will not be wise to look at it directly for too long. Should Betelgeuse explode in 2012 at the moment the magnetic field of the earth has decreased to zero, this could produce a sufficient amount of cosmic radiation to cause a considerable number of new mutations. It could even result in the extinction of some species of organisms. Hopefully the Venus-Orion code will be applicable up until the year 2012, but, if the star goes super nova afterwards, the new succeeding civilization will have to search for another code that will point out the date of the next polar reversal

A Double Even More Spectacular Code!

While Venus makes its retrograde loop, it will pass before the Sun! From Earth we regularly see heavenly bodies pass in front of each other. Once or twice every decade the planet Mercury passes in front of the sun's disk, and we can often see the four Galilean moons transiting Jupiter's disk. Our moon frequently occludes bright stars and sometimes even planets. Other kinds of transits are much rarer. One of the rarest transits is that of Venus passing in front of the solar disk during its inferior conjunction with the sun.

Generally, when Venus is in conjunction with the sun, the planet passes above the sun or below the sun from the perspective of Earth, owing to the inclination of its orbit vis a vis ours. When a transit is observed from Earth, however, another is often seen eight years later, because the orbital periods of Venus and Earth are in an eight-year resonance. After these successive observances, however, an interval of over one hundred years ensues, making transits of Venus very rare indeed. The last transit occurred on June 8, 2004, and the time before that was in 1882. The next transit of Venus will occur between June 5th and 6th in the year 2012. Be sure you don't miss this one!

The Code from Venus, Orion and the Sun

Venus passes before the Sun on the sixth of June 2012. She will be in the middle of the Sun at exactly 1:30 AM.

Venus will be stationary above Betelgeuse on May 15th and stationary above Bellatrix June 27. This means that Venus will be in the middle of her retrograde loop on the fifth of June at 8.18 pm.

Venus will be directly above the middle of Orion while it passes before the middle of the Sun! This positioning seems too strange to be irrelevant. Hence, you see the connection between Venus, Orion and the Sun.

It is for this obvious reason that ancient scientists took this code to be a warning for the End of Times! The glyphs from my book *The Orion Prophecy* will become much clearer to you now:

I am the Fierce Burning Light

navigating in the belt and permitting from far in heaven the judging of the actions of everybody

Explanation: His name is Osiris (Orion). Description: He is the seed of the contents of all human bodies. Second Description:

His name commands from above the Spiritual Parts in the human bodies. Third Description:

The name of the Glorious One shines eternally in the Infinity. He grows every day

at the firmament of stars.

Explanation: the fierce burning sun shows that the magnetic field of the sun has turned. This is accompanied by violent outbursts on the sun's surface, through which the sun seems to be "on fire."

The star constellation Orion is pointed out as chief culprit of this event. He judges the human souls and their survival. Later it is mentioned that Orion is directly connected to the code to calculate the shift of the magnetic field of the sun. And as you have read above, I found it!

The Solar Parallax and the Distance to the Sun

There is another reason that Venus was so important to these ancient Einsteins. The observations of the transit of Venus, made at different points of the earth, may be used to determine the sun's mean equatorial parallax, a measure for its distance from the earth. In his famous proposal submitted to the Royal Society in 1716, Edmond Halley explained how such a calculation could be performed. Because of the effect of parallax and the earth's diurnal rotation, the durations of the transit of Venus, observed from two widely separated places, will differ from each other by a small amount of time. If this observed difference is found to be greater or less than the difference obtained theoretically from an assumed value of the solar parallax, then, according to Halley, the sun's parallax will be greater or less in the same proportion.

Halley provided an explanation, though an inaccurate geometric construct, in order to arrive at the transit's duration from an assumed value of the solar parallax. The main principle of the calculation set out and warmly recommended by Halley, primarily left for astronomers of another generation to work out the duration of the transit more accurately from theory.

The mean distance of the sun from the earth, being the yardstick for measuring other astronomical quantities, is aptly called the *astronomical unit*. Owing to the elliptical shape of the earth's orbit, the momentary distance of the sun may be greater or smaller than one astronomical unit. On the day of the 2004 transit of Venus, the sun's distance was 1.01507 AU.

More than 15,000 years ago, ancient scientists were aware of this value. With the help of the correct distance to the sun they where able to make all other calculations regarding the orbit of the Earth and the other planets. Also, with this knowledge, it was possible to calculate the speed of the sun's magnetic fields. In other words, they mastered the computation of the End of Times. Therefore Venus was of utmost importance to them! Hence, another connection with Venus, Orion and the Sun!

5.
THE MAYA SUNSPOT CYCLE: THEORY AND REALITY

In my previous book *The World Cataclysm in 2012*, I succeeded in decoding the most sensational chaos theory of ancient times: the sunspot cycle theory of the Maya and the Old Egyptians. With this theory, I could prove that they could calculate the magnetic polar reversal of our sun, and more. By means of this theory, it was also possible to calculate the reversal of the magnetic field of the earth. With it I proved that the Einsteins and Newtons from a distant past were able to reduce complex systems into a simple pattern of behavior. They drew up universally valid laws of complexity, resulting in a theory that ignores the seemingly chaotic behavior of the whole: the sunspot cycle theory.

To these scientists, this knowledge was of life-saving importance because, with the help of this theory, they had succeeded in taking measures to survive the previous pole reversal of the earth. Through this they were able to continue their civilization after the mega disaster in the year 9792 BC. And for us this is even more important, because a new catastrophic pole shift that will sweep away our civilization is getting closer every day. All buildings on the earth will be destroyed together with all electronic data, while an immense tidal wave will be instrumental in causing billions of fatalities. These are the sensational results of my research into this theory. Better reason(s) to begin preparing for our own survival don't exist!

But still, many issues remained unresolved. The difference between the theory and the practical observation was too great. I have dealt with the rather complicated description of the movement of the magnetic fields of the sun, but not with the striking resemblance of the observations. In the meantime, I proved the polar reversal of the magnetic field of the sun beyond reasonable doubt, but stemming from all that I hadn't yet solved another pressing question arose: How could I mathematically reproduce the sunspot cycle of eleven years? Figures 10 and 11 show very clearly the difference and also my dilemma.

This theory contains a clear mathematical pattern. With its help you can partially decipher the Dresden Codex of the Maya, as well as the "why" of their different calendar cycles. However, there is a big difference in the observations, because these theories contain six peaks in eleven years, while in reality there is only one peak (see Figure 11).

Both graphs (Figures 10 and 11) show an eleven-year cycle. As you can see there are substantial differences, which illustrates my problem. Where would I have to look in order to find the similarities? How was I going to be able to describe the equatorial and polar fields in such a way as to create a diagram like the one the astronomers were observing? What linearity could I find in my non-linear research?

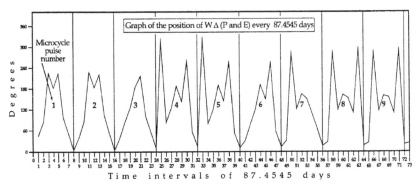

Figure 10.
The eleven-year sunspot cycle according to the Maya (the first six mini-cycles reproduce an eleven-year cycle).

It seemed an immense problem. At first I couldn't make anything of it. The differences seemed too big to me: the graphics of the Mayan cycles showed a fantastic complexity. Dozens of questions raced through my mind, like: where could I find the graphic images of the eleven-year cycle that were hiding here?· Which laws were based on this? Why were there such big differences?

The (approximate) 11½-year sunspot cycle, from observation since 1680.

Figure 11.
The Eleven-year Sunspot Cycle as Observed
After hundreds of years of observation, a regularly repeating pattern in the sunspot cycle has been discovered. Some cycles can last as much as seventeen years, while others only last seven years. However, the average cycle length is eleven years.

Questions, questions and more questions. It didn't seem to stop. And it shouldn't, because after all, we are talking about the continuity of humankind's existence: if I could find a description that fit the sunspot cycle that astronomers are

observing, then the calculation of the "End of Times" of the Maya would be proven irrefutably right.

Up to that moment, the sunspot cycle had not revealed any of its secrets, despite all efforts by astronomers and scientists in the broadest context. Many conjectures were put forward, but still there was no theory whatsoever that could vaguely approach the patterns of the eleven-year cycles: time and again the initial pursuits of the best astronomers, physicists and mathematicians produced no results. In other words, the science of the twenty first century still has not found an answer to this intriguing issue, but I had to urgently find the answer. But where? What data was of life-saving interest for this theory? How far or how close lay the scientific Grail regarding the behavior of the sun? Could I find an answer for the most fundamental of questions, like how the sunspot cycle begins and ends? And what is the underlying pattern that causes this?

I had countless questions, a chaos of whirling thoughts in my head. In that state, of course, I could not make progress. Therefore I started to revise my research. Slowly something began to dawn on me. During my decoding of the orbit period of the earth around the sun, as the Maya knew it, I had stumbled upon a complicated, but logical, mathematical pattern. Would this be something similar, I wondered? Could the solution be closer than I thought? Was there a connection with the solar year?

Adjusting for Approximations

According to known facts, the Maya counted a solar year of 365 days. However, my deciphering clearly showed that they indeed knew that it was exactly 365.242199074074074 days. Could it be that this difference of 0.242199074074074 had something to do with it? For the Maya, this number was important and overpowering. Would it be possible that it could get me a step closer to solving the riddle?

I started to think rapidly. Where could I implement this difference? According to the approximate theory of the Maya, the equatorial field of the sun moved with an average speed of 26 days. The polar field was a whole lot slower and would need at least 37 days to move. I knew from Professor Callebaut (a consultant who had helped me in my previous work) that the average speed of the equatorial field actually observed over the last seventy-five years amounted to about 25.75 days, a difference of about 0.242 days from the Mayan approximation, or moreover, the difference between the actual solar year and the Mayan calendar of 365 days. Would this give the answer to all my questions? Could the solution be that close?

Figure 12.
The Four-year Cycle. This illustration is completely different from the Maya sunspot cycle theory, although the mathematical background is identical. This result appears by adapting the speed of the equatorial field of the sun from the Maya approximation of 26 to the real value. Thus, with a speed of 25.75 days for the equatorial field of the sun, and 37 days for the polar field, the result is a sunspot cycle of about four years (4.31 years). Remember also that the solar year is replaced by an orbit time of 360 days (see Part V: Mathematical Proof).

To test this there was just one thing I had to do: calculate mathematically. With my pocket calculator I started to calculate the mathematical connection between the magnetic fields. Fifteen minutes later I put all the results into my computer and, full of expectation, I pressed the Enter button. Immediately I saw the super fast processing of thousands of calculations, which I had programmed to produce a graph. I was shocked by the output, because the graph shown in Figure 12 appeared.

When you study that graph carefully, you will see a striking resemblance to the fluctuation of the sunspot cycle, only the time period is much shorter: 4 years as opposed to 11 years. Now I was heading in the right direction. But this was still not the eleven-year cycle that astronomers observe. For a moment I again fell into an insane pattern of questions in my head. But I had to stop them because I had found something irrefutable that approximated the cycle! Now I had to continue searching further until I could define the reality, and I should not let myself be scared off by the small obstacles I encountered.

After all my previous discoveries this should be no more than

Figure 13.
The Eleven-year Cycle. In the previous illustration you saw how the sunspot cycle theory changes spectacularly when you adjust the speed of the equatorial field to the real value. When you do the same with the speed of the polar field, the cycle jumps from 4.31 to 11.01 years! A deceleration in the rotation speed from 37 to 37.176 days is sufficient to effect this change.

a formality. But an exhausting one indeed, because to my great surprise, the eleven-year cycle appeared to be subject to strict mathematical laws. Just a small difference in the speed of the polar or equatorial field appeared to make a huge difference in the time period of the sunspot cycle! A couple of examples will clarify this quickly. With a similar speed of 25.75 days of the equatorial field and an adjusted speed of 37.176 days of the polar field, the graph changed spectacularly to an eleven-year cycle. In fact, this means that a speed deceleration of the polar field of only 0.476 percent results in more than a doubling of the period of the sunspot cycle! A completely unexpected result!

For a moment I stopped to give this some serious thought. Wasn't I making a breakthrough here regarding why there is so much difference between several cycles? Most probably. There are, for instance, cycles that last only seven years, while others run up to seventeen years. Nobody knows why. According to my theoretical findings, a slight change in the rotational speed of the polar field is enough to explain these huge differences! This change creates clear-cut changes in the cycles. But when the average speed over hundreds of years is the same, it results in average cycles of about eleven years. You can therefore state that

this theory has to be considered astonishingly correct.

Conclusions:

1) Only a slight change in the speed of the polar or equatorial field can produce an important lengthening or shortening of the sunspot cycle.

2) Mathematically speaking, a very close correlation between the equatorial and polar fields must exist.

Figure 14.

The graph in Figure 14 illustrates a long 11-year cycle. It coincides very strongly with what we observe!

The Time Period between the Polar Reversals

The sunspot cycle lasts longer when the polar field rotates slower—you know that by now. Another factor is connected to this: it has been determined that a "small" polar reversal of the magnetic field of the sun occurs at the highest point of the cycle. When you prolong the time period of a sunspot cycle, you automatically prolong the polar reversal of the magnetic field of the sun! Could I, at the root of this, solve another problem? Wasn't this theory also showing that the time period between the polar reversals of the earth can sometimes differ markedly?

Let me elaborate on this. As the numbers of the Maya and the Old Egyptians show, there is a difference of about 284 years between the time periods of the polar reversals. More specifically,

the time between the two previous cataclysms of Atlantis (the ones of 21,312 BC and 9792 BC) amounted to 11,520 years. The time period between the polar reversal in the year 9792 BC, which completely destroyed Aha-Men-Ptah (later phonetically called Atlantis) and the one that awaits us in 2012, amounts to about 11,804 years, a difference of 284 years. Why?

With the above data in mind I started to research this idea, but it appeared to be a complex problem. When I lowered the speed of both fields by a proportional factor, the time period of the polar reversal increased. In my previous book, I showed that the sun reverses its poles after 3,848 years. When I changed the speed of 26 and 37 days by an equal factor to 26.25 and 37.36 days respectively, this turning point goes up to 3,885 years, an extension of about 37 years. Because the major polar reversal occurs only after three cycles, this results in the following time difference: 3 x 37 = 111 years. But this occurs only with an average orbit speed of 26.25 days. From Professor Callebaut we know that in the last seventy-five years the average orbit speed has measured 25.75 days. How much these changes amounted to in the previous 3,700 years, we can only guess.

In the sunspot cycle the equatorial field starts to move faster when a reversal point is getting closer. As we are now looking ahead to a new polar reversal, the average speed of the last few decades could be higher than the thousands of years before it. But we have no certainty about this. This we can only ascertain when we dig up the Labyrinth in which the Old Egyptians kept their astronomical observations. In it, we can confirm all the calculations that lead to the year 2012. And the excavation needs to be done urgently.

What we will find there has no equal. This architectonic complex is so extensive, that it is almost unbelievable. To build it they must have made phenomenal physical efforts of gargantuan scope. One can hardly understand this, but they were extremely motivated to save their written history and discoveries. The continued existence of their descendents was dependent on it!

According to Plato, the Atlanteans wrote everything on golden tablets. The Egyptologist Albert Slosman confirms this in his books; he also states that the Old Egyptians did the same. According to his translations, the Labyrinth contains the "Circle of Gold," a legendary room, which is referred to in the Egyptian Book of the Dead. They fashioned the room from granite and completely covered it with gold. Inside, there are documents about the history of Aha-Men-Ptah and Egypt and also the astronomical knowledge they possessed, so it is imperative we go there. The scientific knowledge piled up in the Labyrinth is superior to our

present knowledge. All scientists and mathematicians would be awestruck at the sight of the "astronomic pearls of knowledge" which are there waiting for us.

The Turning Point

The calculation of a speed of 26 days for the equatorial field and 37 days for the polar field of the sun, results in a clear turning point after 3,848 years. However, with a small change to the speed of the equatorial or polar field it jumps to other values. The only problem then is that the turning point is difficult to determine. For this reason the Maya used this theory: it presents descendant researchers with the opportunity to find the correct date of a polar reversal, which in practicality doesn't differ much from the real value. Furthermore, you can calculate the scientific fundamentals for astrology with the help of the speed of the equatorial and polar field and the time period of a solar year; the polarity of particles that reach the earth changes every month. Should you continue building on this, you will automatically connect to the sunspot cycle theory.

To go back to my problem: there was still an unaccounted difference of almost two hundred years in the time period between the polar reversals. For that reason I started to implement slight changes in the speed of the polar or equatorial field of the sun. But as I mentioned before, I had a serious problem: my clear turning point disappeared! Whatever I tried, examined and compared, my zero point didn't show up anymore! Finally, after weeks and weeks, I had to give up and move on to other pressing issues. I hope that in the future I will be able to come back to it with a fresh perspective and work it out after all. Interested mathematicians are welcome to give it a go.

However, what I did find is that a difference in the rotational speed of 0.4 percent in both fields, in relation to the values of 26 and 37, is enough to result in a final difference of 300 years, after 11,700 years! Together with my previous finding, I have therefore found two different ways through which the time period between the polar reversals can change, a more than satisfying result. The theoretical section at the back of this book shows the clear calculations used to produce this result.

Why this Difference in Polar Reversal Time?

It is logical that after every violent polar reversal, the sun hasn't the same amount of energy left at its disposal. Because every cycle ends with excessive violence, it is therefore logical, too, that this causes changes to its internal structure. Even a tiny little change is sufficient to influence the speed of the magnetic

fields, either resulting in a shorter or longer time period between the polar reversals. You have seen the same effect in the sunspot cycle. When you change the speed of the field by a fraction, the cycle can easily last fifty percent shorter or longer!

The super-long cycle is undoubtedly also subjected to this. The Maya and the Old Egyptians knew this for sure. Therefore they were able to pre-calculate the change in time periods between the polar reversals. However, up to now I have not been able to unravel their theory.

There are still many questions left, like: How were the Maya and Ancient Egyptians able to determine the turning point that accurately? Is the total reversal interdependent on the eleven-year cycle? How do you pre-calculate long and short cycles? These crucial questions and more certainly need to be answered. Working out these problems will form a lifelong task for our future generations. Only by a well-structured study of the behavior of our sun can future mass fatalities be prevented.

Planetary Destruction and the Shift of Seventy-two Degrees

During the long history of the earth, billions and billions of animals must have died due to pole shifts, but never billions of people. Some may not mind that humankind, the biggest contaminator of our planet, will be decimated. Others will consider this thought to be unbearable. The number of people that die will be exponentially greater than the number that perished in all the wars that took place throughout history up to now—an immense number, a human catastrophe without an equal. Dealing with the aftermath will control our thoughts and purpose thousands of years into the future because the earth will be in a state of being badly stricken and contaminated by a chemical and nuclear mess. And we still do not know and realize what is in store for us! Crucial information has been lost in the course of the ages and this situation now brings us to the edge of a complete abyss: the possible end of everything.

What is certain is that a disaster with casualties on such a large scale never has to happen again. But to realize that surety, the survivors of this catastrophe need to promote a rigorous program of reconstruction in the sciences. In that way, the secrets of polar reversals can be revealed beforehand and preparations can be made. They will also be able to solve the question of why a certain previous shift took place, something I haven't been able to do yet.

This concerns the shift of seventy-two degrees in the year 21,312 BC, which wasn't a polar reversal, but indeed a rapid shift in the zodiac. Furthermore there was a comparatively short time

period between this cataclysm and the previous polar reversal of that time. This amounted to only 8,496 years, where the average time between polar reversals amounts to about 11,500 years. We probably need to search for the cause of this in an irregularity of the sunspot cycle. In my previous book, I showed that after 3,848 years, a partial polar reversal of the sun takes place and a complete one after three times this time period.

Besides this, I had seen that after the passage of half of the 3,848 years (1,924 years) a small irregularity occurred in the theory. It is possible that this interval of time shows the minimum time that a catastrophe on earth can take place. After the polar catastrophe at the end of 2012, we will be safe for at least some thousands of years before the next will take place. After that, new catastrophes can afflict the earth after the following number of years: 3,848; 5,772; 7,696; and 9,620. Of course, this can differ by a couple of hundreds of years, before or after these time periods.

It could also be that I overlooked another aberration that causes the rapid rotation of the earth's axis. But whatever it may be, I pass this task on to future scientists. Starting with my findings, which are in fact a rediscovery of ancient wisdom, they should possibly be able to determine the next cataclysmic dates. Hopefully they will also be able to take the necessary precautionary measures in time, in order to escape from the catastrophes. Better to sound the alarm twice than be washed away by a tidal wave.

As we have seen, many old myths refer to recurring catastrophes. The Mexican *Annals of Cuauhtitlan* describes seven worlds, which they call *Chicon-Tonatiuh* or "The Seven Suns." The annals record every time a flaming sun caused worldwide destruction. A long time ago the scientists deciphered the backgrounds to these disasters. The Maya and Old Egyptian sciences were saturated with knowledge about polar reversals. Also, their whole religion was based on them. They knew how fragile their lives on earth were.

In the year 2012 we will be confronted with the manifestation of their advanced scientific knowledge: within a couple of hours all our knowledge will be swept away and our world destroyed. I hope I will survive this with enough motivated people, because, as of that moment, we have to ensure that this rediscovered knowledge will be taught worldwide.

What is certain is that everybody will regain respect for nature and the environment. This knowledge about magnetic field reversals will allow future generations to grow up with a completely different way of thinking. They will also redevelop the earth more ecologically than we have, since they will know and realize that, after them, other generations will come. We,

however, will be confronted with an interminable mess. It will take tens of thousands and possibly hundreds of thousands of years before this mess will be cleared up. The only advantage will be that this clearly visible ecological disaster will cause future generations to think profoundly for a long time and prevent them from doing the same as we did. Perhaps we can take this as a scant comfort…

Absolute Certainty about the Date

According to our observations, a "small" reversal of the magnetic field of the sun occurs on a difficult-to-determine date. Astronomers can easily be off target by a year! But for the year 2012, our present science parallels the old one: both expect that the magnetic field of the sun will change in 2012. Our present-day astronomers expect a small reversal, because there was a reversal in 2001 and the next eleven-year cycle ends in 2012. The Old Egyptians and Maya, however, postulate a "big" one. They had already calculated this thousands of years ago. The only difference is that the present astronomers expect this to happen at the beginning of 2012, while the Maya calculated the reversal to occur at the end of 2012.

Given the fact that our scientists can easily be off target by a year, I dare to bet anything that the reversal will take place at the end of 2012. In fact, early in 2006, some astronomers changed their minds, and now expect a "big" sunspot cycle in 2012! Keep an eye on my web site for future updates.

From my previous books, you know that the Maya were able to predict the exact previous catastrophe date two thousand years before the event took place! Myths from Peru, Ecuador, Venezuela and Brazil confirm this. They tell about days long gone when white, fair-haired men with beards came to warn them of a forthcoming cataclysm. This is also remembered in Burma. In *Asiatic Researches; Burma* (Vol. VI, page 172) we read: "A thousand years before the destruction of the world a certain *Nat* with a sad face came to announce what was going to happen."

A few people took this warning seriously and built ships in order to survive the flood. Some must have had impressive dimensions. Noah's Ark was just one of at least ten big ships, overloaded with animals, plants, fruit, archives, books, blueprints of machines and written scientific discoveries. All these traditions make it clear to us that the Big Tidal Wave was a worldwide phenomenon. The survivors did not only land in Europe, but also on the mountains of Asia, South America and Africa, while the bodies of millions of animals and people lay rotting in a suffocating stench.

These myths clearly prove that long ago people were able to pre-calculate the occurrence of that catastrophe well in advance. This is all the more reason for saying with immense certainty that the calculation of the Mayan and Old Egyptian scientists can only be correct. The only thing left for us to do is to ring the alarm bell around the world, and prepare ourselves for the forthcoming super cataclysm.

PART II

THE DESTRUCTION
AFTER THE CATASTROPHE

6.
A RELIGIOUS WARNING OF THE FORTHCOMING APOCALYPSE?

I did not want to publish this chapter in my previous book, because I had doubts. Would I lose my credibility, I wondered? In *The World Cataclysm in 2012*, I broke one code message after the other and I deciphered the Dresden Codex. Furthermore, I was able to find the crucial turning point in the sunspot cycle. In other words, everything was focused on exact scientific calculations. With the help of those decodings I proved that the story of Atlantis is true. That fact alone would be most incredible for a lot of people. And it would have complicated everything even more to talk about religion.

But it kept troubling my conscience. Try to understand me, I am a skeptic, but I cannot ignore some remarkable facts. During my research I stumbled upon the explanation of the number 666, a number which has been known for ages in the teaching of Catholicism and is connected with an apocalypse. In the biblical Book of Revelation (also known as the Apocalypse of John) the author says that at the End of Times, earthquakes and natural disasters befall our planet, the sun turns black and the moon as red as blood, and the stars fall on the earth. Amidst hail, fire and blood, the mountains sink in the sea. Sky, sun and moon are obscured and countless people die in this catastrophe. Behind this number a whole science is hiding, which used a technical terminology based on the magnetic fields of the sun. Its cycles can only be discovered after a millennia-long observation of the sky, during which you as a researcher will stumble upon a huge universal theory about the end of a civilization cycle and death. The two are correlated. It is impossible for you to miss this. Something like this can be no coincidence.

The number 666 contains the expected downfall; a terrible end, the worst in human history. Billions of people will perish and the Highest Ruler will judge their souls. Will they reach immortality or be damned forever? The Old Egyptians as well as the Maya, the Hindu and many more, were asking this crucial question. Entire religions were based upon trying to encourage people to reach immortality, just like the Catholic teachings wanted to free the spirit of the heavy hindrance of materialism. In all these religions the same ranges of thoughts show up: the renunciation of materialism and the doing of good works in order to reach the paradise in heaven. Can this be a coincidence? I don't think so,

particularly because I found further connections. For example, a connection between the myth of Osiris and the Christian New Testament is that, just like Jesus, Osiris resurrected to give his followers final instructions. The Old Egyptians connected a science of immortality to this. When you read the Egyptian Book of the Dead carefully, it glows with their spiritual faith in the hereafter and the faith in a superior being. I asked myself more than once: is the God of the Old Egyptians the same as God the Father?

Furthermore there appears to be a connection between the biblical prediction of the tidal wave and the story of Atlantis. In other words, my research opened new ways to interpret secrets thousands of years old. It also established a link to the last prediction of Fatima.

Fatima, May 13th 1917. Lucia dos Santos, her cousin Francisco Marto and his little sister Jacinta were tending their sheep in the dry Cova da Iria, two and a half kilometers from the church of Fatima. Lucia is ten years old, Francisco nine and Jacinta seven. They are playing with stones when, after the angelus, a bright lightning bolt cleft the clear sky. They run home to shelter from the approaching thunderstorm. When they run past the Holm oak, another lightning bolt suddenly appears and they discover a lady with an aura brighter than the sun inside the tree. The lady wears a white dress and holds a white rosary in her fingers. She says to them: "Have no fear. I have come from heaven. Later I will tell you who I am and what I desire. Come to this place in the next six months on the thirteenth day of every month at the same hour." On June the 13th the same scenario occurs. Lightning and in the Holm oak, the lady, shining brighter than the sun. This time Lucia has prepared herself for the meeting: she would like to know what has become of her recently deceased friends. "Is Maria de Neves also in heaven?"

"Yes, certainly," the lady answers.

"And Amelia?"

"No," the lady answers. "Amelia remains in purgatory until the end of the world. But in a not so distant future, I will take along Francisco and Jacinta to heaven. You, Lucia, will have to stay a long time to make me known and loved on earth. Pray every day a chaplet for peace in the world and learn to read." And just like the previous time, the lady ascends and disappears in an eastern direction.

Word of this second appearance spreads even faster than the first time, and the parish priest of Fatima places the children firmly under interrogation to ensure that this was not a trick of the devil. Lucia doesn't want to herd sheep in Cova da Iria anymore, yet on July 13th she feels an uncontrollable urge to go.

This time the lady says, "Continue coming here every thirteenth day of the month, continue praying a chaplet every day for the poor sinners, for peace on earth and for the conversion of Russia." And she mysteriously adds, "In the end my Immaculate Heart will triumph."

Then she gives the children a foretaste of hell: in a vision they see an ocean of fire containing shadows of devils, demons and the souls of sinners which cry with pain and moan with sorrow. Frightened and respectful, Lucia asks the lady who she might be and requests a miracle because nobody believes her. The lady promises that she will make known in October who she is and that she will perform a miracle, so that everybody will have to believe.

In the meantime, the whole of Portugal is affected. Every thirteenth of the month, more and more people come from all parts of the country to Cova da Iria to catch a glimpse of the Lady and to pray. Many are completely convinced that she is the manifestation of Our Lady, the Holy Virgin, the Mother of Jesus. Others keep their heads cool and say that this nonsense has to stop once and for all, and among this group is the mayor. On August 13th, he picks the children up from their home with a horse and wagon, in order to bring them, so he claims, to Cova da Iria to the manifestation. But in fact, he takes them secretly to prison, where he keeps them for three days.

At the site of the manifestations, some twenty thousand believers have gathered. A big peal of thunder rewards their waiting and a tiny cloud descends to the Holm oak, where it stays for a moment and then rises up to the sky, as usual in an easterly direction. Lucia, Francisco and Jacinta are positive that they missed their meeting. But, as the saying goes, 'If Mohamed doesn't go to the mountain, the mountain goes to Mohamed,' and this law applies in the story of Fatima. When the children are set free, the lady visits them, just five hundred meters from their house. Again she promises them that she will perform a miracle in October as long as they keep on praying, making sacrifices and doing penance. They know how to pray, but they are not sure how to make sacrifices and do penance. In order to make a sacrifice and do penance Francisco (who, like his illustrious namesake of ages before, Francis of Assisi, can talk with the birds) decides to give his packet of lunch to the sheep every day.

On September 13th a crowd of people see a ball of fire descend from the sky. The sun seems to fall from the sky upon the earth. "There she is! There she is!," Lucia cries excitedly. But nobody can see the woman. Lucia asks the manifestation to cure the sick in the crowd, but Our Lady, who is not always so kind, replies

coolly, "Some I will cure. The others not."

On October 13th Lucia's mother is terrified. She hides in her house together with her husband and six other children, because she fears that the people will lynch her daughter and the rest of the family when the promised miracle doesn't take place. Although it is storming and raining continuously, about seventy thousand people gather in Cova da Iria. And again, in the afternoon she is there. Today she is wearing a white dress and a blue cloak, like Our Lady of Sorrow, and she announces to the children, "I am Our Lady of the Rosary. Build a chapel here and pray a chaplet every day. If you do so, the war will be ended soon and the soldiers will come back home." And then she is gone. Lucia, Francisco and Jacinta see in a flash Saint Joseph with the child Jesus in his arm, blessing the world.

The seventy thousand spectators do not notice the latter at all, but indeed seem struck by the hand of God by the long-expected miracle. The clouds and the rain disappear as if by magic, the sun glows in all the colors of the rainbow and becomes like the moon: everybody can watch it without being blinded. The sun then turns, tumbles and dances through the cosmos, until suddenly it seems to fall from the sky and threatens to crash to earth. Everybody clutches their chest, holding their breath, fearing that the End of Times has come, but then the celestial body takes its place back in the firmament. During the long wait in the rain, all the spectators had become soaked to the skin, but after the dance of the sun, everybody's clothes are found to be as dry as bone. When it starts to rain softly again, the drops are not water from the sky, but rosebuds that permeate the air with their sweet smell, but disappear when anyone tries to catch or touch them.

This is the way in which the sun miracle is recorded by Avelino de Almeida, head editor of *O Seculo*, the anti-clerical newspaper of the Masonries of Lisbon, 120 kilometers further south. During the miracle, Avelino's mistrust and disbelief disappeared, just as had all the other spectators'. Even the soldiers that had been sent to keep order in the crowd dismounted from their horses and fell onto their knees, giving thanks to the Virgin.

Lucia's Letters

After the manifestations, Lucia took many opportunities to announce the revelations she had received, all except the mysterious Last Secret. This was so confusing and ominous, that the Virgin promised her that she would come back to give her the Revelation again. This took place on the morning of November

23rd 1929. This time Lucia wrote the words down literally and she put them with the other letters that she had written on the other revelations.

In the first letter, Lucia gave a detailed description of the famous miracles at the time of the manifestations in Fatima. She also described how the Virgin predicted the rise of the godless communism. In the second letter, Our Lady foresaw the horrors of the Second World War, the holocaust, the fanatic fascism and the famines. The following letter contained a promise to which a condition was attached. If enough people prayed to convert Russia, communism would collapse, followed by a period of reasonable peace. Pope John Paul II brought this commission to a good end: Russia capitulated, and the threat of an atomic war with that superpower disappeared. As for the last revelation, the Virgin herself asked for this to be announced after the death of Lucia, or by the latest in 1960, whichever happened first. But in 1960 Pope John XXII judged that "the time and the world are not yet ripe to hear the last secret of Fatima."

In 1929 Pope Pius XI had read the letter. He got so upset that he decided that the letter would remain sealed for the duration of his papacy. His successor, Pius XII, refused to read the horrible contents. But in 1942, he dedicated the whole world and, in 1952, Russia to the Immaculate Heart.

After reading the letter in 1967, Pope Paul VI made a controversial pilgrimage to Fatima. Controversial because at that time Portugal still had a fascist regime. While there, he received a vision of the Armageddon. "As if the masses had gathered for the Day of the Final Judgment," he said, full of awe.

In 1991, Pope John Paul II did something that had never before been done in the annals of Catholicism. He dedicated his whole worldwide congregation to Our Lady of Fatima. He urged all Catholics to pray for the secret facts in the letter. He indicated that, should they not listen to his call, a horrifying prediction would become reality: "Repent and improve your life, because the end of the world is near!" As these words were spoken, a silent 84-year old Lucia was standing next to the Pope.

Finally, in May 2000, the Church announced quite unexpectedly the so-called contents of the letter. According to them it didn't concern the Armageddon, but I can hardly believe this explanation. You can find more information on this topic in *The Third Secret* by Steve Berry. Too many questions are left.

Every time when I suspected something during my research, it appeared later to be right. By following my hunches, I was able to solve countless questions that were connected with the forthcoming disaster. I suspect now that the highest authorities of

the Church know something that they don't want to tell. I think, however, they will do so before the fatal date. On what do I base this? In 1917, as the expectant crowd watched, the sun danced in a zigzag across the horizon. At the next pole reversal in 2012, the earth's crust will shift thousands of kilometers. The sun will then move across the sky in an irregular "dance–like" movement. This can hardly be a coincidence. Noah was warned beforehand of the coming doom. Why should there not be a new warning now? Of course I realize that such a revelation would cause worldwide panic. Our whole economic and spiritual system would collapse in just a couple of months. I think the Church keeps its silence for that reason. But within a couple of years the worldwide economy will collapse and fall into a deep depression anyway. At that time, a message about "The End of Times" will not make much difference anymore.

7.
THE DESTRUCTION

The descendants of the survivors of the previous catastrophe, the Maya and the Old Egyptians, left us a serious warning: without any doubt the world will end in 2012. The Northern Hemisphere especially will be stricken. To inform us about this, they left us buildings, myths about tidal waves, star codes, the sunspot cycle theory and a descending calendar. Serious information. The same cataclysm that destroyed their fatherland will strike us now. With incredibly accurate scientific knowledge, they calculated how and when this disaster would take place. They worked at a highly advanced astronomic level, which we have not yet reached, however unbelievable this may sound. We can learn tremendous amounts of information from their calculations and by studying their astronomical zodiac—that cataclysms tormented the earth regularly, among other things. For long periods of time, the ages pass normally. But then, suddenly, an explosion of unstoppable violence occurs on the sun, which sends a burning cloud of plasma rocketing to the earth. Nothing and no one can stop it. We will encounter and endure this event, which will result in massive destruction.

To illustrate the polar reversal, the Old Egyptians left us their astronomic history. In it they tell us exactly what happened during the previous disasters: in one day the movement of the ages was shaken thoroughly. The earth changed her precession abruptly on three occasions and her direction of movement twice. Astronomically seen, their code message is a masterpiece: simple and at the same time horrifically accurate. In *Hamlet's Mill*, Giorgio de Santillana and Herta von Dechend reason that the zodiac was made to describe disasters that occurred cyclically after long time intervals, and they give a lot of evidence for this. From the work of Albert Slosman we know that this was indeed the case. He deciphered the passing of the zodiac over the last forty thousand years. His deciphering shows vividly that the earth's axis started to rotate in the opposite direction at certain regular points in time! And that the civilization of Aha-Men-Ptah was able to predict the last cataclysm two thousand years in advance! Furthermore, I discovered that their descendants pre-calculated the next disturbance in the earth's axis to occur in 2012!

This confronts us with the biggest challenge in human history: our survival of this imminent cataclysm. This gigantic geological disaster will thoroughly destroy our civilization. There is no

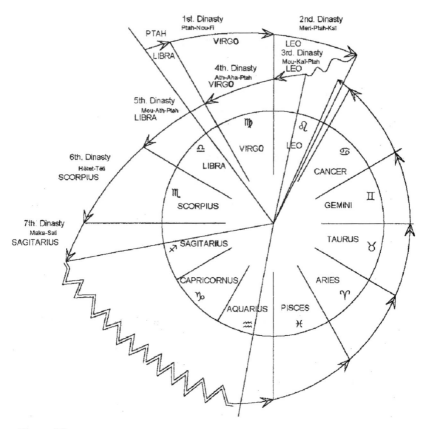

Figure 15.
The astronomical zodiac of the Old Egyptians describes the previous ages in which catastrophes or pole reversals took place on earth. At the end of 2012, we can add to this a new polar reversal. We can only speculate to which age we will be catapulted.

doubt about that. You can react with disbelief, or with panic or denial. Or you can roll up your sleeves and make the necessary preparations in order to survive this. And I mean completely roll up the sleeves, because, to put it plainly, what lies ahead of us is very bad. Not to say completely hopeless. I have already suffered terrible nightmares, but these will not stop the cataclysm. Three days after the sun's pole reversal in 2012, we will see and be in the following situation:

1. The polar reversal of the magnetic field of the sun will send a huge cloud of electromagnetic particles into space. As a result all satellites around the earth will be completely destroyed. Immediately thereafter, the poles will crash and the magnetic field of the earth will be supercharged within a short period of time. In an instant, all electronic equipment

will be destroyed through an internal short circuit as a result of the electromagnetic pulse. Through this, 99.9999999999999 percent of our knowledge will be lost within just a couple of hours. Result: our computer-dependent civilization will be wiped away completely.

2. Huge earthquakes and volcanic outbursts will destroy all buildings and installations, leaving them in ruins. Nothing will be left of high-rise blocks and skyscrapers—everything will be leveled. Completely leveled. The subsequent earth crust shift and tidal wave will leave all knowledge buried in the ruins, amongst which especially will be books, useless forever.

3. Almost all regions will have a climate change. All of a sudden Europe and the United States of America will be thrust into a new ice age, in which life is barely possible. As we do not know how big the earth crust shift will be and which parts will be shifted, we also do not know where to restart a civilization. Possible places could be India, South America, Africa and the high mountains of Thailand. I will go deeper into that later.

4. Because of the tidal wave and the huge storms that will torment the earth's surface, all food supplies will be destroyed. All trees will be uprooted; all growing fields will be lost or drenched with salty and contaminated water. It could take years before sufficient food will be able to be grown again to feed the survivors.

5. All the drilling installations in the world's oil fields will be torn apart. The wells will either leak into the surrounding areas, or the earthquakes will cover the holes. It is certain that it will be impossible to revive the installation works. They will be lost forever.

6. All energy supplies will be destroyed. Tanks with petrol derivatives will be torn open and the freed substances will overflow into the environment worldwide. Huge oil slicks from destroyed oil tankers will contaminate the oceans. They will wash ashore in the tidal waves of up to two kilometers in height and will pollute all of the agricultural land.

The magnitude of this problem should really not be underestimated. For years and years the black residue, together with the freed gas oils, will severely contaminate

the soil, and make it impossible to grow plants, vegetables and trees. Compare this with an oil spill in order to get an idea of the damage we can expect. In many recent cases, a slick of tens of thousands of tons of oil is spread out in the sea. This quantity is sufficient to severely pollute hundreds of kilometers of coastline. Vast numbers of aquatic creatures as well as a huge number of birds die because they become coated in greasy goo. Everybody knows this scenario only too well. But do you realize that in 2012, almost all of our petroleum stores will be destroyed? Probably not. Some figures will put this in perspective. Every day, about eighty million barrels of oil are being drilled up. This amount alone can cause thousands of big oil spills! If you also know that the worldwide stockpiled supplies are sufficient for about three months, you can immediately calculate that about a hundred thousand ecological super catastrophes will plague the earth! This is more than sufficient to contaminate hundreds of thousands of kilometers of coast. In other words, anywhere you happen to be on this planet you will be confronted with mountains of grunge, a cluttered mess covering most of what was the viable processing capacity of the earth. Chances are pretty good that many of the people and animals that are left will perish due to this super contamination. I do not know a better reason for reducing these supplies to nil before the disaster takes place!

7. Harbors and ships will also be completely destroyed during the catastrophic events. The large-scale transportation of goods with, for instance, banana boats or container ships, will be totally impossible.

8. Cars and trucks will be compressed into tin by the forces of nature. If this is redressed quickly, some may be reconstructed, but saltwater causes rapid oxidation and corrosion. On top of this is the remaining problem of the complete destruction of all energy resources. And the factories that manufacture car tires and other essential products will not exist anymore, so any reconstructed vehicles will not last long.

9. Hospitals, dental practices and all other health services will be reduced to ruins. Life-supporting knowledge and years of practice will be gone forever. Should you be hurt, even a small injury could prove to be fatal.

10. During the earth's crust shift with its titanic quakes, the

hundreds of nuclear plants on our planet will be destroyed. It is my biggest fear that the quantity of radioactivity which will be catapulted into the atmosphere of our planet will be sufficient to completely contaminate our living environment. Here we will be confronted with the same problem as with that of the oil supplies: extreme amounts of pollution on a worldwide scale. Nobody can escape from this. We really have to take this into consideration, because the further we stay away from radioactive debris, at least for the first few decades, the greater our chances will be for survival.

11. Life-threatening and toxic products from chemical factories will be dumped into our environment. In many places it will take thousands, maybe even tens of thousands, of years before everything will be absorbed back into nature. For example, the products that become trapped under the poles might remain there untouched until the next pole shift. After twelve thousand years they can re-appear. These pollutants are a serious danger for all future generations.

12. Electrical and telephone networks will be torn apart and rendered completely useless. All electricity generating plants will be reduced to ruins. Even more serious will be the following: due to the induction currents generated together with the pole reversal, all electronic and electrical equipment will be useless for ever!

13. Airplanes will all have crashed before the pole reversal takes place, because of the electromagnetic storms coming from the sun. These storms damage the navigational and electronic equipment and the airplanes will be uncontrollable.

These are just a few of the many instances of destruction you will be confronted with. The list is too long to complete. I could write many books from this list. In short, the cataclysm concerns a total destruction, more deadly than an atomic war and thousands of times worse than an asteroid colliding with the earth! Should you want to prepare yourself for this super catastrophe, I advise you to watch all the movies about atomic wars, earthquakes, volcanic eruptions and colliding asteroids. Should you add up all the consequences shown in those movies, you would not come close to the destruction to be expected! In other words: it is an unknown entity, so you need have no illusions about that. The story of the Swiss Family Robinson shipwrecked on a tropical island would be an absolute utopia compared to this destroyed and polluted world.

The ruin of our civilization will be complete. In the space of one day, we will go back to the Stone Age. And this is expressed conservatively, because our environment will be totally disrupted, leaving very little food and usable natural resources. No comfort, warmth or electricity. For a lot of people this will be sufficient enough reason to choose not to make the effort needed to survive, and accept their fate without any resistance, preferring to die in the apocalyptic events than to keep on living in a seemingly endless fight. In some respects, I would not disagree. And as I reasoned in my previous books, only a small fraction of the earth's population will survive this disaster. The biggest part of the world population has little chance. There are simply not enough safe places and ships. Even with a large-scale building program, we can only save a couple hundred-thousand people at most. And I am still not taking into account the lack of food supplies after the cataclysm. Moreover, there will be a lot of unknowns, like the possible effects of all the chemical pollution, the radioactive debris, etc. Many will realize this and resign themselves to their end. Others will voluntarily sacrifice themselves and vie to survive, for the continued existence of humankind.

My urge to survive is terribly strong. From childhood I have had an inner feeling that when I grow up, I would create something "big." That is the reason why I am so obsessed about this subject. I know and realize that I am probably the only one in the world who has a well-defined rescue plan. Nobody is going to believe it, until it is too late, and then the continued existence of humankind is severely in danger. Realizing this goes against my principles. At this particular moment I am 47, and have no children and therefore my survival urge shouldn't necessarily be that strong. Yet every bone in my body is drenched with it. So why can't I convince those who are parents? Their children are in immediate deadly danger. To many, having children is the most important reason for their existence. Would it then not be worthwhile to save them? Of course it is. Therefore my call to all responsible parents and people who already are convinced: start preparing yourselves. Prepare yourselves thoroughly; store mass quantities of food, materials and relevant books.

But even if we do so it will be an immense task for us—the few survivors—to restart a civilization. We will be confronted with an incredible number of problems. In order to not be overwhelmed by them, we need to concentrate on the most needed products and services. Like what? I have thought about this for a long time. After a lot of pondering I have made a list you can find in the back of this book. You will see in it very simple things, like elementary books about electricity, sciences and mathematics.

Nothing complicated whatsoever. This cannot be otherwise, because nothing will be left. Starting with basic knowledge and materials, we can then work to advance.

Should we not have these basic things, we can forget about it. Should we, however, know how to create electricity, well, then we can reconstruct a civilization that is worthwhile. Nothing works without electricity. Therefore I think a library is of the utmost importance. Knowledge is power. It has always been like that and will always be. We, the survivors, can make a mark in a new world with what we know, control and rule the earth in a natural way. Only in such a way is it possible to succeed in our most important task. It will not be easy, of that you can be sure. Only really motivated and well-trained people can handle this. Should you feel ready for this, I advise you to start working on it as soon as possible and look up the last pages of this book. Choose those things you can relate to best. Your children are already counting on your active support!

8.
HURRICANES AND TORNADOES

At the end of 2012, we should be waiting either up in high mountains or in boats. There is nothing in between. In either scenario, we will be at the mercy of nature's violent side as well as the reversal of the earth's magnetic field. Merciless natural phenomena like earthquakes and volcanic eruptions will strike us. We will be filled with fear, because there is nothing we can do to stop it. And it will not stop at earthquakes: winds hundreds of times stronger than hurricanes will test our nerves. The source will be changes in the speed of the daily rotation of the earth's axis. First, we will have the affects from the deceleration of the planet, and then will come the acceleration in the opposite direction. This is hardly imaginable; a colossal and gigantic event that knows no equal.

Because of these sudden and forceful changes of our planet's behavior, layers of air will stream together from the equatorial areas through a central flowpath, in one sudden movement to the poles. These are just physical manifestations of a collision of fast and slow air currents. Around the equator is where the earth turns the fastest; the higher the latitude, the slower the revolution speed. When the earth starts to cant, the fast air layers will keep their impetus. They will collide with the slower air layers, and will start a gigantic fight to rule on a planetary scale, causing meteorological events that go far beyond the imagination. With their best models meteorologists cannot anticipate this, let alone describe it. But what they do tell is already frightening enough. Some reports show this vividly.

Deadly Tornadoes Rage through the Midwest

On Tuesday 2nd April 1974, meteorologists all over the Midwest observed the development of a dangerous weather pattern. A warm air mass was headed on a collision course straight toward a rapidly moving cold front. The consequences were disastrous. Eighteen-year-old Ruth Venutti was standing close to the high-school building in Xenia, a small town 25 kilometers east of Dayton, Ohio. Her attention was suddenly drawn to a strange phenomenon: in the southwest, a gigantic, horizontal, swirling, funnel-shaped mass was building up. She ran immediately into the school and rang the bell: "A tornado!" but it was already too late. When the tornado struck the building, students and teachers were pressed against the walls of the corridor. Stones flew, pieces

of wood were torn loose, and millions of glass shards rained down, while an unknown and terrifying noise tortured their ears.

Merciless, the monstrous, sky-high funnel passed through Xenia, demolishing homes, crushing people, plucking the trees from the earth like weeds and changing trucks into destructive missiles. The insatiable monster knocked the drive-in movie screen to the ground, and then the swirling funnel focused its force on a freight train. The cars at the rear end were lifted like matches and thrown over the city of Xenia. The tornado touched down for only three minutes, but for those that had been in its center, it had seemed an eternity.

Christmas Cyclone in Australia

That same year, Darwin, the capital of the faraway Northern Territory in Australia, was hit by a cyclone, which is called elsewhere a hurricane or a typhoon. On the 25th of December at 01.00 in the morning, driving became impossible. At 02.30 the first heavy blasts of wind took the radio station off the air. Shortly after 03.00, the wind anemometer in the airport registered blasts at a speed of 210 kilometers per hour, and still the wind was increasing. At about 04.00 the wind withdrew, when the eye of the cyclone passed over the city. The air pressure literally disappeared from the barometer. Suddenly the wind started to blow again at full power, this time from the opposite direction. Almost everyone in the town became homeless that Christmas Day, crawling "out of their destroyed houses like rats from their holes." Ninety percent of the harbor city was reduced to ruins. Uprooted trees and the wreckage of buses and cars laid spread among pieces of walls and roofs. Birds and insects were blown away and the trees left had no leaves. A pilot who was flying over the ruins reported by radio: "Those that have seen pictures of Hiroshima after the atomic bomb know how Darwin looks."

In 2012, when more deadly tornadoes will strike us, we will smile longingly for such mild storms when hearing descriptions as those written above because the destruction we would endure will surpass it many times. After thousands of hurricanes and tornadoes have done their destructive work, everything will be totally leveled. It will start first with a breeze, a prelude to the horror to come. Then it will increase more and more, as the earth starts to slow down. Calculate for yourself. At the equator the circumference of the earth is about 40,000 kilometers. There the rotational speed is about: 40,000 km / 24 hrs = 1,666 kilometers per hour. If we take the report of the previous polar reversal

into account, it will take almost one day. More specifically, this means that the rotational speed of the earth at the equator of 1,666 kilometers per hour will be reduced to zero, after which will occur a proportional acceleration in the reverse direction, up to the same speed. The movement of air caused by the earth's rotation will continue. Are you still surprised by the fact that a wind speed of more than 250 kilometers per hour will rage over the earth?

At the moment the earth starts to rotate in the opposite direction and the earth's crust shifts, the Wind God will really start striking us. At the equator, the air layers will be compressed and will form the center of this angry God. A sort of tunnel effect will be created worldwide, through which the winds will be unleashed. From pole to pole, huge hurricanes with speeds topping 300 kilometers per hour will arise and will punish the sea and land without mercy. South American and African jungles will simply be uprooted and flung back to the earth many kilometers away. The super winds will reach the mountain ridges of the Himalayas at record speed and pulverize the rocks of the eroding mountains. The air will become thick with a mixture of dust and debris. Breathing will become difficult and the wind chill factor will lower the temperature to zero or even far below. This will depend on where you are. For example, if you are in the Alps with a temperature of –15 Celsius and a wind speed of just 40 kilometers per hour, this will correlate with a wind-chill factor of –27 Celsius and with wind speeds of 200 plus kilometers per hour it will be even colder!

If you do not have protective clothing, you will freeze to death very quickly. Besides, you will need a place to shelter, because the biting cold will be so intense that you will not even survive with thermal clothing. You will not be able to hide in tents, because they will be swept away by the winds, unless they are in a strategically sheltered place. But who knows what area will remain sheltered as the earth changes unfold? Enough worries to think about. Even warmer areas will suffer with the same problems. You have to think about that—and other similar issues—if you want to survive the catastrophe in the high mountains. Even in subtropical or tropical zones, it will not be very warm in summer. In many places there will even be snow. A temperature of even a few degrees combined with wind speeds of 200 kilometers per hour will lower the wind chill factor far below the freezing point. The risk of your facial skin, your hands and feet freezing will go up drastically. Not a pretty thought; you must be prepared.

However, the wind chill scenario will probably be temporary. The reason: because of the volcanic eruptions and the highly

Figure 16.

increased activity of the sun, the temperature will rise considerably in a short space of time. Even at a high altitude, the temperature will go up temporarily, but for how long is difficult to say. Shortly after the volcanic eruptions, the earth will be enveloped in an impenetrable cloud of ashes. This will obstruct the solar radiation and the temperature will go down again. For weeks and years the climate will therefore remain disturbed, and we will have to armor ourselves against extreme fluctuations.

The polar reversal will bring a tumultuous cycle of exceptional weather conditions that will surprise scientists. Not only will they be confronted with super winds the likes of which they have never seen before, but also electrical storms that will thrash the skies without any mercy. Just before and just after the polar reversal, continuous lightning flashes will dramatically illuminate the end of an age. Only after hours and hours of that continuous violence will the winds start to diminish and a rain of objects will begin to fall from the sky. For minutes on end, cars, boats, washing machines, roofs, animals and humans will crash onto the planet. The pathetic debris of a lost, destroyed age.

This description of our imminent future is identical to descriptions of the end of the previous age. Scriptures of those times confirm this. The sudden upward thrust of the earth's

layers and the atmosphere by inertia, when the earth reversed its rotation, contributed to cause very powerful hurricanes and immense earthquakes. In a Buddhist text, the *Visoeddhi-Magga*, you can read: "The wind turns the ground upside down… Huge parts crack and are thrown up high, worlds collide with worlds and all cities on earth are destroyed." The Maori tell about this: "The father of the winds and storms swept away huge forests and whipped up the waters to the altitude of the mountains… and the earth moaned terribly." In *Chronicles of Japan from the Earliest Times*, we read that the Sun Goddess hid herself for a long time in a celestial cave fearing the Storm God: "The whole world became dark and the Storm God caused monstrous destruction. The gods made a terrible noise in order to make the sun return, and the noise made the earth tremble."

Conclusion

It will not be easy to prepare ourselves against the coming hurricanes, and you cannot hide from them. Although you will experience the biggest effects of these forces at sea level, you will not be able to escape from them in the high mountains either. Surely we have to secure everything very well, and it would be wise to store our materials in caves. Whether we are going to hide in them ourselves depends on the strength of the earthquakes. If they are too strong, we would take the risk of being buried by the collapsing rocks. Should it be available, we could possibly protect ourselves with a sort of metal skeleton. Another solution would be to dig deep holes in the ground and make bunkers. In that way we can protect our materials at the same time. But, before the end date, we will have a lot of discussions about all of this in order to decide on the best means for protecting ourselves against the forces of nature that have gone crazy. It will cost us blood, sweat and tears, but without our input there will not be a next civilization. This is reason enough to apply all our strength and efforts to our survival.

9.
SUNSTORMS AND COSMIC RADIATION

Over the last two thousand years the magnetic field of the earth has been gradually weakening. More alarming is the fact that Gaulthier Hulot of the Parisian Geophysics Institute discovered in 2002 that the field strength is declining alarmingly fast at the poles. This finding started immediate worldwide speculation about a forthcoming polar reversal. In an instant, modern science lined up with the predictions of scientists of a far-distant past. This cannot be coincidence! Thousands of years ago, priests were able to calculate that the magnetic field of the earth would collapse at the end of 2012, at the zenith of the catastrophe. And now, eons later in time, one person comes up with an identical idea! Only the present scientists still do not realize what the consequences will be: they think that electronic equipment will experience some problems, that the migration of many animals will be disturbed, and that there might be a problem with radiation. They do not expect much more than that. But this is diametrically opposed to what the Maya and the Old Egyptians predicted.

In the previous chapters, and in my previous two books, I have clearly described the disastrous effects of a pole shift. However, I have hardly dealt with one issue: radioactive radiation. I have wondered worriedly what effect this will have on the earth? Are people and animals able to handle this? And what can we do to guard ourselves against it?

Given my knowledge of astronomy, I can quickly get clear answers. It is known that particles coming from the stars and our sun collide with the magnetic field of the earth. Highly charged, energetic cosmic particles are hardly hindered by the magnetic field—they just pass through it, and it doesn't matter whether their charge is neutral, positive or negative. However, in the earth's atmosphere they collide with oxygen and nitrogen molecules, which render them less harmful. Low energy cosmic radiation is normally deflected to the poles. When the magnetic field is pressurized and disappears, you will not have this tunnel effect anymore and the particles will fall randomly on the earth. The effect of this is small and does not imply a threat for plants, animals or humans. Therefore, at first I thought we would not have much to fear from harmful radiation. Then I started to study the situation a bit more carefully; it appeared I had somehow underestimated the consequences. A first deduction was not so difficult to make and I became very concerned.

Ultraviolet Radiation

Everybody knows that you can get severely burnt while in high mountains and that you need to protect yourself well against the solar radiation. The higher you are, the more intense the radiation is. No doubt about that. You only have to ask mountain climbers who use protection factors of twenty or more. Close to the fatal date, a lot of us who plan to survive will be at an altitude of three kilometers or more. Under normal circumstances there would be no problem. However, at the peak of the catastrophe, the light intensity of the sun will increase tremendously. An all-scorching light will be sent in the direction of the earth. The intensity of ultraviolet radiation, which is responsible for the degradation of the ozone layer, will rise quite spectacularly. You can guess the consequences: you will risk burning unprotected skin, making it as black as carbon in this radiation inferno.

Just one answer is possible to this: protective clothing that stops the ultraviolet radiation as much as possible. It is the only way to prevent fatal burns. This is an essential part of the planning. Those who take their chances with boats will have fewer effects from the radiation, because the atmosphere absorbs a lot. Although they will be subjected to a minimal amount of the exposure compared to those in the high mountains, they still need to be careful. Direct exposure to the solar radiation for a short time is possible, but surely not for too long. However, the others in the high mountains will have to be extremely careful. They will have to protect themselves to the utmost against radiation. In most cases, wearing a good sunscreen, thick clothes and a hat will be sufficient to protect them.

Well, this was good reasoning, but in the meantime my thoughts went on. What else could be of importance? What other surprises does the sun have in store for us? Could it be worse?

The Sun as Nuclear Holocaust

At the moment the magnetic field of the sun suddenly collapses, trillions of high-energy particles will be sent in our direction; for countless, indescribable long hours. Hours that will usher in the end of our civilization. Just like almost twelve thousand years ago, the earth will experience a world conflagration. The Tacculi Indians of Columbia tell about this: "The earth was almost totally inhabited until a big fire, which lasted several days, crashed on it, destroying all life, except for two beings; a man and a woman hid in a deep cave in the heart of a mountain, and from them all people in the world descend."

The Ojibwa Indians of North America have a myth about a little boy who set the sun on fire. The sun burned and ruined his feather

coat. In order to have his revenge, he asked his sister to make a bow from her braids. He then set his trap in such a way that the sun was captured when its first beams reached the land. A huge commotion occurred instantly amid the animals that were ruling the earth. They had no light. They gathered in a council to discuss it and to appoint someone to cut the cord. This was a perilous undertaking, because the sun's beams would burn anyone who got close. Finally the dormouse decided to undertake this, because at that time he was the biggest animal. When he stood straight, he looked like a mountain. When he neared the place where the sun was captured, his behind started to smoke and burn. The dormouse succeeded in biting through the cord with his teeth, but he was reduced to a huge pile of ashes in the process.

Figure 17.
Immense solar outbursts will throw trillions of loaded particles into space, only a small part of which will reach the earth. Yet, it will be more than enough to expose the earth to an intense bombardment of radioactive particles, resulting in a lot of secondary radiation.

These myths relate to the immense heat that the sun was radiating. It is interesting to note that this fire takes place when the sun deviates from its course. Within thousands of years from now, our descendants will tell similar stories describing how we experienced the consequences of a new world fire caused by the sun at the end of 2012. Shocked to the depths of our hearts, on December 20th of that year we will see how the earth will become the center of a burning, and extremely deadly, radioactive cloud. Our planet cannot stand so much radiation.

Navigation and communication equipment will be burnt, and animals will not be able to orient themselves anymore. The intensely loaded particles of the sun will collide with the atoms and molecules in our atmosphere and create gorgeous auroras. Filled with disbelief, fear and admiration, many will stare at this. During the ensuing hours, we will see the energetic solar particles continuously bombard the atmosphere. Through this violence, even smaller particles will be generated, which will advance

further and permeate deeper and deeper into the atmosphere. For hours and hours they will torture the earth with their deadly radioactive load. All humans, animals and plants will be exposed to intense radiation. Cases of cancer will rise tremendously, as well as birth defects and miscarriages. Several species of plants and animals will be annihilated. Strangely enough, though, there will also be a positive effect: through mutation, new plants and animals will be created. After some pole shifts, explosions of new life appear. But for the existing life forms, it will be trouble and affliction.

The Maya knew this. In his book *The Mayan Prophecies*, Maurice Cotterell points out how he deciphered it. With the help of decoded images, he shows how children with birth defects will be born after the new sun; it was, for the Maya as it is for us, a painful and unpleasant foresight. After having thought about this, I was able to place the main danger in the hard x-ray and gamma radiation.

Hard X-Ray and Gamma Radiation

At the moment that the magnetic field of the sun reverses, huge quantities of ultraviolet, X-ray and gamma beams will be shot into space. The importance of this radiation is that the energy per radiation particle (or "photon") in these types of beams is immensely stronger than that of the photons in visible sun radiation. The factors by which this energy exceeds that of visible sunlight are as follows: UV—100 times greater; soft X-ray—1,000 times greater; hard X-ray—10,000 times greater; and gamma radiation—a million times greater. Photons of such high energy will wreak major destruction on the molecules and atoms of the earth's atmosphere. *Just a bit more than eight minutes after leaving the sun, they will reach the earth!*

For astronauts in earth orbit, this will be deadly. Airplane passengers flying above twelve kilometers altitude might have to deal with an exposure equal to a thousand or more radiographs! After this, the planes will stop flying and crash. This is a huge amount of damaging radiation. A bit further into the earth's atmosphere, this radiation will be mostly neutralized. In the high mountains, you will be exposed to a considerable volume of radiation, but not a deadly one. But that will change after the magnetic field drops. At that moment, the upper layers of the earth's atmosphere will be heated tremendously. The permeability for all sorts of radiation will increase, and also more X-rays will be generated in the ionosphere by the collision with solar protons, causing a real hellfire, many times more intense than ultraviolet radiation.

It is the X-ray and gamma radiation that will cause the greatest amount of damage! In the high mountains as well as on the sea we will need to protect ourselves! Lead is known as an effective screen for this, but nowadays there are also other possibilities. Closer to 2012, these other possibilities will surely be commercialized, so that we can list them on our website. Some thin successive protection layers of those modern materials will be sufficient to prevent a lot of damage. We will have to protect ourselves in them for as long as possible, while hoping that the ordeal doesn't last too long.

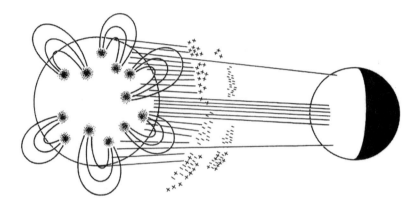

Figure 18.
At the moment the magnetic field of the sun reverses, heavy ultraviolet, X-ray and gamma rays will be sent to earth. Also a gigantic cloud of electrically-loaded particles will be flung into space. A small quantity of them is sufficient to cause a mega disaster on earth: the ozone layer will be blown away, the magnetic field will drop and the poles will reverse. Meanwhile we will be exposed to an intensive bombardment of radioactive radiation coming from the sun! We can only protect ourselves by hiding under layers of protective materials!

The Question of Children

This problem should not be underestimated. After the disaster with the nuclear plant in Chernobyl, a large number of children are still being born either dead or with severe birth defects. After the reversal of the sun and the following collapse of the magnetic field of the earth, we will encounter a similar phenomenon. Prevention is better than cure. In fact, there are only two solutions for this: we either protect ourselves against the radiation or we plan to have children before the crash. In view of the short period of time until the field reversal, there is not much time left to reflect on this. Everyone will have to make up his or her own mind. One way or another, we will have to take this into account very seriously.

To protect ourselves against the deluge of radiation will be our top priority, because fewer problems will result afterwards. Of course there is never an absolute certainty about this, but it will surely make a difference. We must all cooperate in working on this problem.

10.
VOLCANIC AREAS

Volcanoes can cause gigantic worldwide destruction. Everybody knows you shouldn't live close to a volcano, because it can erupt at any moment. At the end of the Maya calendar in 2012, this problem will become even more critical. Within a couple of hours, thousands of volcanoes will become active and will spread their deadly emissions over the continents. Immeasurable pools of fire will plague humanity. Looking back in time teaches us how destructive this can be.

Deadly Volcano Gases Poisoned Iceland

The worst disaster that struck Iceland announced itself on June 1, 1783, through a series of earthquakes. On June 8, around nine o'clock in the morning, the Lakagigar cleft in the southeast of the island burst out with unequalled violence. Huge lava fountains erupted high into the sky and a thick rain of ashes descended on the land, covering a large radius. Boiling lava was continuously spat out for six weeks. The lava flow flooded grasslands and farms. The outburst only died out completely in February 1784. A layer of lava twenty-five meters thick covered an area of about 565 square kilometers. Because the flow of lava advanced slowly, there weren't any victims.

However, in the eight months after the start of the eruption, the cleft expelled huge quantities of sulfur and carbon dioxide and fluorine. An impressive blue mist appeared over the whole of Iceland, and also spread over to the European mainland. From there it passed to North Africa and the west of Asia. On the European mainland the mist caused a terrible stench and people suffered from acute eye irritation. In England someone complained that brassware became tarnished immediately after being polished. The following year Scotland had a crop failure. But without any doubt the mist was disastrous for Iceland. The grass wouldn't grow anymore, the harvests withered, the trees dried out and the cattle died en masse. Three-quarters of the horses and sheep of Iceland died from gas poisoning or starvation. The following eyewitness report speaks volumes: "The horses lost all their meat and in some cases the skin of their back started to rot away. They lost the hair from their manes and tails in big quantities."

This recent report reflects only the tip of the iceberg that is ahead of us. Another report is even more alarming.

30,000 Victims in St-Pierre

In 1902, the Caribbean Island of Martinique looked very

nice and romantic. On April 25, Mont Pelée began ejecting huge clouds of stones and ashes startling St-Pierre, the most densely populated city on the island. In the two weeks that followed, this happened several times. But on Thursday, 8 May, it struck home when the volcano started to rumble and spit out a dark cloud of ash. Almost everybody living just outside the city went out onto the hills to watch the amazing fireworks emanating from the mountain. At 07: 52 an immense explosion lit the sky. At an incredible speed, a big black pillar of smoke shot into the sky, filled it and absorbed all the light. Then, suddenly, the southern side of the mountain burst open. From the hole a thick black steam spewed out, like smoke from a huge canon. At the same moment a second cloud, forming gigantic spirals, rose up and spread a black screen over a radius of eighty kilometers. At high speed, the horizontal cloud came crashing down the mountain slope.

Figure 19.
After almost twelve thousand years, volcanoes will be activated worldwide. Billions of animals and humans will die in this inferno. For humanity, it will be the biggest catastrophe ever.

It rolled down silently in the direction of the city, falling more than gliding. At its forefront, the ash clouds seemed to jump out, while thundering explosions and flashes like bolts of lightning came out of the interior and sometimes glowed with a white-hot fire. The cloud reached the northern border of the city in less than one minute. It then unfurled like an all-destroying blanket. Everything that was touched by it went up in flames.

In the meantime, 30,000 people had died as a result of a combination of superheated steam, having an estimated temperature of perhaps a thousand degrees Celsius, and poisonous gases. The clothing was torn from the bodies of all the victims that had fallen outside, as if a hurricane had hit them. They suffered terrible burn wounds. Many victims looked relaxed, and had apparently suffocated suddenly and without warning in the violent events. Others, through fear, had tried to worm their way to some place of safety.

When a relatively small eruption can generate so many deaths, how will it be in 2012? Thousands of volcanoes will erupt together, resulting in an unequalled slaughter. Stories from a distant past can illustrate this.

In *Secret Cities of Old South America* Harold T. Wilkins describes the legends of Brazilian tribes. They tell of how the sun suddenly became brighter, apparently coming down from the sky, and how a tidal wave crashed on the land. Those who hadn't drowned in the wild waters were victims of volcanic eruptions in the Andes. Fire, magma, mud, soot, gasses and stones were catapulted into the sky, to complete a thorough slaughter of the few survivors. While burning clouds obscured the sky and set forests on fire, people and animals gasped for oxygen. Many choked, and others ended their suffering in hellfire. Few were able to remain alive. The world fire was all-embracing, consuming plants and animals, as well as human beings, until colossal rains, together with overpowering lighting and thunder started their chilling effect. The water fell upon the newborn mountains, where it became steam that started to purify the air, washing away the deadly, poisonous gases. After this, crawling and stumbling, some people took up their lives again.

This is just one of the many myths about the last cataclysm. You can trace, through scientific research documents, how much truth lies within them. The following words of Professor Frank C. Hibben in *The Lost Americans* will surely touch you:

> One of the most interesting of the theories of the Pleistocene end is that which explains this ancient tragedy by worldwide, earthshaking volcanic eruptions of

catastrophic violence. This bizarre idea, queerly enough, has considerable support, especially in the Alaskan and Siberian regions. Interspersed in the muck depths and sometimes through the very piles of bones and tusks themselves there are layers of volcanic ash. There is no doubt that coincidental with the end of the Pleistocene animals, at least in Alaska, there were volcanic eruptions of tremendous proportions. It stands to reason that animals whose flesh is still preserved must have been killed and buried quickly to be preserved at all. Bodies that die and lie on the surface soon disintegrate and the bones are scattered. A volcanic eruption would explain the end of the Alaskan animals all at one time, and in a manner that would satisfy the evidences there as we know them. The herds would be killed in their tracks either by heat or suffocation, or, indirectly, by volcanic gases. Toxic clouds of gas from volcanic upheavals could well cause the death on a gigantic scale... Storms, too, accompany volcanic disturbances of the proportions indicated here. Differences in temperature and the influence of the cubic miles of ash and pumice thrown into the air by eruptions of this sort might well produce winds and blasts of inconceivable violence. If this is the explanation of the end of all this animal life, the Pleistocene period was terminated by a very exciting time indeed.

This report is very clear. Global volcanic activity caused terrible destruction during the previous polar reversal. In 2012, they will burst out just like the previous time and will again take up their task as mass destroyers of life. But that isn't all. Because they spit out such colossal quantities of gases and particles of debris, they can blacken the atmosphere of the whole planet. In *Conquista de Mexico* we read the following: "After the destruction of the fourth sun the world was plunged into darkness for twenty five years." One had to undergo this not only in Mexico—there were other places on the planet that experienced this blackout as well. As the Egyptian *Ermitage Papyrus* states: "The sun is not visible for the people. Nobody can live when clouds veil the sun."

Volcanic outbursts will therefore cause the annihilation of a major part of the world population in a dual manner: by direct killing; and by slow starvation as a result of famines. The Chinese annals of *Wang-sje-sjing* tell that: "The darkness killed the growth of all things." In other words, the lack of sunlight kills the survivors because of the lack of vegetables, fruits and grains.

Worldwide Chilling

These old myths are acknowledged by the work of W.J. Humphreys. In his book *The Physics of the Air* (1907) he explains that the volcanic substances will cause a considerable decrease in temperature worldwide. He points out that this is due to the fact that these particles are more likely to reflect sunlight than to hold in the thermal radiation from the earth. In this regard, the magnitude and shape of the particles are of importance. A number will have the ability to effectively reflect the sunlight and therefore will also not stop the thermal radiation from leaving the earth. Others will have the opposite effect. Humphreys concludes that it is necessary to determine the average magnitude of the floating particles. After performing mathematical calculations involving several factors, he concludes: "Volcanic dust is about thirty times more effective in guarding against sun radiation, than in keeping in the terrestrial radiation..." He also specifies the following: "...the total quantity of dust necessary to reduce the intensity of sun radiation by twenty percent is amazingly small—0.006 cubic kilometers..."

Figure 20.
The black dots indicate the places where volcanoes were active twelve thousand years ago. In 2012 these areas should be avoided. We need to stay at least 500 to 1,000 kilometers away from them in order to avoid the emission of debris, lava and other deadly gases as much as possible. This matter is of crucial importance and is therefore the core of our survival strategy.

After a volcanic eruption, it only takes a couple of days before the volcanic dust is spread through the upper atmosphere. After that period, the above-mentioned quantity will reduce the available sunlight by twenty percent. The quantity of dust that

was produced during the eruption of the Katmai in Alaska in 1912 was enough to chill down the whole earth for a period of three years. For a longer chilling effect, ongoing eruptions are necessary, because volcanic dust falls on earth within three years after an eruption.

If a small eruption can have such a noticeable influence, what can we expect when a large number of volcanoes are activated during an earth crust shift? Not only will the temperature go down drastically, but also continuous eruptions will keep it low for longer. At the same time, the alternating massive eruptions and calm periods will cause severe fluctuations in the climate: extreme warm periods will be followed by extreme cold and vice versa.

Volcanic dust is not the only by-product of eruptions. Huge volumes of carbon dioxide will also be emitted. Tazieff observed at an eruption in Africa that, besides eighty million tons of lava, about twenty billion cubic meters of gas were also released; luckily not all of it was carbon dioxide. These emissions have an important effect on the temperature of the earth. Because it is transparent it does not interfere with sunlight. But it does reflect thermal radiation from the earth. A small volume is sufficient to effectively stop the loss of heat from the earth's surface. In view of the small volume in the earth's atmosphere, worldwide volcanic eruptions can quickly increase the levels drastically, resulting in a rise in temperature.

At this particular point carbon dioxide differs from volcanic dust—as it is a gas—because it doesn't settle but remains in the atmosphere. It stays there until, with the passing of time, it is taken up by plants. Another possibility is that it might react through chemical processes with rocks exposed to the weather. Therefore carbon dioxide, in comparison with volcanic dust, is a longer-term factor with an opposite effect.

After the earth's crust shift in 2012, together with the massive volcanic eruptions, the quantity of carbon dioxide will rise considerably, possibly high above the normal limit. If you are close to volcanic eruptions, you can suffocate. This however is not the main effect. Because huge parts of the forests and plants will be destroyed, the carbon dioxide will remain unused in the atmosphere for a long time. Once volcanic ash starts to precipitate from the atmosphere, the remaining high concentration of gas will cause a sharp rise in the world's temperatures. The growth rate of plants and trees will rapidly increase, and the excess of gas will quickly disappear from the air, undoubtedly together with wild fluctuations of the climate. In several places, many geological processes will undergo acceleration.

Stories from the Past and the Future

From the previous pole shift we know that there was considerable volcanic activity in places that can be described nowadays as relatively calm. Twelve thousand years ago, though, it was also relatively calm in Japan. Could this possibly be because Japan was moved minimally at that time? In those days it underwent a shift of about ten degrees to the equator. It is also significant that South America, which was extensively moved across the equator towards the South Pole, should be seismically active at present. India also moved to the pole and is seismically active, while Europe was hardly moved and is calm now. Furthermore we note that Africa is relatively free from earthquakes and volcanic eruptions, because it also underwent little movement during the last shift. Of course it will be tormented by gigantic quakes in the next cataclysm. However, compared to those that hit South America, the temblors in Africa will be less violent in magnitude and force. In his book *Mysteries of Ancient South America*, Harold T. Wilkins writes about the events that took place twelve thousand years ago in South Africa.

At that time, the ancestors of the Bushmen of the Kalahari Desert in South Africa were thrown to the ground by the heaviest earthquakes they had ever known. Filled with fearful fascination, they followed the echoing noises that accompanied the disaster among the rocks and mountains. Day and night the earth trembled. At the coasts, horrible tidal waves came rolling in, higher than the highest hills. With immense force, they crashed upon the beaches and penetrated far inland, followed by colossal rolling waves. These must have been tsunamis, which are produced when a heavy shock is borne down on the ocean bed, for instance by volcanic eruptions, earthquakes or undersea avalanches. In the open ocean, this causes a swell of from half-a-meter up to several meters, and a fall in the level of the ocean over hundreds of kilometers. On approaching shallow coasts, the waves shorten their length and at the same time steadily grow in altitude. At present tsunamis can be as high as sixty meters. During the catastrophe in 9,792 BC they must have been hundreds of meters high!

Complete inland areas that had never seen the sea drowned, while the waves pushed against the sides of the mountains and even forced back the powerful currents of wide rivers. The night ended in terror. A rain of fire fell from the sky, together with a bombardment of rocks. The survivors saw the sky "collapsing" and a black mist darkened everything. The light of the sun seemed to have gone out, just like a candle snuffed. For several days no one was able to tell whether it was day or night. No pinpoint

of light whatsoever could penetrate the black smoke, except the scorching light of something that they had never seen before. Then an immense cloud of red powder filled the air, followed by fine white ashes. Several explosions made the ground shake. Water became hissing steam and filled the already hot air, caused by the universal fire.

Far across the ocean, an island-continent drowned and a highly civilized race—whose pioneers had contacted the Bushmen—disappeared in the abyss. The sea engulfed temples, palaces and high towers.

This is a legend which, to this day, the South African Bushmen are still telling! At the end of 2012 a part of us will surely look back on this story, because we are close to these events and will undergo the same horrible scenario. A couple of chapters ahead I will explain why. That the 2012 catastrophe will be of immense proportions should become clear from the following.

Tidal Wave Threatens East Coast of USA

It has already been predicted that a tidal wave of one kilometer high and thirty kilometers wide, with a speed of 700 kilometers per hour, will race to the American East Coast and sweep away cities like New York and Miami. That will happen when the wall of the Cumbra Vieja, a volcano on one of the Canary Islands, collapses during an outburst. According to Professor Bill McGuire the question is not whether this will happen, but when. During an eruption of the Cumbra Vieja on the island of La Palma in 1949, a wall of the volcano subsided over a length of two kilometers. This wall can collapse during the next eruption. An enormous rock and land avalanche would fall into the sea and cause a tsunami, a huge tidal wave. If a single volcanic eruption can have such consequences, what is lying ahead of us in 2012 when volcanoes start erupting worldwide? Don't forget the fact that volcanoes are mainly located in the oceans.

11.
GLACIAL AREAS

Twelve thousand years ago, large areas of Europe and North America were covered by glaciers. Even in regions that have a moderate climate at present, there used to be huge piles of ice. At that time, where the Hudson and the Elbe now flow, the land consisted of frozen deserts. They resembled the immeasurable glacier that covers Greenland. And if you read the geology books, things become even stranger. They state clearly that ice ages are a temporary phenomenon. They return with clockwork regularity and crush large parts of Europe and North America into ice masses. Their magnitude is similar to the ones at the poles. Then the ice mysteriously withdraws and a warm period appears, like the present one. After which the ice will again become the master!

All geologists in the world know this. More than that, they also realize that this can happen again any moment. Some among them defend this concept and claim that a sudden change in climate can take us by surprise in a twinkling of an eye. Dr Louis Thompson of Iowa State University and Professor John E. Sanders of Columbia University agree completely with the following statement: "The next ice age can start any day! It is not a matter of whether it will happen or not, but when. One day you will wake up—or not—covered by ten floors of snow."

Snowflakes are products of a disproportion in the energy current of one part of nature to another. In an ice age, that current grows into a complex quantity of patterns that submerges large parts of the world under an icy landscape. But why does this happen? For years this has been one of the main questions of climatologists. In the book *Not by Fire but by Ice* by Robert W. Felix, you can read more about the above-mentioned facts. This book is a must-read for anyone who is concerned about the forthcoming end of our civilization.

For a long time scientists have known that ice ages are created by an extensive vaporization followed by a rapid freezing process. Yet, they do not know how this actually takes place. Many books are written about it, describing possible scenarios—a concerted search for the laws that hide behind this complexity is underway. However, despite many attempts, the scientists are still in the dark. They think that a possible cosmological cause lies at its base, but they are not sure. And the problem gets worse because of the laws of thermodynamics, which state that when you want to produce

ice accretion, you first need a massive warming in order to get sufficient vapor into the air. Then the cold can transform it into crystals, after which billions of tons of snow will fall on the earth. But what causes the massive warming and cooling? Scientists are still guessing at this. Only a few dare to assume a pole shift. But it is from that point of view that we are constructing our proof.

An Earth Crust Shift Yields the Answer

You can easily explain the many phenomena that produce ice ages if you start with an earth crust shift. I support this idea completely and complement it with incontestable arguments. For that reason, I also know with outright certainty that gigantic glaciers will again cover North America and Europe after the pole shift in 2012. I will explain this in a minute.

If you follow my way of thinking, you know that an ice age is perfectly explained by the occurrence of an earth crust shift: as a result of one, a rapid alternation of heat and cold takes place over large portions of the earth. The ice layers of the current polar regions will be relocated to sunnier zones. It is here where their existence ends abruptly in a catastrophe. They start to melt noticeably. Not only because they have shifted to a warmer climate, but especially because of the huge quantity of heat that is released during the polar reversal. The solar flares and volcanoes, which both show a considerable level of activity at the poles, have produced an output equivalent to that of billions of steam generators. On top of that, the shifting and fractionating planes and atmospheres of the earth create an enormous quantity of friction heat. As a result, many ice layers will start hissing like kettles. These masses of ice are transformed into vapor.

In other words, a pole shift produces increased levels of vaporization. As if it were an extraterrestrial show, you will be able to watch huge quantities of steam rising up out of the earth during the hours and days after the cataclysm. Colossal clouds will reach up into the sky. The atmosphere will reach saturation very quickly, and heavy rains will fall on the earth in order to cool it. Deserts like the Sahara will become fertile again. North America will lie in the polar circle, and in Europe the warm Gulf Stream will stop. The consequences of this will be extensive, not to say dramatic: all water will be transformed into the crystal structure of snow.

Ice Ages and Snow Crystals

Scientists can explain and describe these crystal structures. We are now allowed to ask a physicist, "Why are all snowflakes different?" When water freezes, the basic water molecule crystals

form, growing protrusions that make their surfaces unstable in certain places, which causes new protrusions to be created. It is known that the growth of such protrusions has to follow a complex and sinuous structure. The process becomes unstable when a crystal from a starting nucleus hardens outwards, like a snowflake that captures water molecules while falling through humid air. Every section with a protruding surface gets a head start in attracting new water molecules and thus new branches are created.

Figure 21.
A substance prefers even surfaces, like the wall of a soap bubble. In the case of snow, it appears that the effect of surface tension is extremely sensitive to the molecular structure of a coagulating substance. When snow crystallizes it creates a growing protuberance from which lateral branches sprout. The mathematics for this didn't come from meteorologists, but from theoretical physicists. While a growing snowflake is falling down to the earth, the choices made at any moment by the branching protrusions strongly depend on factors like temperature and the degree of humidity. The final snowflake reflects the history of all the changing weather circumstances it has experienced.

After the pole shift in 2012, billions of snowflakes will drop on North America and Europe. With that, all-important conditions are met for a new ice age and, at record speed, the northern mainlands will disappear below billions of tons of ice. In short, this is the disastrous secret of ice ages that afflict our regions with clockwork regularity. Therefore it is not logical to restart our civilization in those places. If we did, we would experience the myth of the previous time, an event that the Toba Indians from the Gran Chaco call "the big cold." In *The Mythology of South America* (by John Bierhorst, 1990) we read, "The people were cold and were crying. At midnight they were all dead…"

Just like in other stories the big cold was accompanied by darkness. According to an old Toba Indian, "The disaster was sent to us on purpose because the earth has to change when it is full of people. To save the world the population has to be depleted…" This disaster myth describes an era in which our ancestors almost became extinct. A terrible succession of natural disasters lay at the bottom of this. The previous pole shift, as well as the previous ice age, fit perfectly with this description. Both periods emanated from geological and climatologic turmoil. For our ancestors, the period after the pole shift when the ice was encroaching must have been terrible. At that tumultuous time they must have died en masse. Many disaster myths tell about terrible cold and darkened skies, together with a black, burning rain of hot coals.

How to Survive 2012

Ice ages caused by pole shifts are terrible, and exterminate animals on a massive scale. The northern regions of Alaska and Siberia were struck the hardest by the last deadly changes. Archeological evidence shows that, before the previous pole shift, there were about thirty-four animal species found in those regions. No less than twenty-eight of them were used to a moderate climate. The farther northward you go, the more carcass remains you find. Those animals could have lived at those places only if there was no permanent ice, and the only conclusion is that, at the moment these creatures died, the environment where they lived froze instantly.

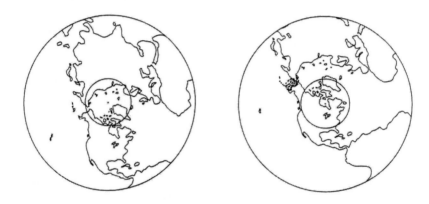

Figure 22.
The earth after 2012. Due to the earth's crust shift, after the polar reversal in 2012 a large part of the United States will have moved to within the Arctic Circle and the warm Gulf Stream, which currently flows past Europe, will cease. In a short space of time, billions of tons of ice will cover these continents. The drawing on the left shows the present situation, and the one on the right shows what we should expect.

In a vague echo of the myth mentioned before, a country that had previously known a seven-month summer was changed into a land of snow and ice. There, Hedenstrom and Sannikov, who discovered the New Siberian Islands in 1806, had a sensational experience. From a distance of fifteen kilometers, they admired the remnants of far-reaching forests, where tree trunks were standing "partly straight up and partly laid horizontally stretched on the frozen ground." Hedenstrom described the scene as follows: "The remarkable wooden hills lie on the southern coast of New Siberia. They are 60 meters high and consist of horizontal layers of sandstone, alternating with layers of bituminous trunks of trees. When you climb up the hills you find fossilized carbon everywhere."

Once more, they were eyewitnesses to the results of a terrible

96

disaster. In one day and one night, the earth changed its axis and rotational direction and an earth crust shift catapulted the complete environment into different climatic zones. The same destiny is lying in the future for us. After the disaster at the end of 2012, the new world will look completely different. In the Northern Hemisphere, it will look a lot like the above-mentioned scenario. For many, this is a frightening thought, but unfortunately, it is only too real, as our world differs so much from the previous one. Twelve thousand years ago densely populated cities like Amsterdam, Oslo, Berlin, Moscow, London, New York, Montreal and Boston—actually almost the whole of North America and northern Europe—couldn't have possibly existed, because they were covered with billions of tons of ice. After the catastrophe in 2012, this scenario will more or less repeat itself! Immense glaciers will again ravage the United States and Europe.

A Gruesome and Particularly Deadly Prospect

This prospect forces us to migrate to other regions. Just like the Atlanteans were once driven away from their country by a sudden ice age, the inhabitants of the Northern Hemisphere will be confronted with appalling natural forces. You need to realize this. Fighting against it is out of the question. Hit the road and run is the message. Just like Noah and others did before with boats. Or, on the fatal day, if you still can, withdraw to higher areas where the climate will not undergo drastic changes. As will be discussed later, not all areas of the world will be affected equally, so you will have to evaluate your destination. It is no use going to the Alps, for instance, because there, within one day, you will meet a certain frozen death at a temperature of 40 degrees below zero. This is because the Alps will become ice cold after the pole shift. You will have the same chance of a deer whose throat is already grasped by a lion, just before the fatal bite.

There are sufficient examples to illustrate this. Relatively recent finds of animals which died over twelve thousand years ago prove that their death came so abruptly that the plants they were eating are still not digested—grasses, wild hyacinths and buttercups were found, which are still recognizable and intact, in the stomachs of the mammoths. Millions of animals, their remains now found in Alaska and Siberia, died suddenly of intense cold, and it is clear they could never have lived in such an environment. Found in abundance in Siberia, their meat is very well preserved and still edible. If you don't want your remains to become the prey of hungry wolves thousands of years in the future, you only have to pick up your suitcase. There is no other way.

A Plan for Intense Cold, Deadly Gases and Extreme Heat

The previous chapters show clearly that we will be dealing with volcanoes as well as glacial areas. If we want to survive, we need to prepare ourselves thoroughly for both. Our survival kit will not only consist of gas masks, but also of protective clothing against the cold. Hopefully we will only need them in a limited way. The possible survival places will be chosen selectively, and I expect to keep far away from volcanic activity. Waiting for the events to come, we will be in the high mountains where it is always cold, and where we have freezing cold temperatures to consider. Mountain clothing is a must, as well as tents, heating equipment and other requirements. We will indeed suffer exposure to poisonous gases, but the concentration where we are will not be deadly. Hopefully, in this way, we will avoid the worst heat coming from the volcanic eruptions.

After the earth crust shift, we should find ourselves in a subtropical or tropical area. Yet, at first, I do not expect to experience much of this climate because, after the catastrophe, it will remain dark for years. Clouds of gas particles, ashes and dust in the atmosphere will obscure the sunlight for a long time, in what we call a "nuclear winter." The temperature will go down globally and life will be inexpressibly difficult. With our pool of prior knowledge, we should be able to deal easily with these problems. We will probably have to develop glass construction. Because all glass will be destroyed, it is advisable to bring along big transparent rolls of plastic. They could help us to get through the first difficult years. If it is true that the earth will be surrounded by dust for decades, difficult times are ahead of us. Even in the subtropical zones, frosty cold air, hail and ice could become a daily reality—even in summer. Being prepared for all these difficulties will allow us to remain a step ahead.

PART III

THE REBUILDING

12.
A RELEVANT GEOGRAPHIC PLACE

Before starting the new civilization, we need a geographically relevant place. It is known that countries become prosperous by producing their specific products and trading them with other countries specialized in other products. For that reason it is important to have harbors and rivers at our disposal: people have a tendency to populate these places. This bigger concentration in itself will create more specialization and an expansion of the economy. Companies that are specialized in the same product can exchange new production techniques more easily, creating a circle that reinforces the whole system.

The costs of inland transport are higher, and it is therefore more difficult to trade and to specialize. Also the climate should not be too warm, because it obstructs invention. At the equator the problem gets worse because of diseases like malaria that can severely set back productivity. It is for these reasons that, in our history, Europe and North America became the most important industrialized areas in the world.

The choice of the right place is of great importance if we want to start a new civilization. Size, climate, position and accessibility are key factors. In the beginning it is advisable to restart a civilization in tropical or subtropical areas, where food is more available. Having a sufficient food supply is very important, especially during the initial phase. After that, depending on the progress of agriculture and sciences, the choice to restart elsewhere can be made. And we need to take into account the building of harbors. Without harbors there will not be a rapidly growing civilization. Of course several problems will show up. The main problem is undoubtedly the water level.

The Fall of the Water Level

Twelve thousand years ago the water level in the ocean was about 120 meters lower than at present. Large parts of North America and northern Europe were covered by hundreds of meters of ice. Following the previous pole shift, these areas came to lie in a more moderate climate and the ice caps melted. This resulted in a drastic rise in the sea level. At the end of 2012, this situation will reverse. America and Europe will again be buried under billions of tons of ice and again, water will be taken away from the oceans. In record speed, harbors that were built too quickly, will dry up. In many cases, new harbors will have to be built maybe tens of

kilometres away from the old coastline. Not a pretty thought if you have just completed the work on your infrastructure. Therefore it is better to wait until the situation is more or less stable. But these will be decisions to be made by future generations.

How the future world will look is not so difficult to depict. It will be a copy of the previous antediluvian one:

- There will again be a land link between southern England and northern France. In many places the English Channel is no more than forty meters deep and will quickly dry up. Whether glaciers will arise in these places depends on the magnitude of the earth's crust shift.
- The land bridge between Alaska and Siberia will also resurface. Starting from Europe, future expeditions can conquer America again. It is, however, advisable to wear warm clothes even though Alaska and Siberia will have now a moderate climate. Continental America will, on the other hand, be moaning under a gigantic ice cap.
- Many islands will become bigger and in shallow places, new islands will appear. Malta and Sicily will be joined, while Corsica and Sardinia will form one landmass. Captains and cartographers will regularly have to adjust their charts due to the changed circumstances; this is a must in order to prevent shipwrecks
- Presently the banks of the Grand Bahamas are only covered by shallow water. Twelve thousand years ago they formed a big plateau rising about 120 meters above the sea level of that time.
- Australia and New Guinea will have the connection they used to have and will form an expanded continent. Settlers will be surprised at its immensity.
- Japan, which presently consists of three main islands, will form one landmass and will connect with the long Chinese coastline.
- The Strait of Hormuz is a busy shipping route. A great number of oil tankers pass through there every year. After the pole shift, this route will quickly dry up and some torn and broken pipes and remains of oil platforms will be left on it—a completely different situation from the first years of the twenty-first century, with a threat of war over the availability of oil.
- Good news for holidaymakers: the Maldives will almost double their surface area. However, in the new reality it will be very difficult to reach. A return journey by sailboat after the cataclysm will easily take two years. If this were not the case, a lot of people would be interested in going there.
- Sri Lanka will again be connected to the Indian mainland. The coasts of India, as well as those of China, will regain a lot of

land.

• Malaysia, Borneo and Sumatra will merge and connect with the coasts of Vietnam, Thailand and Cambodia. Because the areas lying in between will be very shallow, this can happen quite quickly.

• The coastal zones of Brazil, and especially of Argentina, will expand quite a lot.

In summary, the least industrialized countries in the world will become suitable for colonization. Examples are the Sahara and many coastal areas that will reappear and again be accessible. A considerable amount of land will emerge worldwide, almost as much as the equivalent of the United States of America, South America and Europe combined. That is quite a lot, enough to keep a mass of settlers busy for thousands of years. But even more important to know is that many new coastal areas will have a pleasant climate. As old sources of pollution will have mostly disappeared, the newborn humanity will undoubtedly flourish.

Figure 23.
In the centuries (to millennia) following the catastrophe, massive amounts of ice will be building up, covering Canada, America and northern Europe. Due to this, the ocean level will sink gradually and a considerable amount of land will be gained. The dark areas illustrate this situation between Thailand and Borneo.

A New Inhabitable Continent

A new landmass that will also show up, and surely must not be forgotten, is Aha-Men-Ptah, the legendary Atlantis that is now

buried under the South Pole. After the melting of the ice cap this is, without any doubt, the ultimate place to restart civilization. In fact, this continent is my personal preference. There will be no pollution whatsoever and ecologically it can become the most suitable place in the world for a civilization! There are no melted nuclear plants and no leaking chemical and petrochemical factories. Everything that will flourish will be pure and untouched. If we are able to remain there for more than ten thousand years, most of the nuclear and chemical mess in the rest of the world will have disappeared, and we surely will have new places to re-inhabit. Yet, I will try not to run ahead on this.

Like I said before, I strongly recommend immigration to the early Aha-Men-Ptah as soon as possible. From this place a highly developed civilization was once able to rule the whole world, which speaks volumes. The inhabitants sailed the world's oceans, made maps of the whole world and had colonies everywhere. Our descendants can surely do the same, maybe even better. With the knowledge we are supplying them, they can conquer the world again and put their mark on a worldwide policy.

Aha-Men-Ptah meets all the needs summarized at the beginning of this chapter. Besides, it forms a separate land that has no connection to other continents. Therefore it cannot be conquered by less cultured civilizations. Furthermore, one leader can rule it like in the old days. My preference goes to a new sort of pharaoh. Did their history not prove that their civilization could exist for thirty thousand years without interruption? Doesn't this show that a succession of pharaohs supports the continuity of a civilization? Sure it does. No other model of civilization can match this. Still, we should realize past mistakes and not make them again. Their civilization went down because of mutual disagreements. And their priests and scientists kept too many secrets that hindered the dissemination of their knowledge. This severely limited new inventions and the reinforcement of their economy and army. If we are able to prevent these problems, civilization can again blossom and our descendants will rule the earth forever. Only a good mixture of democracy and aristocracy can provide this.

The unique location of this continent gives us the necessary starting capital and the natural resources to succeed in our plan. Because it is situated in the middle of the ocean, it automatically gives inhabitants a natural inclination to expand. In order to visit other worlds, you will have to build ships and harbors. As shown, ships and harbors are the strongest tools you can utilize in developing an early economy. There is no doubt about this whatsoever. We only have to be careful not to rush things. The

drop in sea level will take some time. In the beginning, we will have to do with mini-harbors and small cities. When we have more certainty about a stabilized water level, we can start making bigger infrastructure works. And with that, we can establish a flourishing civilization the world over.

Figure 24.
Antarctica or the early Aha-Men-Ptah. Depending on the magnitude of the earth's crust shift, part of the old Atlantis will appear, after lying under the South Pole for almost twelve thousand years. As soon as it is sufficiently free of ice, and trees start growing again, it can be colonized. The polar circle shows the place where we have to consider cold temperatures. The outer areas will have temperatures like those presently found in Sweden and Germany, where a new civilization can be founded without many problems.

Conclusion

I am pleading for our return to our source with, just like in the old days, a leader who can inspire the people. There, where a superior civilization was once started, we can breathe new life again. Prosperity, health and a natural way of living will then dominate the earth for an immeasurable period of time. We can have a new paradise on earth. And I don't think I am just dreaming.

Once more this is nothing new, and the decline and rise of the civilizations can continue endlessly. It could happen within a hundred years or sooner, after large parts of glacial areas melt and plants and trees grow again. As a matter of fact, after a short period of time the ice cap covering that place will be changed into forests. Data from Newfoundland appears to support this theory. The data from carbon dating shows that the first forests started to grow there 11,800 years ago, which was quite soon after the previous pole shift. Since this pattern appears to repeat itself, I advise our descendants to be prepared to re-colonize this legendary continent. If everything goes according to our plan, it is likely that, after a thousand years, a considerable resurrection of our lost civilization will have taken place. It is up to our descendants!

13.
THE REBUILDING

The rebuilding will be a huge challenge. You will have a chance only if you are prepared for the worst. For example, as a survivor, you need to have as much knowledge as possible at your disposal, or be able to get it from books, because almost all sciences will have to start again from scratch. Computers, machines and electrical equipment, will definitely be destroyed. An immense amount of knowledge will have disappeared. And the technicians who had learned the knowledge will be dead. You will be the center in this destroyed world. You, as one of the few, will have to pass on the knowledge. Your main task will be to pass on what has happened, and the notion that it will happen again. A task is awaiting you, bigger than the biggest you can imagine.

We only need to pass on knowledge of the most essential issues:

• Knowledge of melted nuclear plants: It is highly recommended that we restart our civilization in places that are far away from the nuclear plants that were destroyed. For example, we might choose Africa or Antarctica. After thousands of years the radioactive zones can be re-inhabited. One has to take this seriously into account especially in India, because it has a lot of nuclear plants, just like Japan. Our knowledge about measuring radioactivity must surely not be lost.

• The connection between the world population and pollution: Right after the catastrophe, priority has to be given to a partial re-inhabitation. One has to keep a certain control over this, because the earth can only handle a certain number of people. For thousands of years we will still be confronted with the ecologic consequences of the present overpopulation. At the high point of the following civilization, the whole world population should comprise about a hundred million people, and no more. They will enjoy a high standard of living.

Before the then-future catastrophe, they can reduce themselves, until only a hundred thousand remain. They in turn would then be able to continue the civilization. To keep the world population limited, one can use the method that was discovered by Australian scientists: a bit of lemon juice. It appears the safest and cheapest way to prevent pregnancy. According to the laboratory research of physiologist Roger Short, a piece of cotton wool drenched in one milliliter of lemon or lime juice placed in the vagina appears

to kill spermatozoids immediately.

• The size of cities: Without exception, cities have to be kept small. Woods and parks must have a central place in the new cities. Life in a natural surrounding stimulates mental as well as physical health. Tall buildings and other excesses of our present consumer society have to be avoided.

• The connection between chemical substances and the destruction of nature: Almost all chemical substances, like pesticides and herbicides have to be banished for good. In their place, biological agriculture has to be promoted. In that way, diseases can be prevented, and we can be sure that the new generation will have a healthy food supply.

• The disadvantages of building too many food companies: Processed foods are contradictory to our health and our ecological policy, and we should oppose the manufacture of things like candy, chocolate, white sugar, packaged soup, etc. The consumption of food in its natural state, like fresh soup, fresh vegetables and fresh fruit has to be promoted as much as possible. About thirty thousand diseases can be prevented by following a fruit and vegetable diet. Everybody knows how important it is to remain healthy. This way of living will have a central place in the New World. The real "preventive" medicine will be taught in schools. Then doctors will need to concentrate only on the treatment of accidents.

Figure 25.

• The cultivation of meditation and fasting instead of hospitals: Fasting is the only way to cure disorders caused by infectious diseases, like pneumonia, influenza, and so on. Venereal diseases can also be cured completely by fasting for 16 days. During a period of fasting you may drink about one and a half liters of pure water daily, without taking anything else. Because this is very difficult to do on your own, special centers have to be created. Hospitals will remain a necessity for operations, but will have a less prominent character than today.

These new paradigms will allow us to build a much happier society. The physical and mental health of all terrestrial inhabitants will stand at its center. Illness will then be something from a distant past. An infinitely better world will be the result. These will be the principles we will have to pass on. I mention below some simple things that our descendants may apply. Of course the list is much longer, however, the more you try to pass on, the bigger the chance it will be lost.

Drinking Water, Lavatory Facilities and Fuel

Fighting Bacteria with Five Hours of Sun Warmth

Bad hygiene and the lack of lavatory facilities are the main cause of the pollution of drinking water. Systems that separate clean water from waste water need to be developed (and are not extremely complicated), however, it is inevitable that for some time, drinking water will become contaminated with harmful microorganisms from human waste. To get clean drinking water from water that is polluted by bacteria, one fills a transparent bottle with the contaminated water. Blacken one half of the bottle. Put the bottle in the sun for five hours. After five hours, it is safe to drink the water. There are two basic factors involved: the solar radiation, and the rise of the water temperature. Microorganisms that live in the human stomach and intestines are extremely sensitive to UV radiation. Exposure to UV radiation kills them. The effectiveness of this method is much higher when the temperature is raised to fifty degrees Centigrade.

A Simple Water-Saving Toilet

In order to prevent extensive contamination of ground water and the waste of water, a simple toilet can be constructed: a rectangular wooden cube with a lavatory seat. Under that seat there is a big bucket filled with dry leaves and wood from the garden. After using the toilet, you just have to put a scoop of the mixture of leaves and wood on top of the refuse deposited. It doesn't have a bad odor, because the process of composting neutralizes it. When the bucket is full, you put the contents in the garden on a compost pile where you can also add organic home garbage. After a year, all this will be composted and you cover the pile with straw. After this period you will have compost of the highest quality. Do not underestimate this method, because many epidemics are caused by bad hygiene. As always, it is easier and better to prevent than to cure.

Morning Urine as Fertilizer

Urine can be a powerful fertilizer, but only under certain circumstances. The best method for producing an effective infusion (which ties in well with the fruit and vegetable diet I will outline subsequently) is as follows: after getting up, men drink fruit juice or water (1.5 liters). When they urinate, they should do so in a bucket, which should be left in the open air for at least one day. Then the urine has to be mixed with rainwater (in a ratio of 1 to 12). You then sprinkle all your fruits, flowers and plants with this incredibly stimulating mixture. In a short period of time, you will cultivate a paradise of flowers, fruits and plants! It is, however, important that men do not drink alcohol or eat meat. The urine of women is far too strong. The urine of both men and

women can always be added to the general compost heap. During the catastrophe, almost all plants and trees will be uprooted. This technique can induce a quick flourishing of all destroyed plants and fruit trees!

Drinking Water

Rainwater will remain the best. A barrel in which you can gather thousands of liters is most appropriate in times of dryness. This water can also be used to wash yourself and the dishes.

Biodiesel

Being an ecologically responsible civilization, we need to get our energy sources from nature. Using vegetable oils as fuel in the eventual development of motorized equipment (or the restoration of any remaining automobiles) can help us tremendously, because plants take up the energy released from this type of fuel into the air more quickly. Besides, the vegetable oil doesn't have to be transported. The production of colza oil, for instance, can take place close to the coleseed fields with a relatively simple installation. And even if the oil did have to be transported, environmental disasters would be out of the question, because the vegetable oil is one hundred percent biodegradable and harmless to the environment. Furthermore, the oil doesn't contain heavy metals or sulfur and will therefore not contribute to soil acidification, pollution of water sources or damage by acid rains. The oil is not flammable and has no risk of explosion. You can even put out a burning match by dipping it into the cold oil. And of course it is not poisonous, and can even be consumed.

In the event any remaining cars can be salvaged, they will need to run on this "biodiesel." At a normal environmental temperature, the viscosity of vegetable oil is too high: the motor cannot squirt it into the fuel injectors. But if the oil is heated to 70 degrees Centigrade, it can be easily processed. Once the car is running on vegetable oil, it runs quite well and the fuel consumption is practically equal to that of using diesel oil.

In order to convert the car for burning vegetable oil fuel, it has to be adapted with a conversion kit that usually consists of: larger diameter fuel pipes and hoses, filters, an electrical acceleration pump, a heat exchanger, magnetic valves, thermometer, and a regulating computer.

The question of production can be readily answered: 1 hectare of coleseed produces 1,500 liters of colza oil, enough fuel for a diesel car to drive a distance of about 25,000 kilometers. An area of 100 by 100 kilometers would provide a million cars with fuel annually.

14.
ESSENTIAL FRUITS, VEGETABLES AND GRAINS

After the catastrophe in 2012, the survivors will have the opportunity to eat as much natural foodstuffs as they can. At present it is very difficult to follow a natural eating regimen. Many people would like to, but our consumer society's temptations are

too strong for them to do so, e.g., the widespread junk food industry. After the earth's crust shift this will change drastically. Everything will be destroyed and it will be quite easy for everybody to switch over to natural food, which will, by the way, result in far-reaching industrial implications. The majority of industries will simply not have to be restarted, like candy factories and slaughterhouses. And let's not forget the tobacco industry. All those changes will alter our view on ecology that will result in a dramatic change to the landscape.

Figure 26.

Many good books on eating natural foods have been written, for example *Diet for a New America*. When you have read it, you will surely agree with me.

Healthy food is of primary importance for the new civilization. This entails well-balanced meals that are based on the principle of correct food combinations. These will not only cause a marked improvement in people's health, but will also result in top physical performance. My books on diets explain the physiological laws of these combinations, and clarify how seriously everybody underestimates the possibilities of achieving top performance through eating real, natural wholesome foods (i.e., fruits and vegetables).

These books provide information on how you can shift your energy frontiers, your endurance, your mental resistance, your creative power and performance level, in a manner you can only dream of now. Furthermore, I explain and prove why fruit and vegetables are superior to all other foodstuffs, and why you can remain young longer and potent up to an advanced age. Women for example, will no longer suffer from menstrual problems, while men's sperm production will function well up to an advanced age. Your super-endurance and increased athletic performance

level will flourish from the natural restoratives in your body: the vitamins, the minerals and the micronutrients from your food. It is up to you to experience this great feeling and to join the club of the super trained. As if in a dream, you will appreciate the mighty feeling of super health through which you will always be in top shape, with a maximum of biological energy, mental resistance and physical endurance.

Almost everybody thinks that if you eat a small quantity of a variety of foodstuffs in one meal, you will have enough nutrients. Well, this is not the case at all! This eating pattern keeps your vitamin reserves very low. Research shows that stress and extreme heavy physical strain, amongst other things, bring about a rather high consumption of B-vitamins in your body. If your vitamin reserves are low and, for example, you have a small car accident, your physical resistance would inevitably weaken and you would become ill. Another example is that when a woman has used too much of her strength during childbirth, she can fall into a severe depression due to a lack of folic acid. And should you work too hard, the road to nervous exhaustion lies open. Even a bicycle ride, a day out, a walk at the beach or in the forest can use up your physical reserves in such a way that you can become ill.

I hope you now understand that a lack of vitamins can have greater consequences than you might think. I will give you another example. All people who are overweight have a vitamin B1 deficiency—in other words, a deficiency of the energy vitamin. A vicious cycle starts. First they feel washed out from the lack of energy. A bad mood follows, together with emotional instability. This causes more nervousness and more instability. In general they will look for their relief in food, and resort to even more bad food. Because this food is insufficient in nutrition, they will feel even more washed out than before.

A fruit and vegetable diet will provide you with a high vitamin intake, enabling you to accomplish heavy physical labor. Of course you will also be able to do your normal daily tasks easier. This high vitamin absorption builds up your immune system against stress. Even more important is that this abundance of B-complex vitamins will make you more mentally alert and less tired at the end of the day. In short, you will have a better life. The only thing you have to do is change your menu to nice fresh fruit and fresh vegetables. You will have all B-complex vitamins in the purest possible natural form and at the same time a huge injection of vitamin C. Adopting such a diet right now will produce immediate benefits, and prepare you to better handle survival in the post-cataclysm world.

Vitamins are not the only important factor in producing top

performance. Minerals also play an important role. So your main target should be to cover your needs of both vitamins and minerals. Otherwise, you risk malnutrition of your muscles, brain and nerve cells. For instance, a deficiency of a combination of magnesium, calcium and potassium shortens your attention span, disrupts your concentration, and reduces your abilities of comprehension. Your memory becomes bad, you quickly become mentally tired, extremely irritable and generally run down.

The solution is mineral-rich food: fruit and vegetables. You will immediately regain your zest for life: your deficient glands

will be abundantly supplied with calcium, potassium and magnesium. My recommended diet (about which I have written four books) provides a top performance program that gives the best solution for all the most extreme demands, and it will give you energy and endurance. It will help you attain far-reaching goals and improve your abilities because of the mighty electromagnetic powers of fruit and vegetables. Therefore it is more than logical that we should know as much as possible about crucial fruits and vegetables. These foods will have to take care of a happy and healthy

Figure 27.

population. Given my experience and knowledge on the subject, it was not very difficult to choose the most essential ones:

• Kiwis: These green fruits contain a rich supply of phyto-chemicals, substances that prevent or cure many chronic diseases. The kiwi is almost "the" perfect fruit. After only a couple of bites you feel the stimulating forces enter your body and mind. It is a strong anti-oxidant with a high concentration of magnesium and useful minerals and it is full of vitamins C and E. Although the hearty green fruit is not an aphrodisiac, it can play an important role in your love life: kiwis contain the amino acid arginine. Arginine is a vasodilator (a substance which causes the dilation, or relaxation, of the blood vessels) which is used in treatments against impotence.

• Oranges and Grapefruits: These are my favorite fruits. Every day I drink about one and a half liters of fresh orange and grapefruit juice—only in the morning on an empty stomach. I use a straw, because both juices contain a strong acid that can damage dental enamel, so the juice should not touch my teeth! Pineapple

and kiwi are other acidic fruits that can damage the enamel. One of the main reasons is that they are picked in an unripe state and therefore still contain many free acids. For a complete explanation, you will need to read my book *Vitality for Life*.

Orange juice contains nice pre-digested nutrients, ready for instant use by the body. Besides that, it cleanses the blood by converting and breaking down lactic acid and other residual products at record speed. It also helps to remove lactic acid from the body, in order to prevent an overly acidic condition, to allow you to remain in top shape. And more than that: the bioflavonoids in oranges increase the permeability of the small capillary septums. Through this, even more vitamins, minerals and enzymes can reach your cells, making them so much stronger. Sick people recover quickly after drinking large quantities of orange juice. It is the best known and strongest immune system tonic of all fruits and vegetables. Considering this fact, I would like the new civilization to drink fresh juices in the morning. This is not only easy, but it also prevents almost all known diseases. Of course we need to have sufficient fruit at our disposal. You can be sure that my top priority will be the urgent restoration of orchards of these fruits.

Figure 28.

Please Note: Only use acidic fruits in the form of juice! Drink it with a straw and see to it that the juice doesn't touch your teeth. Only in this way will the fruit acids not damage your teeth. Four acidic apples a day are sufficient to severely damage your dental enamel!

• Bananas: Steamed or baked, the fruit sugars of these fruits give an enormous amount of energy. They are easier to digest and you can eat five to eight of them a day without any problem. Besides, bananas are rich in potassium, which you need in order for your muscles to work at maximum speed. Should you be a professional or recreational athlete (or should you wish to be in shape to survive the cataclysm in 2012), you have to consume this super food regularly.

On January 6, 1993, I was expected at the Free University of Brussels to do an exhaustion test that would show differences between vegetarians and non-vegetarians. Three days before the test I had a slight cold because I had exhausted myself during the holidays. My remedy against a cold is fasting, therefore not eating a thing until the symptoms have disappeared. On the morning of the aforementioned test I felt cured, but also completely empty

and exhausted because of the fasting. So I drank about three liters of orange juice and steamed eight big bananas. While eating the bananas, I felt the strength coming back into my body.

At the University the doctor gave me an oxygen mask to measure my flow and I had to sit down on a stationary bicycle. He also connected me to a heart-lung machine. Then I started the test that took three hours. To my surprise it went very well! I reached a maximum oxygen assimilation of 54.82 millilitres per kilo of bodyweight—a high value, and the highest of the fifty recreational sportsmen who were doing the same test! So there you see how powerful orange juice and bananas are!

Figure 29.
Steamed or baked, bananas are a good source of energy. They can be the main source of energy in our new, ecological civilization. Top athletes, mountain climbers or people who need to do heavy physical work, should eat them by the tons.

You might notice that I mentioned I steamed the bananas. One way to provide variety in the diet is to prepare the food in different ways. To steam bananas, put a small layer of water in a cooking pan. Put four to eight bananas in it and let them steam for twenty minutes over moderate heat until they are cooked. Stir once in a while.

• Other very important fruits: mangos, grapes and melons. They contain a lot of vitamins and minerals and can be consumed in large quantities.

• Potatoes: Potatoes can be the principal source of energy-giving carbohydrates. During an expedition in New Guinea, the Australians Hipsley and Clements discovered a population that lived on Mount Hagen at an altitude of 1,500 to 2,200 meters. Research showed that this population ate very simple foods. Their menu consisted mainly of sweet potatoes (80 to 90 percent, or 1.5 to 2 kilos per day), young plants, palm hearts, several varieties of nuts and other similar produce. Medical analyses reported: "despite this simple food, all members of this population, the children included, have excellent health. Strenuous physical performances were no problem at all."

At the restart of our civilization, we need to take this into account. Because sweet potatoes contain a lot of pro-vitamin A, and white potatoes don't, you need to combine white potatoes with carrots to get the same nutritional value. Few other foodstuffs

can compare to this winning combination.

An important survival strategy for the new world will be that, in 2012 and 2013 we are going to eat potatoes and carrots en masse, because they can be kept for a long time. We will not need much more variety in order to be able to live! We will have the highest quality food for at least half a year, and by that time we should have a new harvest available. Once the fruit trees have started to grow again we can start reintroducing fruit into our diet.

Potato Storage: It is known that plants grow in the direction of light, a phenomenon that is called phototropia. This is explained scientifically by the fact that the plant cells on the shadowed side contain more growth regulator (auxin) that stimulates the cell growth, through which the stalk on the shadowed side grows faster causing the plant to bend towards the light. The shadowed light that promotes growth is in the blue light spectrum, while reddish light slows down the growth. It has been ascertained that seed-potatoes, when stored under red light, do not create new shoots. Later, the plants grown from these potatoes produce a good harvest. To make use of this phenomenon we have to try to use red light for the conservation of our potatoes after the cataclysm.

• Carrot Juice, Super Juice: Carrot juice is the sweetest and one of the tastiest vegetable juices. It is the richest source of vitamin E, organic calcium, copper and iron. It also contains an exceptional revitalizing power because of its huge quantities of potassium and magnesium, which are most beneficial for muscle tissue and the nervous system. Furthermore, it contains plenty of B-complex vitamins and its power as a tonic lifts you to new heights. The regular use of this juice also increases respiration. The explanation for this is that the vitamin Beta-carotene keeps the bronchial mucosa healthy (these are a thin layer of muscle fibers which are extremely pliable and resilient). When these fibers receive insufficient amounts of Beta-carotene, their cells harden and the normal excretion of disinfecting mucus becomes obstructed and inhibits optimal respiratory function. For these reasons, carrots will play a central role in our diet.

• Grains and Rice: Besides potatoes, grains and rice are important providers of energy. To grow these in sufficient quantity, mixed cropping (wherein different strains of plants are sown in the same field) would have to be promoted. Rice, for example, cannot be cultivated in a monoculture system. Mixed interplanting is fine: for example, split rice together with a dry variety. The yield of split rice in a mixed cropping system is almost ninety percent higher than in a monoculture system. Fungal diseases are also less likely to occur; when a fungus infects a rice plant, it is less

likely to spread because there are fewer identical plants nearby to infect. Furthermore, the non-susceptible plants stationed between the susceptible ones function as a physical barrier. In order to select the correct rice varieties you need to test them beforehand with a fungus trace. It has been shown that one row of split rice cultivar beside four rows of a dry rice cultivar gives an excellent result. For grains, the same principles apply: two or three barley varieties are far less susceptible to fungi than one.

These simple findings can prevent severe famines, so don't take them too lightly. At present nobody is thinking about this, but I guarantee you that after the catastrophe they will be!

•Sprouts and Shoots: It takes some time before vegetables started from seed grow into plants. In the meantime we can use sprouts and shoots. For example soya shoots are easily and quickly cultivated, as are the sprouts of many grain varieties. All these contribute to the delivery of vitamin C to our body and keep our blood alkaline. Wheat grass juice is another example of a mineral- and vitamin-rich food. A glass a day will keep you healthy. The cultivation of the grass is very easy: after soaking the seeds for 24 hours you sow them in humid potting compost and cover them with a thin towel. Put it away in the dark until the seeds have sprouted, after which you bring it out into the light. After twelve days you can harvest it. Cut the grass short and strain it very fine (put it in a berry mill, if you have managed to save one). Drink the juice one and a half hours before dinner.

•Egg Yolks: A fruit and vegetable diet needs to be supplemented by the addition of raw egg yolks. The need for eggs means, of course, that we must ensure the survival of a large brood of chickens. Egg yolks are not only necessary for enhancing the taste of the food, but they also contain all the necessary fats, oils, vitamins and minerals. Vitamins B12 and D, which you normally find in meat and fish, are present. In order to prevent a shortage of both of these necessary life-supporting vitamins, it is advisable to eat two raw egg yolks every day. For women especially, this is most important—a possible deficiency could cause their children to be born deformed.

Minimum daily requirement of vitamin B12 in micrograms:

Babies	0.3
Children from 0,5 to one year	0.5
Children from 1 to 6 years	0.8
Children from 7 to 10 years	1.0
Adults	1.0
Pregnant women	1.5
Breast feeding women	1.5

One egg yolk contains approximately 0.7 micrograms of vitamin B12. This is less than the necessary quantity for adults and children older than seven years, so more than one should be consumed daily. Women, especially during pregnancy and the breast-feeding period, should always eat two to three raw egg yolks per day. This is really very important when you follow a fruit and vegetable diet, since a breast-fed baby gets his or her vitamin B12 from the mother's body.

Please Note: Never consume raw egg white. Raw egg white contains avidin and obstructs the absorption of biotin (Vitamin H). It separates from the egg yolk easier when you first heat the egg a little bit in hot water. Egg white must always be eaten cooked.

Other vegetables completing this diet are broccoli, celery, cabbage and fennel. This eating regimen is not only simple with easy-to-prepare food, it is also superior to all other daily diets. In short: there are only advantages, so why shouldn't we apply it extensively? Once you are used to it, or if you have been raised this way, you really don't want anything else. Have a look at the television survivalist programs. The future "Robinsons" will have to survive on some varieties of fruits, plants, rice, eggs and maybe some fish. After the earth's crust shift, you will get used to the change in diet rather quickly. Hunger will be your biggest motivator, and you will be more than happy if you can eat fruits and vegetables!

Sample Menus

My books on this diet are only available in Dutch, for the time being, so I felt obliged to give you some examples of daily healthy fruit-vegetable menus. Hopefully it will motivate you to begin this diet at once! In the following menus, the time at which food is to be consumed is expressed in "military time." If you are unfamiliar with this system, "12.00" denotes noon. Afternoon and evening hours can be determined by subtracting twelve from the time given, e.g., "16.30" translates to 16.30 − 12 = 4.30 pm. Likewise, "18.30" equals 18.30 − 12 = 6.30 pm.

Figure 30.

First Day
07.00-12.00: 2-3 liters of fresh fruit juice (example: apple, mango and orange)
16.30-17.00: 1-2 glasses of vegetable juice (lettuce, celery and carrots)
18.30: 150-250 grams semi-polished Basmati rice with two raw egg yolks, 300 to 600 grams of vegetables like carrots, chicory, very young beans and celery with grated coconut

Second Day
07.00-11.00: 2-3 liters of fresh fruit juice
12.00: 6-10 steamed bananas
16.30-17.00: 1-2 glasses of vegetable juice
18.30: 150-250 grams of semi-polished Basmati rice with avocado, 100 grams of pumpkin, 200 grams of fennel and 150 grams of celery with a slightly baked egg yolk

Third Day
07.00-12.00: 1.5-3 liters of fresh fruit juice
16.30-17.00: 1-2 glasses of vegetable juice
18.30: 1-1.5 kilo potatoes, 2 raw egg yolks, 400-600 grams of vegetables like carrots, broccoli, fennel or celery

Figure 31.
The addition of bread to these menus proves to be very beneficial for top athletes. Athletes that tried this eating pattern reported a considerable increase in endurance. They also became less susceptible to illnesses.

Fourth Day
06.30-08.00: 1-3 liters of fresh orange juice
09.30: steamed bananas or 8 to 12 pieces of semi-whole-wheat bread (baked without salt)
Note: bread digests much better when you eat it separate from any other foodstuff. Try this, and you will be astonished by the result.
After 3.5 hours: 6-12 steamed bananas or slices of bread
After 4.5 hours: juice of unwashed organic vegetables (celery, lettuce and carrots)
After 1-1.5 hours: steamed bananas
After 1 hour: potatoes with two slightly baked or raw egg

yolks and 400 grams non-starchy vegetables (see lists of foods categorized by starch content below)

Fifth Day
Morning: 1-3 liters of fresh orange or melon juice
Afternoon: rice or bread with vegetables with little or no starch + if desired, avocado
After 4.5 hours: juice of unwashed organic vegetables (celery, lettuce and carrots)
After 1.5 hours: rice + bread + vegetables with little or no starch + 2 raw egg yolks

Sixth Day
06.00-08.00: 1-3 liters of melon juice
09.00: steamed bananas
Afternoon: bread with avocado or bamboo shoots with baked rice
After 4.5 hours: see first or fifth day

Seventh Day
06.00-08.00: 1-3 liters of orange juice
09.30: steamed bananas or 8-12 slices of semi-whole-wheat bread
Afternoon: baked rice with vegetables (carrots, dwarf beans, fennel)
After 4.5 hours: 1-1.5 kilos of potatoes with a bit of butter or oil, 2 raw egg yolks, 400 grams of vegetables like carrots, celery, broccoli and Brussels sprouts

Figure 32.

Warnings
• *Never eat fruit after having eaten something else!*

• Eat bread, rice and potatoes as *dry* as possible

• *Never* drink during a meal. Always drink at least 45 minutes beforehand! Otherwise you will have problems with digestion, particularly with starches.

• Do *not* drink after dinner! Only a little bit of mineral water is allowed. You are risking diarrhea and gas.

• If you eat vegetables or starch at lunch time make sure the fruit has had at least four hours to digest.

• If you ate bread in the morning *do not* eat acid vegetables or vegetables high in oxalic acid (see lists below) at lunchtime!

Otherwise the part of the starch that has not yet been converted into glucose will ferment!

• Large amounts of raw vegetables are difficult to digest, which is why they start to ferment, so don't overdo it! Young carrots and root vegetables digest most easily.

• Semi-whole-wheat bread digests much better than coarsely ground whole-wheat bread or plain white bread. It can be combined with avocado, butter, non-starchy vegetables, mildly-starchy vegetables, and other starch.

• It is best not to eat any proteins at lunchtime. They take far too long to digest. Too much fat with starch can also considerably lengthen transit time. For example: starch + butter + egg yolk can lengthen digestion time by up to eight hours! Avocado digests much better, except when it contains large amounts of fiber. In that case, digestion time (with starch) is about five to six hours.

• It is all right to have a protein meal for lunch once in while, but do not overdo it. Proteins are best eaten in the evenings.

• When you eat bread, rice, potatoes and other starches separately, they are more easily digested. Together, they can cause fermentation. Should they give you diarrhea or gas, eat them separately!

Starch-based Combination Possibilities

The following lists will help you determine which foods combine well to provide easily digested, nutritious meals.

Starchy Foods

Biologically the following starchy products are best combined with mildly-starchy vegetables, non-starchy vegetables and fats.

Acorns	Maize
Barley	Meal
Barley Flour	Millet
Barley Malt	Oats
Bread	Parsnips
Buckwheat	Pasta
Chestnuts°	Potato Flour
Chufa Nuts (Sedge Tubers)	Potatoes
Coconut	Rice
Cornstarch	Rye
Couscous	Salsify (Oyster Plant)
Crackers*	Semolina
Custard Powder	Sweet Corn
Flour	Sweet Potatoes

Grain	Toast
Jerusalem Artichoke	Tapioca
Knäckebrot* (Crisp Bread)	Water Chestnut
Macaroni	Wheat Flour

°Always roast the chestnuts. Some are poisonous when eaten raw!

*No sugar, cheese or preservatives.

Non-Starchy Vegetables

Asparagus	Fennel
Bamboo Shoots	French Beans
Borecole (Kale)	Green Beans
Broad Beans*	Green Cabbage*
Bush Bean*	Lamb's Lettuce
Butter Beans	Mushrooms (small)
Cabbages (young, sweet)	Nettles
Cardoon	Oxheart (Cabbage)
Carrot Leaves	Peapods*
Cauliflower	Pumpkin (young, small)
Cauliflower Leaves	Red Cabbage
Celeriac Leaves	Runner Beans
Celery	Rutabaga (greens)
Celery (greens)	Savoy Cabbage
Chervil	String Beans
Chicory (Belgian Endives)	Sugarloaf
Chinese Cabbage	Turnip (greens)
Curly Kale, Borecole	Wax Beans*
Dwarf Beans	White Cabbage
Endive (not bitter endives)	White Celery

* Young shoots contain almost no starch or protein. Mature beans do though!

* Always remove the foliage, the green or the leaves of the vegetables when you buy them. If you do not they will leach the minerals and the vitamins from the vegetables (for example carrot tops)

* Mushrooms contain toxic substances, which is why they may cause diarrhea. Only eat young mushrooms (steamed or fried).

* Older vegetables contain cellulose which is difficult to digest. It is best to eat young vegetables

Mildly-Starchy Vegetables

Artichoke	Kohlrabi
Beets (young)	Onions (young)
Broccoli (not bitter)	Pumpkin (reg. and giant)
Brussels Sprouts (young)	Rutabaga
Celeriac	Snap Beans
Carrots	Turnips
Corn-on-the-cob (young)	

Please Note: All other vegetables combine badly with starch! They may cause you to have diarrhea or suffer an allergic reaction! When you eat acidic vegetables like tomatoes and sweet peppers separately, they digest well. A dinner can therefore contain a combination of: tomatoes, sweet peppers, sauerkraut, peppers, cucumber, zucchini, beetroot, seakale beet, spinach + raw egg yolks or 50 to 100 grams of cheese.

Acid, Fruiting and Bitter Vegetables

These contain acids and bitter substances, which is why they may not be combined with starch!

Broccoli (bitter)	Garden Sorrel
Cabbage (bitter)	Jalapeno Pepper
Celeriac (bitter)	Olives (fresh)
Cucumber	Peppers
Eggpant	Pickles
Endive (bitter)	Sauerkraut
Escarole (bitter)	Tomatoes
Fennel (old)	Zucchini

Vegetables High in Oxalic Acid

The quantity of oxalic acid in these vegetables is fairly high. Consumption in excess may damage your health! It is preferable not to eat them at all, although after boiling and draining, a large part of the oxalic acid disappears. It is best not to drink the juice of beetroot, too.

Beetroot	Rhubarb
Beet Tops	Spinach
Purslane	Swiss Chard

Vegetables High in Mustard Oil

These vegetables are extreme irritants. They can make you very ill if you eat them regularly. The advice in natural medicine with regard to these vegetables is to *avoid them as much as possible or not to eat them at all!*

Black Radish	Onions
Chives	Parsley
Garlic	Radishes
Garden Cress	Scallions
Leeks	Watercress
Mature Mustard Cress	

Herbs

The following herbs (dried) used in moderation can make your dishes much tastier.

Basil	Mint
Celery	Oregano
Chervil	Parsley
Chives	Rosemary
Dill	Sage
Fennel	Sweet Bay
Marjoram	Thyme

Be creative in using herbs. Herbs give a new taste to everyday food. Oregano gives potatoes or breads a delicious and totally different taste. Herbs can also be used as a replacement for salt and strong spices. Use them in moderation, though.

Tested and approved combinations:

Basil, Oregano and Sweet Bay
Oregano, Thyme and Chives
Dill, Chives and Basil
Sage and Thyme
Marjoram, Thyme and Basil
Basil and Marjoram
Oregano, Marjoram and Rosemary

These are the main parameters of the new eating regimen that will be promulgated after 2012. It is not only more ecological, but also saves a lot of work. The cultivation of fruits, vegetables

and grains will be emphasized, nothing more. This will result in a situation where, after some decades, most people will work only several hours a day! The rest of their time can be spent on sciences, art, theatre, etc. In other words: our descendants will find themselves in a new Golden Age!

15.
THE LIBRARY
FOR A NEW WORLD

Paper and ink are of crucial importance. Not only do books need to be saved from destruction, the production of paper and ink also needs to be at the forefront of a new civilization. These are essential to the future transfer of knowledge. In order to maintain a library, you must have one first. In the first century of our era, Philo of Alexandria wrote: "As a result of the continuous and repeated destructions by water and fire, descending generations of the previous ones did not receive memories about the nature and the order of the events." This just exemplifies the fact that the passing on of knowledge about the terrible events during the pole shift must be carried out as widely as possible.

Everyone needs to be familiar with what has happened. In *Timaeus*, Plato reports the following: "That the memory of catastrophes of fire and floods got lost, because all the literati, together with the knowledge of their civilization, had died." And because the survivors died and did not have the chance to write it down, "this big turmoil was soon forgotten."

It has to be clear: for the next civilization to be warned about a future cataclysm, the survivors of 2012 will need paper and ink. We must write down in our diaries with great precision how our arrogant civilization brought ruin upon itself. This has to be taught at school to every new generation, together with the knowledge of calculating, beforehand, a shift of the earth's axis. The lessons should also mention that our superior civilization that had at its disposal the finest and most sophisticated technology, could not foresee the impending polar reversal, let alone calculate it. Only in that way can our descendents be prevented from making the same mistakes that we made. Should we not achieve this, everything will be lost again in a series of destructions and resurrections.

Furthermore it has to be taught that the previous civilization of Aha-men-Ptah, although with simpler means and tools, succeeded in calculating future polar reversals and pole shifts, simply because they had given it absolute priority. Faith moves mountains. Their search into the background of these catastrophes dominated their world. Therefore they finally succeeded in finding the long-searched-for saving answer: the sunspot theory containing the polar reversal of the magnetic field of the sun. This knowledge needs to be taught to everybody.

The Quality of Paper

Before 1850, paper was produced from rags, and kept quite well. Then an acute shortage arose. Experiments with many other organic materials followed, and Scandinavian wood pulp found its breakthrough. Some decades thereafter, the wood pulp paper appeared to deteriorate faster than the rag paper. This was due to the pH value of the material. Since 1950, quality paper is usually found to be de-acidified paper. In order to conserve our knowledge as long as possible, we absolutely must take this into account. Without well-preserved paper, the new civilization will fall back rapidly into barbarism!

Mathematics

Without mathematics, one cannot build up an advanced civilization. Addition, subtraction, division and multiplication are the simple things that are of great importance to a re-emerging culture. To construct buildings you need to have knowledge of three-dimensional geometry, for instance the volume of a pillar, the width of a circle, the surface of a square, etc. At present, sophisticated calculators are doing these tasks. Up until the polar reversal they will work perfectly. However, due to the polar reversal and the resulting electric pulse they will be completely destroyed, so we will have to rely on mental arithmetic. In order to arm ourselves against this and the quick loss of our mathematical knowledge, we could make, for example, a simple wooden abacus. I think therefore that the taking along of abacuses (and the knowledge of how to use them) will be of great importance to the well-being of our future. Also we should not forget to bring along mathematical tables with the most frequently used logarithms, sines, co-sines and tangents.

Soaps

Undoubtedly we are living in an over-hygienic society. Of course this doesn't mean that after the disaster in 2012 we need to live in a reversed situation. Hygiene remains of importance, especially during childbirth. Before starting to work, the midwives, doctors or other people need to wash their hands with soap and domestic bleach. A minimal knowledge of making soap is therefore advisable. In the past people used green soap for almost everything. They not only washed their clothes with it, but also themselves. So why couldn't we do the same in the future?

Music and Dance

Everybody knows the important influence of music in our lives. Mega concerts always attract tens of thousands, sometimes

even a hundred thousand, devotees. Imagine that after the polar reversal all knowledge of music dissolves into nothingness and that all beautiful musical compositions are destroyed. Of course we cannot bring along everything, but a minimum seems advisable. Besides the knowledge of the building of instruments, like pianos, guitars, violins and flutes, we could take along a mini library with the best of modern and classical compositions. Music dispels our problems and brings us into some sort of a flow condition, which inspires us to grand achievements. All primitive races seemed to know this and therefore regularly celebrated festivities with dance and music. We will need to use the mighty means of dance and music in order to feel connected after the catastrophe and create a rebirth. Who wants to take care of this?

Figure 33.

Money

Money forms a complex problem. To build a new financial system is not that simple. A reference book with the precise facts on how you should do this would be of considerable help to us. Going back in time may be inspiring. You might not know that the Egyptians used money. In his book *The Report of My Research*, Herodotus writes about this: "An inscription of Egyptian hieroglyphs on the pyramid shows how much money was spent on the workers for radishes, onions and garlic. I remember well how the man who translated the text for me mentioned an amount of sixteen hundred silver talents! If that is true, I wonder how much was spent on the iron tools, the regular food and the clothes for all the workmen that had worked on this job; let alone the time that was spent on the hewing and heaving of the stones and the building of the underground rooms. That cannot have happened in a wink of an eye, I would think."

An anecdotal story states that, when Pharaoh Cheops ran out of money for the building of his pyramid, he had his daughter work for him. Herodotus tells us the following: "However scandalous, Cheops used every means when he was out of money. He ordered his own daughter to work for money in a whorehouse. The exact amount is not mentioned, but the girl gathered all the money her father needed."

So you see, even the Egyptian civilization could not do without money. It is the only means to motivate people to start working.

Without money you are moved to be satisfied with what you have. You will do a bit of trading, grow your own vegetables and that's that. Of course this scenario discounts desires. The desire for money is inborn in human nature and forms a considerable motivation for the creation of new inventions and products. Even the Egyptians knew this. And in the future it will be the same. We will need to keep an eye on it so our new world does not develop into a consumer society. A strong central authority will have to issue strict laws for starting companies and the use of raw materials. This is the only way to prevent ecological catastrophes.

Furthermore we need to make sure that people can earn money, but cannot become rich. Wealth is a pernicious factor for maintaining an ecological society. Everybody realizes that after the catastrophe all money will be worthless. Dollars or Euros cannot be used anymore. How the new currency will look or what it will be like is something to decide on later. It would, however, be handy to start using gold and diamonds again. In the long history of mankind these have always kept their value. They are the only "money means" we can take along in order to build a new civilization.

Electricity and Electronics

These inventions rule our lives and have made them incredibly easier. Who can imagine a world without radio, television, computers, freezers and electric light? In the catastrophe that lies ahead of us all electrical power plants will be completely destroyed by global earthquakes that measure beyond the capacity of the Richter scale. Also, the polar reversal will generate induction currents that will burn the circuits and transistors. As a result, no electric or electronic device will work. We will have to start again from the basics. In my opinion we should not bring along very complicated works on electronics, but only the basic facts of electricity, for instance: How do I create electricity with wind-force? How do I regulate the voltage? How do I make simple fuses? Which natural materials are useful as isolators? Where do I find the copper for wire? How do I make the carbon bars for motors? Which simple alloys can I use in order to make lamps? Well, the list of questions can be endless.

The problems we have to overcome are complex. Without simple basic facts we will definitely lose all knowledge. Within some decades our descendants will look with curiosity upon the destroyed and rusted devices and possibly not know anything about them. We must try to prevent this at any cost. Knowledge is power and the simplest facts on electricity can help us a lot in creating an ecologically responsible society.

Sciences

Thanks to quantum mechanics, the field of electronics has expanded enormously. This, together with the progress in physics and chemistry, has resulted in scientific revolutions in many areas. Transistors and sophisticated computer equipment are some of the countless results. Subsequent to its discovery, space satellites, televisions, radios, radiographic equipment, scanners and almost all electronic equipment came into being.

In order to restart sciences, it is sufficient to have the basic laws of chemistry, physics and quantum mechanics at our disposal. With simple manuals we will be able to build up sufficient know-how to make science flourish again. With complicated books, for instance about writing computer programs, we cannot do a thing. First we need to have at our disposal the knowledge of how to build a computer. And that in itself is very complicated. After the polar reversal—with its generated induction currents—transistors and circuits will not function anymore. Do you know how to build a transistor without instructions? Well, I don't. Therefore I repeat: only the basic laws and most simple manuals have to be taken along. Please try to understand, because this will be the nucleus of our new wisdom cult. All other things are useless because of the complex problems we will encounter at the rebuilding of a completely destroyed civilization.

In this chapter I have mentioned only a few things about what we will need at our disposal. At the back of this book you will find a more detailed list. I advise and ask everybody to carefully study this list and contribute to our new civilization! As the saying goes, "Well begun is half done."

16.
RUDIMENTARY MEDICINE

In addition to sufficient sources and quantities of food and a roof above our heads, our new civilization will need a basic level of medical care. As much as they are taken for granted now, treatments for toothaches and other necessary operations are some of my biggest worries. Toothache is a very common woe, and can make your life quite bitter. Even the old pharaohs were troubled by it. X-rays show clearly that they suffered from toothaches. We need to do everything in order to prevent it, but it is not that simple. Dentists know how to treat you, but they do not know how to make the anesthetics they use, or where to find the raw materials for fillings. Without these two basic products there cannot possibly be an advanced dental practice. We therefore need to address special attention to this subject. Do not underestimate these problems! Almost daily I ponder how to make anesthetics in order to perform dental operations and how to make the necessary fillings and false teeth. Nobody thinks about it because these things are taken for granted, but I assure you that after the catastrophe it will quickly become one of your biggest worries. For that reason I ask: who will solve these problems?

Surgical procedures are another immense problem. At present, potentially lethal wounds can be cured using existing modern operating techniques. People who have been in accidents are helped through physical therapy, and many continue untroubled by their injuries for the rest of their lives. In the case of a rupture of the Achilles tendon, it can be repaired. If this were not the case, you would be leaning on one leg for the rest of your life. Or imagine a difficult childbirth that requires a caesarean section. Can you imagine this without an anaesthetic? Well, I can—do not read the following paragraph unless you can handle a grim, graphic description of what it might be like!

2014, *the Atlas Mountains in Morocco:* Linda has to deliver a daughter. Her baby is in a breech position, and it is also too large for her pelvis. Whatever the doctor tries, the baby does not want to turn her position. The doctor and the midwife are confronted with a dilemma: performing a caesarean section or cutting up the baby. They decide upon the first option. Two men hold Linda's arms, two her legs and one holds her head. Then the doctor cuts her belly open. Linda screams horribly. The pain and the fear open her anal muscles and her faeces are driven out. It completes the smell of fear that escapes from her body. Blood

spurts in all directions, while the doctor takes out the baby. When he stitches the big wound, Linda has severe convulsions due to the pain. Every time the needle enters her flesh forcefully in order to connect it tightly again, she gives a nerve-racking scream. This is a horrible experience for everybody present.

This story illustrates more than clearly what is ahead of us if we don't have the use of anaesthetics at our disposal. Many simple operations will be impossible because of the complications.

Being the survivor group we quickly and clearly need to realize how important modern operation techniques are for saving lives, and place requirements for them high on our list of priorities, an important part of which will deal with anaesthetics and the knowledge of reanimation techniques. Without these we cannot perform operations. Once again I am calling on someone: who can take care of this, so that—with limited means—we can reproduce the necessary life-saving products?

Medicines

These are no problem at all. A healthy fruit and vegetable diet doesn't require medicines. You will not become sick; at worst you might contract the flu or bronchitis. Of course, in the tropics, malaria would be possible. These and other illnesses can be cured easily through fasting. For instance, when you have the flu or pneumonia, you have to fast until the fever drops below 36.5 °C. With malaria, you need to fast

Figure 34.

for two weeks. There are only three problems we will probably encounter:

• How to make a proper clinical thermometer? The old mercury thermometers appear to be of decisive importance!

• How to make antibodies against the poison of scorpions and snakes? This problem I pass on to people who want to take care of it.

• How to kill a parasite that lives in still water? In several subtropical and tropical countries, a parasite lives in creeks and pools where the water doesn't run. You can only kill this parasite with medicines. Who will take care of gathering the necessary knowledge for making this product? This is really very important! In the past many Egyptians died at young age, because they were contaminated by this parasite.

This knowledge about medicines will probably be sufficient.

By following a fruit and vegetable diet we will unburden ourselves of about thirty thousand illnesses. Only fractures or physical injuries caused by accidents will remain, but these can be cured by operations, without the use of antibiotics or other products.

Medical Instruments

A number of medical instruments are vital in monitoring the health of the population, and providing physical care. Here are some thoughts:

•Mercury Thermometers: As mentioned above, only mercury thermometers are able to quickly and accurately measure your body temperature. After the polar reversal, all other battery-powered clinical thermometers will no longer work, or will lose their power rapidly. Since January 2003, mercury thermometers are prohibited in The Netherlands. Other countries will probably follow this example. For this reason I bought dozens. I urge everybody who wants to survive also to buy some. They form an essential part in our arsenal. They are absolutely life saving and necessary! Without thermometers it will be difficult to say whether your temperature remains below 36.5 °C for a whole day—the benchmark for determining when you can stop fasting when ill. Above that temperature, you are not allowed to stop fasting, because then the fever will come back. Clinical thermometers can also be used to determine a woman's ovulation cycles.

• X-ray Machines: These machines are a basic in modern medicine. Given the total destruction of all electric circuits and electronic equipment, there is no use bringing along such a machine. What we can do is take along a simple blueprint to include in our library, which would enable us to rebuild one.

• Sphygmometers and Stethoscopes: These should absolutely be taken along. The first measures blood pressure, and the second allows physicians to listen to the heartbeat, and possibly detect any aberrations. Both instruments are simple to use, and, for operations they are undoubtedly necessary. Having these basic tools will prevent our medical knowledge from reaching rock bottom. Scalpels, tongs, cutters, scissors and the like have to be on our list too, as well as needles, thread, bandages and band-aids.

This is only a cursory list of rudimentary requirements, but by 2012 we surely will have a more comprehensive, adjusted list of essential requirements.

PART IV

POSSIBLE SURVIVAL PLACES

17.
THE BEHAVIOR OF THE TIDAL WAVE

If you want to survive the forthcoming catastrophe using a boat, you, of course would want to know where it would be possible for you to land. This will be a problem. You know from the first chapters that after the polar reversal the earth will start rotating in the opposite direction. It is only logical that the oceans will have to follow this pattern. At present the earth rotates from West to East. In other words, you see the planet rotate from America to Africa. After the catastrophe this rotation reverses and the planet will start turning from east to west, or from Africa to America! Ultimately, would this make much of a difference, causing you to make big changes in your sailing direction?

A Dead-end Starting Point

I pondered this question for quite some time, and finally concluded that the change in the direction of the earth's rotation won't make much difference with regard to the direction. It can only lead to backward and forward motions. However, due to the Law of Inertia the oceans can reach incredible heights, which can lead to gigantic inundations, or huge waves. Let me explain this. Should you for instance be sailing to America and the wind drops, your boat remains stationary. When the earth starts turning the other way you have to deal first with a moment of deceleration: for a while you will be swept along with the original rotational direction of the earth (in the direction of Africa). Next, due to the reversed direction of the earth, and the influence the reversal of the ocean currents will exert, you will experience an impulsive moment of movement towards the new direction, straight to America. Once the initial speed has diminished, you will become stationary again. The end result of this travelling up and down on the waves should be more or less neutral. Note that, for the sake of convenience, I do not take into account the change of wind direction and the change of current patterns in the oceans.

The Influence of the Earth's Crust Shift

While in this frame of mind I went to search for other influences and started to intently study my data again. The reversal of the earth's rotation causes a catastrophic earth crust shift: the continents move thousands of kilometres. What effect would this have on ocean travel, I wondered? What influence could a shift of thirty degrees in the earth crust have on the world

seas? My thoughts were flying. I tried to imagine the whole. I saw masses of land moving up very quickly and decided that this action would have an enormous impact on the direction you would end up travelling in. It had to be like that. But could I find proof for this?

Again I went through the scheme of the previous earth crust shift. America lay partially under the South Pole at that time (the present North Pole) and it shifted to lower latitudes. Due to the moment of deceleration massive, tsunami-like waves must have crashed down over this continent that would already have been swamped due to the reversed rotation of the whole earth. At the same time the shifting earth crust would have pushed the water in the direction of the present South Pole. Therefore several antipodal forces are affecting each other. The whole thing became a terribly complicated picture at this point, because I actually lost the North with it. For months I thought about this and didn't get one step further: the previously mentioned scenario is just too complicated to allow for a qualified statement. It is impossible to determine the patterns that the currents will take without a computer model. Perchance a reader can solve this problem? Anyway, there still remains a lot to learn from the catastrophe of 9792 BC.

Tidal Wave: the Opposite of the Previous Time?

From Albert Slosman's book *Le Grand Cataclysme* (which I have used extensively throughout my research) we know that the Atlanteans who left their father country Aha-Men-Ptah, which is presently covered by the South Pole, landed with their unsinkable boats (called 'Mandjits') on the new coasts of Morocco. We know this pattern, although for the time being I cannot explain this theoretically. Only the question remains of what will happen to the currents in 2012. Considering my previous findings, America will again be covered by ice at the new South Pole. In 2012, continuing this logical line of reasoning, the movement of the water will have to be in the opposite direction from the shift it made the previous time: from the present North Pole to the South Pole.

I am counting on your using this knowledge that I have given you. It is not hard to interpret. Think logically and you will come to the following simple conclusions:

• Should you be located with your ship offshore from Brazil or South Africa, there is a big chance you will land on the newly formed North Pole (which is, at present, the South Pole). Part of the land will become ice free, but the ice masses will not have melted yet. You will have to contend with freezing cold, rigorous

circumstances and little food. Not such a pretty prospect, unless you would like to become a walrus.

• Should you be sailing somewhere between Canada and Europe, there is a good chance that you will land on the coasts of Africa or South America. Of course there is no certainty about this. I can only give you the direction I anticipate that the currents will take. From there, everybody will have to decide for themselves which starting points will give them the best chances. If you believe the scenario will be a reversed scheme of the previous catastrophe, a starting point on the English coast would lead you to the South American coast. I cannot swear it will happen in this way, however, my intuition is quite strong and I hope it can help you to endure the turbulent waters.

In the distant future, the reports of the coming tidal wave disaster will sound very similar to how we are presently describing the previous one. In his book *The Lost Ship of Noah: In Search of the Ark at Ararat*, Charles Berlitz relates that Chinese annals say that, in a very vague prehistory, China was tormented by an immeasurable catastrophe: "The world was on fire and the waters rose with their complete stretch to a big height and threatened the skies with their floods." An immeasurable wave "that reached the sky" was thrown onto the mainland and washed over the mountains and fell apart in the middle of the Chinese Empire. The mountain valleys held the water and the land remained inundated for decades. At the end of 2012 an equal catastrophe will not only bring ruin upon China, but on the whole world. It is up to us to prepare ourselves for this, and use the knowledge in this chapter to our advantage.

18.
UNSINKABLE BOATS

If you choose to endure the forthcoming tidal waves and hurricanes at sea, you absolutely need to have an unsinkable boat at your disposal. Note well: the boat should not only not sink, it should not capsize either. In my first book, *The Orion Prophecy*, I planned to defeat the waves with a large ship. In the meantime I have had more thoughts on the subject and have consulted several people with knowledge of watercraft. They all said the same thing: chances are that such a ship will become uncontrollable, break up and sink. In other words, my plan was not waterproof!

Should your boat start seriously leaking you will be dire straits. So I relegated this idea to history. How was I to deal with this since I did not have another plan? Where did I have to search? Was there indeed a solution? Undoubtedly there had to be. The inhabitants of Aha-Men-Ptah escaped by means of their Mandjits, which were small unsinkable boats that they launched in a huge flotilla. Should I have to organize something similar?

At first I had my doubts. I do not know much about sailing and the documentaries on the subject did not convince me that this was a good method of survival. Television airs regular programs of sailing contests in which yachts capsize and the crew gets imprisoned inside the cabin. The unfortunate crew cannot free themselves because the water rushes in and the boat sinks. We can follow the coverage of the plight of the unfortunates for several days. During those days they remain locked up before they are rescued. This assumes that the yacht can be located. At the end of 2012, after the reversal of the poles, this would be a hopeless situation that must be avoided.

We will be witness to global destruction, and chances are pretty high that there won't be anyone available to rescue you from awkward situations. For that reason I started to ask some questions, for example: how can you possibly prevent such a situation? Do unsinkable boats exist? Who knows more about this?

At the particular moment when I was asking these questions, an article appeared in one of the Dutch-language newspapers of Belgium about a shipbuilding company in the town of Malle:

Unsinkable Motor Yacht from Malle
Do you like sailing? Then you know undoubtedly that here in Flanders magnificent motor yachts are built. It is

known far beyond our borders that they are unsinkable. At present the company that builds them in Malle wants to go a step further. They are going to develop an unsinkable motor yacht with an approximate length of ten meters. If they succeed they can also start building bigger sailing ships. The Flemish Authority supports this. It believes in a worldwide prevailing quality.

I read the article and knew I had found my starting point. I made enquiries and found the name of the company: ETAP. On Friday the 25th of October 2002 I jumped into my car and drove out to pay them a visit, and—bull's eye! I explained my problem extensively to the sales manager Jan van Speybroeck. Our conversation was as follows:

Me: "Can the unsinkable boats you are constructing endure waves forty meters heigh without sinking? In the film *The Perfect Storm* they were that high. It concerned the most destructive storm of the last hundred years with wind speeds of more than two hundred kilometers per hour. I ask you this because I am expecting worse than that."

JvS: "Unconditionally my answer is yes. Look, all our boats are double-walled and covered with a layer of plastic foam. Even if the wall cracks and the yacht inundates it will stay floating."

Me: "Can the yacht capsize and remain floating as you can sometimes see in a documentary on sailing contests?"

JvS: "No. Our keel has been made heavier. In case the yacht capsizes, it will always roll back into its upright position. The capsize situations you see in the sailing contests will not occur with our ships."

Me: "That's good news. It worried me, because in those programs you see the sailor captured sometimes for days, because he cannot escape his ship.'

JvS: "You don't have to worry about that. Yachts for sailing contests have a different keel and are built in order to sail as fast as possible. Therefore they can easily capsize. I can formally assure you that our boats cannot."

Me: "Do you expect other problems?"

JvS: "Through the rolling of the waves, the mast will surely break and after the calming down of the gale, the ship will be uncontrollable."

Me: "Do you have a solution for that?"

JvS: "Yes. There is the possibility of installing a jury mast. With the help of the remnants of the mast and other parts of the boat, you can install a small post on which a sail can be placed.

It's less efficient, but many boats have travelled long distances in that state."

Me: "In case that doesn't work, is there another possibility?"

JvS: "The diesel engine! You can start it in order to sail to your destination."

Me: "Dear me, that can be a problem, because due to the polar reversal the electric control of the motor will be damaged. So we cannot restart it!"

JvS: "I considered that too. If that is indeed the case, the situation becomes complex."

Me: "And do you see a possibility to solve this problem?"

JvS: "No, not now. Maybe the only thing to do would be to have a small emergency engine aboard which you can start manually."

Me: "Would you be able to start a big motor with that?"

JvS: "If you bring along the necessary accessories you would."

The above conversation reveals some of the problems that would confront anyone in an ETAP, which in short are:

• Broken mast after the calming down of the tsunamis.
• Uncontrollability because the diesel motor cannot be started.

People who choose this option need to take this into account. All creative solutions are welcome!

Some months after this conversation I contacted Jan van Speybroeck again. In the meantime, he had read a large portion of the English version of my first book, *The Orion Prophecy*. He was deeply impressed by the immensity of the cataclysm. When I asked him if he wanted to survive, his answer strangely enough was negative.

"Look," he said, "everything will be destroyed. Nothing will be left, no food, no comfort, no electricity, no cars, etc. In short: nothing. I do not want to live under such circumstances. I would rather choose a short time of pain, and I will quietly wait for it at home."

He is not alone in his opinion. After reading my descriptions of the cataclysm there aren't many people who wish to expend the effort to survive. It is for this reason that I have written this book. It is my last attempt to rally enough "survivors." Some sailors I've been in contact with show a bit more of a survivor's instinct. They sort of fancy the idea of fighting against the waves and hurricanes—just for the experience of it. One of them was

even quite laconic and said, "Sure I want to experience this. It will be many times more spectacular than an outing to Disneyland!"

If more people would think like that I would have a large survivor team by now, but unfortunately, this is not the case. This sailor remains a rare exception. I would urgently like to find more like him.

Unsinkable Boats Generate Substantial Safety

In my opinion these boats will give people the greatest chance for surviving the cataclysm. Besides these yachts, there is just one other possibility, and that is to move up into the high mountains of some well-chosen areas. However, this option contains many

Figure 35.
Unsinkable boats could make a valuable contribution to the survival of our civilization, just as they did 12,000 years ago. In the previous cataclysm they carried along a major selection from their library. Through this it became possible to help sciences flourish again. In 2012 we will have to have organized something similar. Our advantage will be that the ETAP yachts are far more enduring that the Mandjits of the Atlanteans.

more risks and insecurities. You may be consumed by volcanic gasses or swallowed by fissures in splitting mountains, or it's possible you might be washed away by the global tidal wave. It is up to you to decide where you will be.

I would like to see an important group of people choose to try the yachts. Personally I become seasick very quickly. Just a little a bit of current during the crossing from France to England has me running to the railing, even on a big ship. My sole comfort would be that in 2012 almost everybody else will be seasick during the

tidal waves and tornados as well. However, I don't think I will be in a boat on the crucial date. Despite all of the negative aspects I have mentioned, I think I will hide in a mountain chain.

Anyone considering escape by boat needs to take into account that the ETAP yachts are small, and that is a disadvantage. You cannot bring much food, survival material, or many books. Each ship can only carry the most important things, so the literature will have to be divided amongst them. The boats belonging to a group need to stay close to each other, however, in most cases this will be next to impossible. After the chaos has dissolved, the survivors will have to summon all their force to reach the place of gathering, which itself may prove hard to find in a greatly changed world. But it will be imperative to meet, so that all the information that has been spared can be gathered in one place and a mini-library can be constructed as quickly as possible.

Remember, at this moment ETAP is the only producer in the world of comfortable, unsinkable yachts. Should my books finally succeed in inspiring the masses to take action, and if you have hesitated too long, you will never be able to get such a yacht. Timing will be an issue even if you want to rent a boat, once you are convinced of the necessity.

A License for Hiring a Boat

Yachts can be rented. To mention some places: the Azure Coast, South Brittany, Corfu, Gouvia and Mallorca. In 2012 there will surely be more places. In order to rent a boat there is, however, one problem: you need to have a boater's license which means that you have to take an instruction course on boating. Without a diploma you cannot rent a boat. Therefore start taking lessons well beforehand, or have someone with you who does have a license!

ETAP YACHTING N.V.
TEL: +32 (0) 3 3124461
FAX: +32 (0) 3 3124466
Internet: http://www.etapyachting.com

19.
THE PROBLEM OF DETERMINING LOCATION

Today, the whole world uses GPS (Global Positioning System). With GPS, you can determine your exact location on earth with near pinpoint accuracy. People rely on GPS technology every day, even if they aren't aware of it. However, there are people whose jobs depend on it—ask any modern Navigation Officer or Sea Captain if he can calculate his position using traditional equipment; he most probably cannot. GPS is an important tool of our modern navigational system, used in applications that range from guiding missiles to giving driving directions. The downside to technology is that the smarter we make our machines, the less we can figure out on our own.

Before GPS, a sextant, maps and charts were used to determine latitude. A sextant is used to measure the angle of a heavenly body, (i.e. the sun or the north star) in reference to the horizon. You can then convert this angle, using a chart from a Nautical Almanac, into your degree of latitude in relation to the poles and the equator. However, latitude is only half of the location equation; the other half is longitude.

To determine longitude, you need to know the local time in relation to Greenwich Mean Time (GMT). This requires a chronometer; another word for an extremely accurate clock that will not deviate during long travels, nor will it be affected by climactic extremes. Once you have calculated both your latitude and longitude, you will then be able to locate your position on a map with reasonable accuracy. By now, though, I am sure you have gathered that only a few sailors in the world know how to navigate using these techniques. After the catastrophe, when modern technology no longer functions, this lack of training will lead, undoubtedly, to tragedies.

From my first book, you know that solar flares and electromagnetic particles being thrown off by the sun will destroy all man-made satellites orbiting the earth. In addition, the polar reversal will generate enormous induction currents, which will affect all electronic equipment no matter where it is, causing it to become useless. This means that even before the earth's crust starts shifting, the complete GPS system will be destroyed, ergo, no Navigation Officer or Captain on any oceangoing vessel will know their position anymore, unless they have the old navigational equipment available. However, even if they do have

the equipment, all our knowledge about degrees of longitude and latitude will temporarily be useless! Let me explain this.

The Shifting of the Earth's Crust
and the New Degree of Latitude

After the polar reversal, the earth will start to rotate in the opposite direction causing an impressive shift in the earth's crust. The previous time this reversal occurred, the earth's crust moved about three thousand kilometers in some places. A huge distance! This goes to illustrate how forcefully the continents were moved. For instance, New York will be situated thousands of kilometers to the north of its present location.

In 2012, when the Earth begins to rotate in the opposite direction, landmasses will be shifted back toward their previous locations. But how far will they move? Unfortunately, the answer to that question is: "Nobody knows." After the polar reversal it will be impossible to calculate either the degree of longitude or the degree of latitude! This is the point at which we encounter huge new problems, one of which is: where will the new harbors be situated? You are suddenly lost, floating in the middle of the ocean and the only point of recognition—your degree of latitude—is no longer where it used to be. Despite all your knowledge and preparations, you are back to square one, in the Stone Age. You have no other points of comparison. Will you be able to deal with this?

Figure 36.
When you leave from the Cape Verde Islands and you keep following the same degree of latitude you will automatically reach the Dominican Republic. This is a well-known shipping route from ancient times and is still used by thousands of sailors today.

Today, when you keep following a certain degree of latitude you automatically reach your destination. For instance, you can start your journey from the Cape Verde Islands, sailing in the direction of America. As you sail along, continuing to follow the same degree of latitude you started on, you will automatically reach the Dominican Republic; just like Columbus did when sailing his trade route—a piece of cake. Any beginner can do this.

After the catastrophe, however, the situation will be completely different. The Dominican Republic will no longer be situated on the same degree of latitude, which may have shifted by thirty

degrees or more! To make matters worse, that is not all that will change!

This is truly a cosmic phenomenon of catastrophic proportions! Because the inside of the earth will change polarity, you will not be able to find any celestial landmarks in the same position in the sky anymore! In fact, the Sun will rise in the west. Therefore, you will not be able to determine your degree of latitude! This problem can be solved, but it will take some time and require you to perform several calculations first. Eventually you will know how to use new stellar landmarks (like the southern star) to help you determine where you are. I will come back to this later. First I have to explain another phenomenon.

The Degree of Longitude has also Moved Drastically

At the moment that the inside of the earth starts rotating in the opposite direction, the lithosphere will lose its firm anchor with the nucleus. Due to the inertness of the rocky casing of our planet, the lithosphere will keep floating for a while. Greenwich, England will no longer lie at the zero meridian. This provides you with another problem: how do you calculate your degree of longitude? You can no longer use Greenwich as a point of comparison, because it is now located in a completely different position; in a completely different time zone!

Figure 37.
As the crust around the earth shifts, some landmasses will undergo drastic changes. The Cape Verde Islands will probably shift only a few degrees from their original degree of latitude, but South America and North America could move up to thirty degrees or more! Should you follow the same degree of latitude, as earlier mentioned, you will not reach the Dominican Republic— you will most likely end up somewhere near the Amazon River in Brazil!

Because you do not know where you are, it will be impossible for you to determine your distance from the coastline. For example, should you be following the route of the Cape Verde Islands to the Dominican Republic, you surely would want to know how far off you are. If you don't know where landmasses are, and you keep on sailing at night or through a fog, your ship may collide with rocky cliffs and sink! Fortunately, if you have done your work properly, you have a relatively unsinkable boat. Although it will keep floating, it will most likely end up in a terrible state. Not a pretty sight. In any event, it would be a good idea to sail slowly in order to prevent a shipwreck.

Impossibility of Determining Position

Will it be possible to avoid all this confusion by making some assumptions? Can you involve the magnitude of the shift in the earth's crust in your calculations? Events should occur in approximately the same order as they did in the previous cataclysm. Perhaps, with the aid of some scant data you might be able to hazard a guess as to your position in reference to your new surroundings.

However, this pattern of thought doesn't really provide any clues. It remains essentially guesswork. Putting it mildly, you might easily make a miscalculation of a thousand kilometers or more; too much of a difference to say anything meaningful about your actual position. Columbus was in a much better situation; with the help of old maps, he knew what the commonly known world looked like, while, at the end of 2012, in the middle of an ocean of a completely changed world, we will not! For that reason we can ask ourselves: is there indeed a solution for this problem? To tell you the truth, my answer is a definite no.

The problem of place determination can only be solved when you have reached land. Look at your old maps to see if you can determine where you have come ashore, observing landmarks in your surroundings within a circumference of 200 kilometers. It may be possible to determine how far the landmasses have shifted along the degree of longitude if there are any landmarks left to compare your map with. Everything, most likely, has shifted. At present, the zero line of longitude passes from Greenwich to Ghana. If we look at Greenwich, the zero line would not pass through Ghana anymore, but presumably Nigeria. Once you have calculated the new zero degree of longitude, and put it together with a new stellar landmark for determining latitude, such as the southern star, you will again be able to find your route at sea.

Mathematical Projections for a New Map

Before starting to sail the seas and oceans, it is advisable to first calculate and draw a map of the new earth. This is not that simple. The earth is round and only a globe can show the earth in its correct proportions. Everybody needs to have at least two globes aboard. With the help of calculations you have already made for degrees of latitude, you can reasonably calculate the shift of the landmasses.

As best you can, determine where the new poles of the earth are located by observing the sky (more on this below). Mark these on the globe, then disconnect the globe from its stand. At the location of the new poles, make an incision in the globe so that the globe can be put back on its stand in its new orientation. This

will give a somewhat clearer vision of how the earth has changed and perhaps enable a better guess as to where you are. Although substantial changes will have occurred, there is a good chance the large landmasses are somewhat intact.

When making a new map, copying new cartographic data on a flat surface will definitely result in distortions. This procedure can only be done properly while the information is being projected. Today, the more commonly known wall maps are Mercator projection maps. All projections require complex mathematical calculations, among them the degree of latitude expansion. This is not easy at all and demands a lot of time.

In order to prevent wasting a lot of valuable time, we could anticipate some of the changes we will encounter and produce maps ahead of time to reflect those possibilities. Three different versions of these maps should be enough. One should show a shift of twenty degrees for America and South America, the second a shift of thirty degrees and the third of forty degrees. With these maps on hand, it should be much easier to navigate the seas. However, in case we have to do without them, a globe will be of vital importance to guide us through the turbulent waters.

Calculating Degrees of Latitude

Some years ago a sailor, Crichton E.M. Miller, discovered a method that was used in ancient times to determine latitude. In his book, *The Golden Thread of Time,* he explains accurately what this device was and how it was used.

The degree of latitude is defined as the angular distance between a heavenly body and the equator. A very simple measurement, but when you want to make this measurement as accurate as possible, you need to have some mathematical knowledge. Miller asked himself how navigators were able to do this historically, and, after a long search, he found a very simple measuring tool. The instrument he rediscovered proves that the early sailors had excellent skills in mathematics, better than presumed. In order to use this antiquated tool, you need to know a lot about the movement of the earth, the cosmos, geometry, astronomy, land survey, and of course, mathematics. The secrets of this practical instrument of measurement reflect the fundamentals of an earlier civilization. With measurements from this instrument, sailors were able to determine their position on the oceans and on world maps. The result was a global maritime civilization.

Crichton E.M. Miller used a simple ruler, one meter long, to recreate this instrument. He positioned the ruler as the hypotenuse of a right triangle (see Figure 38), opposite the 90 degree angle. On the ruler he marked every other centimeter to represent one degree.

After some time, Miller improved his design by adding an exponential scale. An exponential scale is constructed by projecting the degrees of a circle on a straight ruler as shown in Figure 38. When you look at the scale from left to right, the units broaden as they move further away from the center; the greatest margins of error occur over 60 degrees and under 30 degrees. In navigation one degree is equal to sixty nautical miles and one minute to one nautical mile.

With this instrument the old navigators had only to pass the north-south axis, some tens of kilometers on a graduated ruler of about a meter long, in order to determine the circumference of the earth. This measuring tool was also used for determining the angle of the polar star (i.e., the North Star) to the horizon when calculating latitude. They would then, by comparing this with their previous measurements, find the difference and, after 111 kilometers they would measure a difference of one degree. From there, they only had to multiply the physical distance by 360 in order to know the earth's circumference.

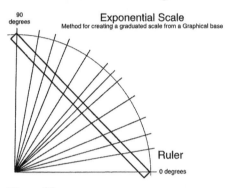

Figure 38.
This is a simple construction of a degree of latitude indicator with which you can accurately determine the degree of latitude up to about ten kilometers.

The Sign of the Dragon and the Determination of the Degree of Latitude

If you have a look at the whole cycle of the zodiac, which lasts 25,920 years, you will see how it stands in relation to the polar star. During the cycle, the polar star makes a perfect circle in the sky. Visually this can be depicted very easily. The polar star makes a circle around the constellation Draco. When you study this in depth, you can connect the placement of the polar star with a specific date. Therefore you can calculate the place of the polar star with its coordinating date and vice versa.

The Polar Star is in Another Position

With the passing of the ages, the polar star and the southern star shift very slowly. In fact, this is such a slow process that these stars seem to have quite a stable position in the sky; until, of course, they suddenly change their relative position to a

viewer from earth, due to a polar shift. Native peoples around the globe have legends telling about the shift of the polar star. The Laplanders, or Samisk people, who traverse the plains of Northern Scandinavia and Russia, tell this version: "On the last day, when Arcturus will shoot down the Northern Nail with his bow, the skies will come down in a torrent and crush the earth, setting everything on fire."

After the magnetic field of the earth has been reversed, the inner rotation of the earth changes, and therefore, the precession will also change. In other words, the earth will arrive in a new zodiacal age, which results in a new position for the polar star. Scientists of old knew this would occur. They depicted the constellation Draco as a cobra with a swollen neck, sticking out its head in the sky. In Hindu mythology, we read that Takashaka, the Naga King, caused a lot of damage with the burning, red hot poison coming from his nostrils, just like a dragon. It is a manifestation of the destructive powers that accompany a polar shift.

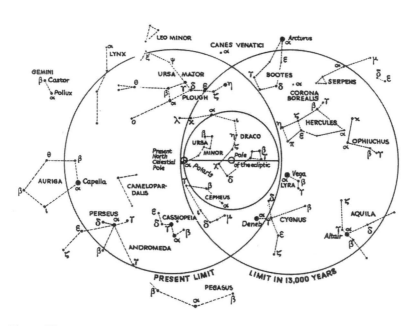

Figure 39.
The new position of the South Pole; note that Polaris, currently known as the North Star will now be associated with the South Pole. Circles of sky and earth. The circuit of the (present!) North Pole, functioning with the passing of the different ages.

Together with the shifting of the ages, the polar star's position in the sky also shifts. In a time period of 25,920 years, the polar star actually makes a circle around the constellation Draco (the

smallest circle in the middle of Figure 39). This is a conclusion of the utmost importance, because the reversal of the pole's magnetic field can cause a sudden change of the star's position as seen from the earth. By careful study of the constellation Draco, we may be able to determine where the new South Pole (actual North Pole!) is. The pole can be at any place on the circle. Once we have figured out where the Pole is, we will know in which new zodiacal age we have landed.

Both the polar star and the southern star take 25,920 years to make a complete circle in the sky. The position of the southern star is much more difficult to determine than the polar star because there are fewer clear stars nearby. The inner circle in Figure 40 shows the place where we need to search for the new polar star after the change of the position of the poles. Once we know new the position of the polar star, we will also know the position of the new southern star and vice versa. As with the southern star, we will be able to determine again our degree of latitude (number of degrees of the northern latitude).

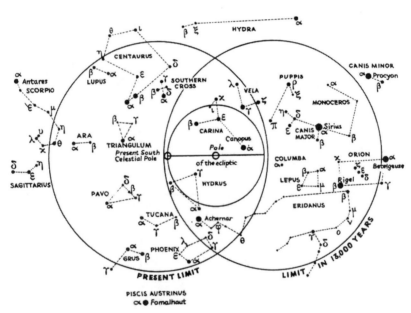

Figure 40.
The new position of the North Pole. Note that the Southern Cross and Canopus, currently associated with the South Pole will now surround the North Pole.

The Present Southern Star is
More Important than the Polar Star

Today, there are more people living in the Northern Hemisphere than in the Southern, which is logical. When you have a look at a

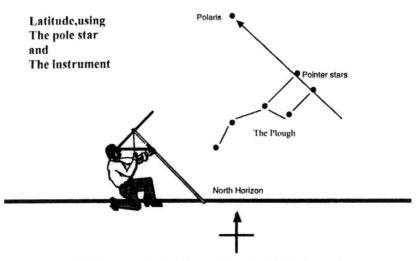

**Latitude,using
The pole star
and
The instrument**

Polaris

Pointer stars

The Plough

North Horizon

To find latitude at night,clear skies permitting,one must first find the pole star.
The north pole star is currently Polaris and is found by first locating the constellation
known as the Plough or Big Dipper.
The Plough constantly revolves around Polaris in an anti clockwise direction,when
viewed in northern latitudes.
The two stars at the outer edge of the big dipper are known as the pointer stars.
By following the pointer stars as in the drawing ,the next star that is seen in line
with the pointer stars,is Polaris.
By pointing the instrument at Polaris and reading off the degrees from the scale
one is able to find ones latitude directly.This is because when pointing the cross bar
at the pole star the view is a parallax due to the great distance of the body being
observed.
The plumb line will always point to the earths centre due to gravitational pull and
consequently an angle between the star and the earths centre can be observed.
The nature of the instrument being in the shape of a cross and the scale being
mounted on the opposite side allows the opposite angle to that of the actual angle
between star and the earths centre to be measured.The smaller resulting angle is
equivalent to the 90^ degrees of latitude from the equator to the pole.
As the observer moves toward the pole ,following the curvature of the earth,the
instrument will tilt further back increasing the angle.By moving toward the equator
the angle will decrease.
Therefore the angle can be measured directly from the scale and a latitudinal
position obtained

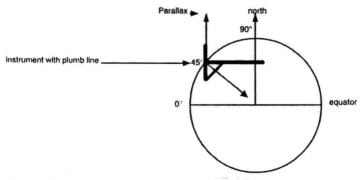

Parallax → north

90^

instrument with plumb line —— 45°

0° equator

Figure 41.
In this simple manner, the degree of latitude can be determined.

world map you will see that there are more habitable landmasses in the north than in the south. In the north you find, for instance, big countries like China, Russia, India and Canada. In the south, there are more oceans. But, will this remain the case?

After the polar shift at the end of 2012, North America will shift thousands of kilometers and will be covered, for the most part, with ice. The Antarctic, early Atlantis, will partially reappear (ice free) on the map. It is possible that India and China may shift as far as the present Southern Hemisphere, while Africa would shift a little farther north. According to this scenario the present southern star will be the most important marker in the determination of position. Should we choose the newly hospitable Antarctic to be the starting point for our new civilization, life would be reminiscent of how it was twelve thousand years ago, when the Atlanteans were sailing the world seas.

Conclusions

• Our degree of latitude can only be determined with the help of a measurement that relates to an apparently static heavenly body such as the polar and southern stars. Several determinations will help us to calculate the shift in the earth's crust and to produce a new world map. In this way we will be able to see where—when the nuclear winter has withdrawn—the most comfortable living area will arise.

• The Antarctic will have become a milder climate, and the landmasses in our present day Southern Hemisphere will be much more habitable. After the water level recedes, many landmasses will be regained in South America, Australia and on the axis of Thailand-Malaysia. In order to sail the oceans and seas, the present southern star (future polar star) will be of vital importance.

20.
WHERE DO WE ASSEMBLE AFTER THE CONTINENTAL SHIFT?

The question of where we will gather after the cataclysm presents us with a huge problem. Do you know how far the continents will shift? Of course not! Unfortunately, I must admit that I do not know the answer to this question, either. Nobody can predict where the continents will ultimately end up, which, sadly, brings us back to square one. Without this crucial knowledge we will not know which landmasses will end up having zones with a climate that will be able to sustain human life.

Today the earth is turning counter-clockwise. In *Timaeus,* Plato described the shifting in the earth's crust as follows: "The globe makes all kinds of movements, forwards and backwards and then downward, wandering in all directions." This uncommon portrayal of the behavior of the earth's surface perfectly describes a polar reversal. At the end of 2012, once the polar reversal has taken place, the earth will begin rotating clockwise. At this time the earth's crust will have shifted, pushing North America in the direction of the pole. It will seem as if the earth is moving itself in all directions: from left to right and from below to above and vice versa. There are plenty of directions the continents can move in! But where will they end up? Not a soul can tell you this. We can only speculate.

Fourteen thousand years ago the scientists of Aha-Men-Ptah calculated that their whole continent would be destroyed completely, come 9792 BC. With great certainty, they knew how the earth would start behaving. It is highly probable that they based their predictions on the polar shift of 29,808 BC. They must have speculated that the same type of shift would take place in 9792, but in reverse, leading them to the conclusion that the continents would drift back in the opposite direction. After many calculations they also figured out that their entire continent would become the South Pole and would therefore freeze over and become uninhabitable. For that reason they decided to lay plans for a mass exodus to take place on that fateful day. As you have read in my previous book, many were able to escape despite the multitude of difficulties they encountered, among them, a civil war.

Escape and Overpopulation
Because the Atlanteans had hundreds of years of preparation

to survive the last cataclysm, there are billions, instead of tens of millions, of people living in the world today. Taking this into consideration, we encounter an unfortunate moral and ecological question: would it be better that a great many or that only a vital few should survive? For the time being, this question need not be answered. Few know about the forthcoming catastrophe. Even fewer are convinced of taking measures to ensure *anyone's* survival. Perhaps only a few thousand will survive, a minute fraction of the percentage that survived twelve thousand years ago.

The reasons we will suffer such devastation are simple: lack of preparation and planning. The last time a polar shift occurred, the Atlanteans were prepared. They had built enough unsinkable boats to carry everyone off the continent. They had also devised an evacuation plan, which they practiced in preparation for the coming event. Presently, there are few ships available to the public that will withstand the devastation of a polar reversal. There is no plan for escape.

A Catastrophic Shift?

In the event a polar shift of greater magnitude than anticipated should occur, all our present plans may be futile; that is to say, in a case such as one wherein the present polar landmasses would shift all the way to the equator in a very short period of time. Such a drastic shift would have disastrous effects on planetary life.

In the July 25th 1997 issue of *Science* magazine, there is published proof that such a monumental polar shift can occur. The facts were gathered by researchers of the California Institute of Technology and relate to a period of 535 million years ago. Geologists at the California Institute discovered "that a change of 90 degrees had occurred in the turning direction of the earth's axis." Landmasses that were previously situated at the North and South Poles slid around the earth and stopped on the equator. Two opposite points that were previously situated on the equator became the new poles. The researchers compiled the evidence found at the base of stones deposited during and after this interval of time, and discovered geophysical proof that all the big continents were subject to an impulse movement, a rapid, catastrophic rotation of great proportions involving the whole earth's crust.

Should we experience a catastrophe of the same magnitude as mentioned above, our numbers will drastically decrease. Few habitable areas will be left on earth for some time due to the fact that the land under the South Pole is frozen and buried beneath enormous amounts of ice. When newly situated at the equator, the continent will require time to melt before anyone will be able

to live there. Currently habitable areas will become colder and less able to sustain life.

Of course, this is the worst of the worst-case scenarios that can be imagined. According to the facts, a shift this drastic hasn't occurred in 535 million years. However, this being said, the chances are that this could be when it happens again. A slight polar shift is disastrous enough; a ninety-degree polar shift would be a serious nightmare!

Anyway, I do not want to obsess on the worst that can happen. My theory rests on a shift of thirty, maybe forty degrees; a bit farther than the previous shift, but I'm taking into account that the periods between solar flare-ups right now are a bit farther apart than they were before the previous polar shift. The longer the sun contains its energy, the more power there will be to unleash when it comes time to release it. To me this seems a reasonable basic assumption. I therefore expect a somewhat larger shift in the earth's surface structure, but in the opposite direction than what took place in 9792 BC. Let's hope I am not mistaken in believing in a conservative estimate.

Figure 42.
When the polar shift takes place, sending the earth rotating in the opposite direction, there are some important locations in the world that will remain tropical after the catastrophe. These are: (1) the Central Andes; (2) the Highlands of Ethiopia; (3) the Highlands of Thailand, and (4) the Highlands of Northeast Borneo. These zones can become important assembly points where civilization can be restarted.

This brings us back to locating possible places that may provide sufficient space for the survival of humans. The earth's crust is fairly rigid. After a polar shift, the shape of the continental landmasses should not deviate much from their pre-catastrophic forms. Locally, considerable differences can occur, but the whole should remain more or less the same; however, some parts will rise above sea level, while others will sink below it.

The sliding around of the lithosphere is what causes us the greatest consternation. When the crust loses its anchor, the continents will move around on the surface of the earth; this will restrict the number of available choices for habitation. If we do some homework, though, we may be able to map out some scenarios in advance, based on a shift of thirty to forty degrees for North America. The reality after the catastrophe, optimistically, should not differ much from at least one of our models. From

these models, we will be able to pick out several starting points for a new civilization. Pessimistically, the shift can turn out very different from our predictions, so we need to keep our options as wide open as possible. Should one starting place fail to be suitable, we need to have a few backup locations chosen to take its place.

The assembly places we are choosing are important to people who want to survive the tidal wave with the help of unsinkable boats. After the catastrophe the people in these boats will be separated from others in their boats, large distances of wide-open ocean between them. Groups of survivors will be completely alone, adrift on the open sea. Without a proper plan, chances for continued survival grow slim; the odds of restarting a new civilization without those people diminish. The bigger the group, the better are our chances for survival. By establishing possible meeting places beforehand, we are offering everybody the ability to reach a new place they can call home where they will meet with others who have the same goal in mind. In order to create this reality, we need to take the following into account:

Meeting places need to be prioritized and restricted to a certain number—a maximum of five assembly places per model. In order for us to survive the "nuclear winter," designated meeting places have to be situated as close to the equator as possible.

According to my calculations, our choices would have to be situated in the following areas:

- South America (somewhere at the height of Lake Titicaca)
- Africa (Drakensberg, see Chapter 22)
- Asia (India, Thailand or Borneo)

We will be posting our choices of preferred meeting places on our website (see Appendix) before the fatal date.

21.
THE RISING AND SINKING
OF MOUNTAINS

If you have decided on moving into the mountains in order to survive this catastrophe, it is of the utmost importance that you choose a mountain that will remain stable. If the mountain should sink into the ocean, the water, with its treacherous and unpredictable currents, will sweep you away without mercy. Should the mountain rise, water will be of little concern to you; however, there are other dangers to be aware of such as rockslides and a phenomenon resulting in huge, deep mounds of small rocks given to slippage referred to as "scree." In this chapter, we will examine and attempt to answer a very difficult question: If a mountain is going to move, is it possible to predict if it will rise or sink?

In *The Path of the Pole*, Professor Charles Hapgood makes some very interesting remarks concerning the subject of geological redistribution. According to him, it is indeed possible to calculate the probable movements of a mountain. He tells us that, when the entire crust of the earth shifts, diametric opposite points on the planet will be moved toward the equator and others, toward the poles. To appreciate this description you will need to have a look at a globe.

When you examine a globe closely, you will find that there is a small bulge along the line that represents the equator. This bulge shows how pressure on the poles, caused by the rotation speed of the earth, pushes the Northern and Southern Hemispheres together. During a massive polar shift, the area of the crust lying over the equator must shift with everything else. For this to happen there needs to be enough force to be able to push the rigid crust that lies beneath the continents over the actual bulge at the equator. The portion of the crust that gets pushed over the equator will be forced to stretch, and the area of the crust that gets shifted toward the poles will therefore undergo compression.

Which Continents are going to Shift?

It is important to know in which direction the earth's crust is going to shift if you are to predict what areas will be affected when the lithosphere begins to expand and shrink. Europe, Asia and Africa are locked together and, therefore comprise a much larger landmass than the Americas combined. Due to the physical laws of inertia and friction, it is a fairly safe bet that the continents

with the least amount of mass will be propelled the farthest when the force of the polar shift is upon them. Therefore, because they have the least amount of mass, the continents of North America and South America will be shifted the farthest away from their original locations during the cataclysm.

In our model, we will discount the oceans in between the continents because the water they contain will be moved.

The world map in Figure 43 shows that North America and South America have a much smaller mass than Europe, Africa and Asia combined. When the inside of the earth starts turning in the opposite direction, the New World with its smaller mass will be swept the farthest away from its original location. On this equal surface projection map, you can clearly see the difference in mass between the combined Americas and the block that is formed by Europe, Asia and Africa which make up half of the world's landmass. Most mapmakers stretch the images of the landmasses at higher degrees of latitude giving you the wrong impression of their actual mass. Have a look at a globe and you will understand what I mean. The globe, because it is the same shape as the earth, shows all of the continents in correct proportion.

Consequences of Movement in the Direction of the Equator

When the lithosphere shifts in the direction of the equator, it will be forced to stretch, putting immense pressure on the earth's

Figure 43.

crust. This pressure, or stress, is relieved in the form of exploding volcanoes and earthquakes. The result: the lithosphere, as it slides over the equatorial bulge, will incur damage in the form

of huge faults that will split apart the earth's rigid, stony crust. Immediately, hot, liquid magma from underneath the lithosphere will be forced up to fill the cracks.

In order to visualize the results of a shift of such great magnitude as this one will be, it is important to have an idea of how all this movement relates to distance. When you take the earth as a whole, the difference between the equatorial diameter and the diameter from pole to pole amounts to approximately 43 kilometers. Therefore the circumferences differ by approximately 135 kilometers. For instance, suppose the lithosphere slides far enough that a point of one of the current poles should move over the equator. In order to pass the equator, the polar circumference needs, in this case, to stretch half of this distance, or 67,5 kilometers. This equates to an expansion of approximately 170 centimeters per kilometer. However, this example is based on the worst case scenario. Because the magnitude of the previous shift amounted to about thirty degrees, or in other words, a third of the distance between the pole and the equator, average expansion amounted to about 56 centimeters per kilometer. However, it would be a fallacy to visualize the earth's crust as it expands in the direction of the equator to have equally divided pieces. In the real world such a scenario doesn't exist. A more correct conclusion would be that the lithosphere will become subjected to huge fault stresses at the weakest points and, in fits and starts, they will find some relief by shifting.

Stress felt in the earth's crust along one fault line may be relieved as the earth moves along a corresponding fault line hundreds of kilometers away. The lithosphere is not very elastic and, for that reason, it expands mainly by stretching broken blocks of continents and pieces of the earth's crust. In general you can say the fewer faults in the lithosphere, the further these newly separated chunks of land will have to spread apart. It could be possible that the total expansion of the lithosphere will remain concentrated in a few critical places, such as one of the mid-Oceanic gorges. However, it would be safe to say that some landmasses will be shifted further than others, toward the equator, with the greatest amount of redistribution occurring along the axis of the polar shift. It is here that the first big faults will appear in the lithosphere. Numerous points lying in between will move proportionally in relation to this axis. However, ninety degrees from this line little, if any, movement will occur at all.

The Forthcoming Shift and its
Resulting Impact on Fault Sectors

In 9792 BC, North America shifted towards the equator. Because everything will now be taking place in reverse, the same

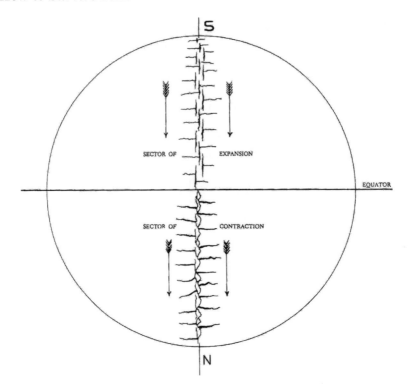

Figure 44.
The forthcoming shift and its resulting impact on fault sectors

landmass will now be shifting back toward the pole. Figure 44 depicts the lithosphere, as it will appear after it has been shifted back toward the pole. Movement of existing landmasses will be from the South Pole to the North Pole with an axis through the continent of North America. The continent of South America, as it moves over the equator, will have to expand. North America, because it will be moved toward the pole, will be forced to contract.

It is important to keep in mind the rigid nature of the lithosphere; it is not very elastic, and not very strong because of its varying thickness. Due to our expectation of differences in the forces that will be exerted on existing continental landmasses, we may be able to predict local reactions. In Figures 44 through 46, we have illustrated our predictions so that you can see the main results. The faults will run in two directions. There is a polar axis that has the biggest shift, with faults and smaller gorges lying to its right.

The man who extrapolated this theory, James A. Campbell, expects that countless faults will start running parallel to each

other. Many small faults that appear right-angled in relation to the bigger faults will form a kind of grid. Campbell suggested a method in order to visualize this. Put your hands together, fingers interlaced. Now, imagine that there is a sphere between your palms and that the sphere is growing, pushing your fingers apart. The opening between your hands depicts a large fault; the smaller spaces between your fingers depict the smaller faults. Another important aspect of these faults is clarified in Figure 45. The sectors that are shifting towards the equator are opening themselves from the bottom and, almost immediately, are being filled up by magma. The line that gradually becomes darker, at the right side of the picture, illustrates this phenomenon. At the same time, the faults forming in the continents that have shifted towards the pole are tightly compressed making it more difficult for the lava to reach the surface.

Figure 45 shows the different effects of a shift in the earth's crust. The upper right quadrant depicts the area where South America will shift up toward the equator. Here the faults will occur below the lithosphere and will quickly become filled up by

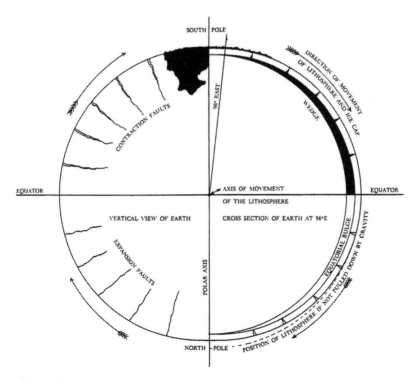

Figure 45.
The shifting of the lithosphere: a vertical overview.

magma (illustrated here by the thickening black line). The further the shift along the equator, the larger the fault and the more magma we will see as a result. Argentina and Brazil will be shifted about thirty degrees which, in turn, will result in intense volcanic activity. America, the landmass that would be in the lower right quadrant, is being pushed toward the pole. The lithosphere, as shown here, will open from above the earth's surface due to the compression of its rigid layers, and will therefore experience less volcanic activity. Furthermore, the dotted line outside the sphere in the lower right quadrant in the illustration points out where, theoretically, the earth's landmasses will be redistributed should they not be pulled under the other continents and crushed by gravity.

The Force that Creates Mountains

Figure 45 illustrates one way mountains come into being. When the lithosphere shifts over the equatorial bulge, gravity starts to work on it. In other words, the surface area at the poles is lessened because it is getting compressed, as evidenced by the smaller radius of the poles and the shrinkage of the landmasses that are situated closer to the poles. Gravity is a greater force at the equator as evidenced by the larger landmasses surrounding its perimeter. You can also look at it like this: the part of the earth's crust that is being pulled down by gravity needs someplace to go, so, because there is too much mass involved to allow sufficient space for it to spread out, it folds up. Therefore, "global" gravity is compressing the lithosphere into a relatively small space. For example, should part of the lithosphere be shifted from the pole to the equator, it would be forced to expand, then it would be folded up in such a way that it would create mountains almost ten kilometers high.

In Figure 45, the dotted line represents altitude. In reality, the mountain peaks at the equator are not situated any further away from the center of the earth than the flat parts. In relation to their distance from the middle point of the earth, the height remains unchanged. What has changed since the mountain chain was being formed is the surface of the continent around the mountain range. A difference of ten kilometers between the mountains and the lowlands has been created because gravity has been pulling down on it. Could we have here the answer to the riddle of what great forces created the mountain chains? The mountains are not pushed upwards; the surface is pulled down by gravity, it just folds up where there is too much mass.

Figure 46 depicts the fault on the axis that runs through North America. As mentioned before, the strongest forces exerted on the lithosphere will be along the axis in line with the area where

the greatest amount of shift will occur. Therefore, only one meridian is designated. Pictured in the half circle above the dotted lines are faults that will form below the earth's crust. In 2012 the lithosphere will stretch and cause mountain ranges from Peru to Argentina to sink. In the area below the solid lines are places where compression may cause mountain chains to come into existence (America).

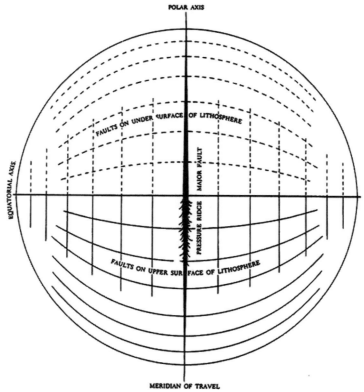

Figure 46.

Electrocution on a Large Scale

Survivors, I caution you here that extremely powerful lightning strikes will be a phenomenon you will have to reckon with. These spectacular surges in electrical current are highly dangerous to living things. Because the wind velocity high in the mountains is far greater than in the valleys, lightning can strike without warning. Hurricanes and other weather events caused by the pole reversal will provide us with a gigantic, rampant show of lightning resembling the finale in a fireworks display. The danger

during this event will be far greater than any common fireworks show, so you will need to be prepared to hide, either by digging yourself in or finding shelter under a rock.

Didier Ulrich of the Swiss meteorological service says, "... unfortunately the human body is a splendid conductor for an electrical discharge, better than a rock. Therefore do not touch a tree or whatever, because the lightning searches for the least resistance, and that would be us. It is altogether wrong to run away when there is lightning because you will raise the difference in voltage between your feet. This explains why cattle are struck more often than humans are, because their feet are standing farther apart than ours are. When mountain tourists cannot find a hiding place, the best thing they can do is to sit on their rucksack, preferably on a stony surface, not move at all and hope for the best."

Conclusion

The Vilela and Toba Indians from Argentina have left us a legacy of stories telling us about how difficult survival was the previous time a polar shift occurred. Their myths tell of an offended spirit that shook and made the earth tremble and how it dumped them into absolute darkness for an entire year. When normal sources of food diminished or died off, the starving masses ate their dogs to survive. When the situation got worse, they ate their children. The Toba say that the cataclysm was necessary in order to save the world from overpopulation.

When you look at a world map you see that in the case of Peru, one of the last areas to shift completely over the equator in 9792 BC, a large part of the coastline was compressed and raised in relation to the surrounding zones. This activity created the strangest lake in the world, Lake Titicaca, which contains seahorses although it is now a freshwater lake. During the coming events of 2012 Peru will be shifted back in the opposite direction, and Lake Titicaca will first be 'pulled down,' after which it could possibly get pushed back 'up' again. The mountain chains surrounding the lake, from Bolivia to Argentina will be part of what gets stretched and may sink back into the earth, but how far is anybody's guess.

To avoid the fierce, violent tidal waves as they rise, you will need to be on a mountain at an altitude of at least three kilometers above the current sea level. However, as I have just explained, you must be aware that, during the polar shift, you cannot be sure whether the mountain you choose to survive on will rise or sink, putting you at risk for drowning despite all your efforts to the contrary.

Further away, in India and China, people will also encounter a big shift in their degree of latitude in 2012. It will be the same scenario as in South America; their mountains will fall. Still,

many mountains will remain suitable for habitation during the cataclysm because they are quite high. Should you fall from five kilometers to three, you will still remain far enough above sea level to avoid being struck by the tidal wave.

A lot of important information was covered in this chapter so, read this chapter again carefully, and study all the data. Only then, with great consideration, will you be able to make a clear choice as to where the best place will be for you to go and be able to survive.

22.
PLACES WITH THE
BEST CHANCE FOR SURVIVAL

After the catastrophe of 9792 BC, re-establishing agricultural centers was a very high priority for survivors interested in the restoration of their civilization, which had been all but destroyed. The survivors knew that the only way to secure their future was for them to have a lasting food supply at their disposal, but getting food to grow wasn't easy and became a tedious struggle. Nearly every bit of previously arable land had been saturated in salty ocean water. For this reason, along with widespread fear that perhaps there would be additional tidal waves, our forefathers, possessing unshakeable courage, fought against their drastically changed environment and re-established their civilization at a much higher altitude than what they had been accustomed to.

One can trace back in time to when the destruction of Atlantis took place by studying the history of animal husbandry, the growing of grains and other experiments with agriculture,

One of the most direct ways to retrieve the geographic origin of a cultivated species is to find out where it grows spontaneously without the help of humans. This idea led an enthusiastic Russian Botanist, Nikolai Vavilov, to begin his collection of more than 50,000 wild plants. Through his work, Vavilov was able to pinpoint eight different places of origination and his conclusion was that there is a direct connection between these eight points and the highest mountains on earth. According to Vavilov, "most crops descend from plants that originate from an area high above sea level." His research plainly shows that, shortly after 9792 BC, agriculture was reborn in mountains with an altitude of 1,500 meters above sea level.

Such data as this is important for us to know when planning for our own survival. Vavilov showed that the zone in which the initial development of most of our important crops occurred lies in a belt between twenty and forty-five degrees latitude north. In South America this belt follows the mountain chains in a linear direction from Ecuador to Argentina and from the south of Mexico to Costa Rica. In Asia, civilization sprouted high in the mountains of Malaysia, Thailand, Northeast Borneo, the Himalayas and the Hindu Kush. In Africa, life started again in the Ethiopian highlands, the mountains of Morocco and Algeria. The Apennines and the Balkans became the breeding grounds for new life in Europe.

As seen in Figure 47, by placing Aha-Men-Ptah at the center of the world, it is easy to find the places where agriculture originated. With the pole reversal of 9792 BC, a tidal wave with a height of at least 1.5 kilometers arose and soaked the land at lower altitudes with salt water, contaminating it, making it impossible to grow crops. The survivors were forced to withdraw higher up into the mountains and it was in these mountains that agriculture was reborn and the domestication of animals took place. Premature civilizations were often found high in the mountains as well, but downstream of more mature settlements. We need to organize a similar plan of action for after the pole reversal in 2012. Several places where civilizations were restarted before will qualify again.

As the years passed, the survivors of the catastrophe in 9792 BC slowly descended down out of the mountains and into lower areas. Like new rulers they were able to start their irrepressible march. We know the results, and, as survivors, we will have to do the same. A polar shift will cause such tremendous

Figure 47.
Vavilov's centers of the origins of agriculture.

damage that huge parts of the earth will be become temporarily uninhabitable: wooded areas will vanish, animals will drown, previously arable land will be unusable, the climate will become unbearable, etc. From whatever angle you look at it, waiting for nature to withdraw and recover from her violent temper tantrum is our only viable strategy for survival.

Where are we going to hide from the tidal wave? Which areas are the most suitable for our goal of surviving in the aftermath of such a life-altering event? Immediately after the tidal wave recedes, we will need to make a temporary settlement somewhere in the mountains, at a high elevation, where, hopefully, the arable land will be left unpolluted by salt water. From this location we will rule over the remnants of a completely destroyed world; people of a crushed past, robbed of our homeland, with an insecure perspective on the future. We will have to make the best of the situation. But where should we go?

To choose the best place, we will have to visualize the effects that a shift in the earth's crust will actually have on the landmasses of the earth. As noted above, the earth isn't actually a perfect sphere

and, as a result, some areas of it will be compressed as they shift toward the poles and others stretched when they move toward the equator. The compression of the earth's crust creates volcanic activity underground, which in turn will cause a great number of volcanic eruptions at the earth's surface. The stretching between tectonic plates, on the other hand, results in widespread cleaving, clefts and rifts. But the most important thing to keep in mind is that the continents that get shifted the farthest from their present locations will be the ones to undergo the most drastic changes.

The inhabitants of these continents will meet their end in a mortal embrace of death. One can imagine the stories and legends that will be told by our progeny when they find the mass graves we've left behind as a testimony to this immense catastrophe that tortured our planet. With such a discovery, I am sure that ancient myths will be raked up again—stories of how a forgotten civilization arrogantly approached its end, how its cleverest scientists never suspected the forthcoming disaster even though their ancestors had left warnings about its imminent arrival. And finally the story will tell how this civilization was violently

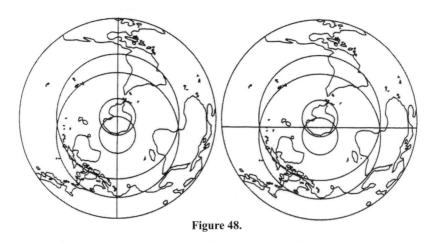

Figure 48.

torn apart during a terrible cataclysm and left covered, for what seemed eternity, in a shroud of snow and ice. Such a story will be retold by parents to their children, a tale of an ancient advanced civilization that had conquered earth and space; however, this time they will be talking about us, about our lives, not about our ancient times or such a place as Atlantis.

When the crust of the earth shifts again in 2012, North America will undergo the greatest amount of change. In one day, a large part of the continent will disappear under the North Pole.

Like the previous time, the shift will wipe out entire populations of many animal species along with billions of people belonging to the most advanced civilization ever.

Africa, on the contrary, will be shifted very little; therefore, it is on this continent that we will have the best chances for surviving the cataclysm. In the first drawing in Figure 48, the line you see represents the area that will be affected the most when the polar reversal takes place. Note that Africa is far from this line. The second drawing in Figure 48 shows the line across which the least change will occur. The only large landmass it crosses is Africa, meaning that the great continent of Africa will, for the most part, remain as it is now.

What are the Practical Results of an Earth Crust Shift?

A lot will depend on the magnitude of the shift. The bigger the shift, the more overwhelming the climatic changes will be. Some areas will become much colder because they will be shifted toward the poles; others will become warmer as they move closer to the equator. Some areas will escape climatic changes altogether. When you study all of this closely, you will find that the areas that will remain largely unaffected are pretty much the same areas that remained unchanged after the previous shift. One thing is clear though; changes in climate will definitely influence the eventual locations of re-emerging civilizations.

If the magnitude of the shift is about the same as it was the last time, even though things will be shifting in the opposite direction, the highlands of Ethiopia and Thailand should maintain a stable climate. These areas are historically significant because they appear to be where agriculture originated after the last polar reversal. The highland areas of Ethiopia and Thailand lay in between the present and the future path of the equator and, most importantly, they will maintain an equal quantity of sunlight annually. Without a doubt, the highlands of Ethiopia will offer up an oasis for our survival, mainly because, the first hundreds to thousands of years after the last cataclysm, it rained there extensively as a result of the melting icecaps and the shifting of the climatic zones. We can therefore expect something similar. Vaporization means rain. Desert areas will flourish for long periods of time. After the ice has melted, though, the deserts will again slowly heat up to scorching temperatures and we will need to move on again.

A Non-volcanic Mountain in South Africa

Where do we go to restart a new civilization, and how do we get there? I have been trying to put the pieces to this immensely difficult puzzle together for years! The Atlanteans survived using

boats, but do we need to do the same? Absolutely not! Of course, I feel there is a greater chance of surviving the cataclysm if people use the unsinkable boats made by ETAP, but for reasons outlined above, I do not think that will be my strategy. I feel that we should not exclude the fact that in the past, a great many people survived by moving high into the mountains. If we are to survive, most of us will have to make arrangements to do the same; there is only a limited quantity of unsinkable boats available.

After much deliberation, I have chosen South Africa as my relocation point. My reasons are as follows: there is little pollution in Africa, it has a subtropical climate and, historically, it didn't shift much after 9792 BC. The Drakensberg Mountains in South Africa offer one option that seems worthy of further study. As long as this mountain range doesn't collapse—and my studies have gone a long way to prove that there should be little shifting in this region, and therefore very little rise and fall of its mountain ranges—it has an altitude high enough to withstand the tidal wave. Also, the climate in this region of South Africa, which will be summer-like in December, will remain agreeable due to the fact that Africa's proximity to the equator will not change very much. Of course the Drakensberg Mountain range is only one of our choices. We could just as well pitch our camp on Mount Kilimanjaro. The closer to the equator, the warmer it will be, and the better, because the big dust cloud that will arise after the event will block out all solar radiation, sending us into something like a nuclear winter.

Figure 49.
This drawing shows the probable location of the Drakensberg Mountains after the pole shift in 2012. As you can see, its position in relation to the equator has not changed much. This place is ideal because it concerns a non-volcanic mountain far away from other volcanoes. In the first years after the catastrophe, civilization will be able to find temporary shelter here.

There is, however, one major risk we would be taking by choosing Kilimanjaro—we may die due to increased volcanic activity. We must, therefore, carefully look at and weigh all the pros and cons of any choice we could feasibly make. I will absolutely not be the one to tell you that you would not be able to survive in the neighborhood of Mount Kilimanjaro, but it could become very hot in that area. The same scenario exists

for the Atlas Mountain in Morocco. Twelve thousand years ago, considerable volcanic activity was caused by the polar reversal and the subsequent shift in the earth's crust. The reoccurrence of this unstoppable event will undoubtedly present us with the same problem, the reawakening of long-dormant volcanoes.

However, unless I have received counter-arguments by 2012 that are convincing enough to change my mind, I will personally be found pitching my tent in the Drakensberg Mountains. Should we find it to be too cold after the event, we can always move to higher latitudes. Who is with me?

Another Earth Crust Shift

In the event that the earth's crust should happen to shift differently than expected, the Drakensberg Mountains will still remain one of the best options. Should Africa, for instance, shift thirty degrees north, it would come to lie on top of the equator, which would help to maintain a more agreeable climate in the area. Should it shift south, away from the equator, we should be able to survive the changing climate in this location long enough to find a more hospitable place in which to relocate. Hopefully we will not encounter any of these scenarios, though, because if they did come to pass, huge volcanic eruptions, the sinking and rising of mountains and other forces that will destroy the continent would then occur. In the worst case scenario, it would not be unthinkable that the Drakensberg Mountains will sink into the earth and the tidal wave will crash over us. Let us all keep our fingers crossed and hope that this is not what will happen.

Everyone Must Decide for Themselves

Finally, it is your decision, and you alone will be the one to decide where you will be when this catastrophic event occurs. You must be the one to decide where and how you will survive. I have studied everything, all the options, over and over again and I have made my choice. Of course there can never be any "without any doubt" certainty in such a case as this, but I have done my best to explain it as well as I possibly can. I believe that only minimal changes to the scenario I have set forth are possible and I hope that there will be many people who choose to join me in the Drakensberg mountain range. I have considerable hope that, in this way, our civilization can be saved.

23.
THE END OF TIMES

Countless fossils and other unusual objects can be found in unexpected places on our planet. When we excavate these things, it is as if we are finding the pieces of an immense historical puzzle. However, what if this puzzle is really a message, a warning sign of what lies in our future? Shells and skeletons of sea animals have been found at elevations as high as the Himalayas, which means that in the distant past, fish swam over these mountains—an indication that the Himalayas were, at some point, lying below sea level! At present, Eurasia is forty-five hundred meters or more above sea level. In *Our Mobile Earth*, R. A. Daly writes, "from a geological point of view, not so long ago the plain from New Jersey to Florida was below the sea. At that time the breakers lashed directly on the Old Appalachian Mountains. Before that time, the Southeast part of the mountain chain was below sea level, covered by a layer of sand and mud that became thicker the closer to the sea. Then, this wedge-shaped sea-sediment was lifted up and was cut through by rivers, resulting in the Atlantic coast of the United States."

What caused the sea bottoms of long-gone eras to become high-altitude upland plains? What is the cause of these enormous forces that bend and push up on rocks, creating mountains then breaking and crushing them? Only pole reversals and shifts in the earth's crust can explain this. The opposing forces that accompany this geological activity have "lifted up" continents from the sea bottom and "pushed up" the mountains. In 2012 many areas will change in appearance. New mountain chains will be formed while others will disappear. Thousands of years from now, stories will be told about an era in which people were able to travel to the moon and land on Mars with their space shuttles. People will tell about the superior airplanes that had been constructed and how these ancient peoples had researched the deepest oceans. And yet, their end was even worse than that of the previous civilization because, despite their sophisticated knowledge, they were not able to anticipate the events that would bring about the end of the world as it was known.

After the 21st of December 2012, people will be able to give the same description of this era's end as they did of the previous time: "The life-giving earth crashed, burning ….the whole country was cooking … it was as if the earth and the wide Sky above were closing in on each other."

This was the description of the most horrible event that took place in a far distant past—a global fire accompanied by terrible earthquakes, thousands of erupting volcanoes, the "rising" of mountains, the roaring of a splitting earth, the screeching of raging tornadoes and a colossal flood.

In many places this event is still remembered. The Mayan eras were named after the successive suns: Sun of Water, Sun of Earthquake, Sun of Hurricane and Sun of Fire. These suns pointed to epochs that related to the several catastrophes that had struck the world. In his book *Researches II*, Humboldt Gommara, the Spanish writer from the sixteenth century, tells the following, "The nations of Culhua in Mexico believe, as we can see in their hieroglyphic drawings, that before their sun, four other suns were extinguished successively. These four suns are just as many eras in which our race was rooted out by floods, by earthquakes, by a world fire and by the force of destructive hurricanes."

As described in their *Edda*, the Icelanders believe that nine worlds succumbed. In the highlands of Tibet the stories about four lost periods are still alive. The holy book of the Hindus, the *Bhagawata Poerana* tells about four eras and cataclysms in which humanity was almost destroyed. Every world period ended in catastrophes of fire, floods and hurricanes. One of the most important descriptions is found in an Indian tradition which tells of total destruction of the world by water. The waters rose and took over the whole earth, reaching so high that a ship landed in the Himalayas. Sanskrit texts, the *Vedas*, make it clear that such a cataclysm washes away all traces of the previous world and that a new era can start on earth. In order to safeguard the *Vedas* for future humans, the gods

Figure 50.
The Mayan calendar found at Altar 5 in the extensive ancient city of Tikal, Guatemala.

created an institution to keep them alive—The Institute of the Seven Wise Men. This Institute is comprised of a brotherhood of adepts that possess great faculty for memory. These men practice yoga, are ascetics, visionaries and great teachers. They fight against evil and they know the answers to the biggest secrets. They are

reincarnated from era to era, like guides of an eternal civilization and guards of cosmic justice. These men are doing exactly what we should be doing right now—*preparing for the future.*

Mayan Symbols Depicting the End

There is no doubt about it that 2012 is an important astronomical year for the Maya.

Seen from our earthly perspective, Venus will pass in front of the sun. The earth, Venus and the sun will be perfectly aligned. The last time this happened was in 2004, and before that, in 1882, which is approximately the same time as when the holy Maya buildings were rediscovered. In 2012 two solar eclipses will take place—one with the sun and the moon in one line and astrologically united with the Pleiades. The other eclipse, which will take place later that year, will have the sun and the moon aligned with the head of the constellation Serpens. The Pleiades and Serpens are essential keys in Mayan astronomy, but, even in the Old Testament you can find references to the Pleiades. The following passage is from James Fraser's 1916 book *Folk-Lore in the Old Testament*:

> The tidal wave was caused by male waters from the sky, which met female waters that were coming from the ground. The holes in the air through which the uppermost waters escaped were made by God when he moved stars from the star sign Pleiades. And in order to stop the rains God needed to fill up the holes with a couple of stars that were borrowed from the constellation of the Bear. That is the reason why up to this present day the Bear is walking behind the Pleiades. She wants her children back, which will happen on the Last Day.

That Last Day will take place in 2012. In that year, from an esoteric point of view, the solar eclipse signifies the beginning of a fundamental cycle of darkness for the earth. The sun and Venus form a light cycle. In that particular year, both cycles will collide fundamentally. Darkness and light will start fighting for the throne, consuming the world in their aggression. The retrograde circle movement that Venus makes above Orion will illustrate this astronomically. Seen symbolically, this event will open the celestial gate to "The End of Times."

Many North American tribes believe that the Milky Way is a path in the sky by which the dead must travel on their journey to higher skies. The Milky Way is often depicted with two gates at the places where it cuts the ecliptic. One of these intersections

or "gates" lies between the constellations of Gemini and Taurus, beside Orion. The other "gate" lies on the opposite side of the ecliptic between the star signs of Scorpio and Sagittarius. Indian myths from Honduras and Nicaragua tell of a "mother scorpion" that lives at the end of the Milky Way. This scorpion is identified with the "mental star" Antares—Alpha Scorpio. This very bright star is located on the southern intersection of the ecliptic and the Milky Way and marks the southern gate. On December 21, 2012 Venus will stand firmly in this vicinity and her position will mark the "deadly bite" that the "mother scorpion" will give to the world. After the

Figure 51.
In American Indian folklore, the Milky Way lit the path to the spirit world. (Painting "The Milky Way" copyright Richard Hook, found at www.firstpeople.us)

catastrophe has taken place, Venus will show the way to all the newly lost "souls": through the northern star gate to the celestial spheres. Let's hope that we—"the new civilizers"—will not be part of that group.

Science Colliding with Mythology

Because of all the hazy symbolism and difficulty in deciphering the words and numbers of ancient texts, we will be confronted with "The End" only at the last moment. However, ancient scientific theories contain an extraordinary accuracy, and only now have we been able to decipher the background. And yet all modern scientists close their eyes arrogantly, not wanting to see the alarming messages of our ancestors, our civilizers. Their science is classified as being "mythological" and "non-existent," only because they thought differently and therefore expressed themselves in ways that are incomprehensible to "modern" man. Insurmountable barriers prevent our understanding of their advanced science and huge astronomical knowledge, because they have depicted it using forms and formulas other from those we normally look for. After the cataclysm, we must not make the

same mistake! We must find a clear means by which we can pass on our knowledge of cyclic destructions.

For instance, the Izapan-Maya creation myth was very clear to its creators, but not to us. Their scientists controlled the beautiful power of mathematics with which they mapped our solar system and a large part of the cosmos. With these maps they found correlations between phenomena in space and terrestrial events. Our ancestors built their world image on speculations in which the destination of the human soul and space science were intertwined. The creation myth says that One Hunahpu, the December solstice sun, must conquer the star sign of Big Bear in order to be reborn and rule over a New World Era. At that moment countless souls will leave their bodies. Many Izapa monuments are therefore pointed to the December solstice. But which solstice will be fatal? According to the Izapan it will be the one of 2012, at the end of the thirteenth baktun, correlating with 13.0.0.0.0 in their Long Countdown calendar.

When the Maya said that "things are numbers," they meant that a complete astronomic and mathematic science lay hidden behind everything they did. These unknown geniuses entwined this in their complicated thinking patterns, which in their turn resulted in the construction of beautiful buildings. We need to make superhuman intellectual efforts to place ourselves in their perspective. A monument in Izapa depicts the rebirth of One Hunahpu: his arms are stretched out wide, which signifies the end of a period (like the end of a World Era). There are more clues to find outside the monument. At the western end of the ball court, we find a throne and some small monuments which contain several metaphors that coded the predicted end. The throne consists of legs, in between which a divine sun head, or sun Ahau face, appears. This birth scene is pointed to the east, to the place where the December solstice sun rises. It depicts the future event as the birth of a new sun. Beside the throne we find a round stone ring in which a stone ball was placed. This is the symbol for the disappearance of the December solstice sun; he is swallowed down and his life ends. Close to the ring we find a snakehead, which originally had a sun Ahau face in its mouth. Without any doubt this shows that the snake is going to kill the sun, also showing that a rebirth precedes death. And we, the active participants, will be the victims of the end of this historical cycle.

For almost everybody this is very complicated symbolism which can be interpreted in all kinds of ways. However, when you also have a look at the scientific number series with which they worked, the myths become frightfully clear. They tell about

Figure 52.
Many monuments in Izapan are pointed to the December solstice. This symbology is fully explained in John Major Jenkins' book *Galactic Alignment.*

disturbances in the sun's behavior, about shifts of the earth's axis, pole reversals, the catapulting to other eras, an immense deluge, rising mountains and other destructions. For that reason I no longer doubt the superior knowledge that they put in encoded messages and left us to study. When you look at the codes through their eyes, you will know and understand they were pointing to a forthcoming end—a global disaster that will strike humanity in the depth of its heart.

Page 74 of the Dresden Codex, part of which is reproduced in Figure 53, shows that Mayan scientists calculated an inundation after 13 cycles of the Long Count have passed. The countdown end date is 0 Katuns, 0 Tuns, 0 Uinals and 0 Kins. At that moment the earth's direction of movement will turn backwards and a gigantic tidal wave will strike the continents. Above you see the snake shaped creature that will destroy the world by sweeping water over the skies. The body of the snake takes the shape of a celestial belt that is subdivided into symbols of star signs; signs of solar and lunar eclipses hang from his belly. The black figure on the bottom depicts Ek Chuah, the God of War. He holds two spears and a baton that are all pointed down. On his head stands a Moan bird, depicting a portentous omen. Below the eclipse symbols stands the Old Woman Goddess, the patroness of death and destruction. From a bowl that she is holding upside down, a flood is also flowing.

The Countdown Continues at Full Force…

We are living our last days and do not realize it. Why don't we listen to the truth of the myths and legends of these lost scientists? Why do we not believe in their calculations? What are we waiting for before organizing the biggest rescue expedition ever? It is not that difficult to decipher that everything points to a mega disaster. Counting, addition and subtraction obsessed the Maya, because they were obsessed by time. They left us at least six different descending calendars. At the moment a calendar ended, they feared that the universe would be destroyed. With calendars of different lengths they felt safer. They thought they could avert a cosmologic catastrophe. When the 260 days of Tzolkin ended, Tun (or the Long Count) continued to run. Every fifty-two years Tun coincided with Haab, and was called The Holy Year. When this occurred, the Maya sacrificed people in order to prevent annihilation. The Maya feared that at the moment that all calendars jumped to zero they would be without time. A calamity without an equal would be involved.

Number Zero and the End of the Mayan Calendar

Based on the prediction of the wise men of the Maya in the

Figure 53.
The Destruction of the World on page 74 of the Dresden Codex.

vicinity of the Yucatan, the world will end in 2000 "*y pico*"—"and a bit." How much is that "bit"? The Great Cycle of the Maya calendar started in complete darkness on the 11th of August 3114 BC and will end after five millennia on the 21st of December 2012. According to the Mayan wise men thirteen cycles will have passed, and the clock will have turned to 0 Katuns, 0 Tuns, 0 Uinals and 0 Kins, since the beginning of the Great Cycle. That day will be presided over by the Sun God, the ninth Lord of the Night.

Number Zero and the Magnetic Field of the Sun

According to the sunspot cycle theory of the Maya, at that particular moment the magnetic field of the sun will jump to zero, and the zero depicts the end or the beginning of a sunspot cycle. Therefore a double zero! That must be the reason why the Maya were so obsessed with the zero in all the different calendars coinciding. And what is waiting ahead of us? We can expect a gigantic mega short circuit in the inner nucleus of the sun, or in other words, the awakening of the Sun God in an explosion of solar outbursts. For us this means the End of Times—for humanity, the biggest horror ever. Or, in the words of the Katun prophecy in the *Book of Chilam Balam of Tizimun*:

Ca hualahom caan	Then the sky is divided
Ca nocpahi peten	Then the land is raised
Ca ix hopp i	And then there begins
U hum ox lahun ti ku	The Book of the 13 Gods
Ca uch i	Then occurs
Noh hai cabil	The great flooding of the earth
Ca lik i	Then arises
Noh Itzam Cab Ain	The great Itzam Cab Ain
Tz'ocebal u than	The ending of the world
U uutz' katun	The fold of the Katun
Lai hun yeciil	That is a deluge
Bin tz'oce(ce)bal	Which will be the ending
u than katun	Of the word of the Katun

And in the words of Marduk:

When I stood up from my throne and let the flood break in,
the connection between Earth and Heaven was broken off
…

The gods, which trembled, the stars of heaven that changed their position and I did not bring them back.

These scriptures show the death-struggle of our civilization. It is like a huge uprooted tree with its roots in the air. A breath of air can break off any connection. After the catastrophe this will be even more precarious and our lives will be hanging by a thread. With all possible power we will have to plant ourselves again in the universe. Let us therefore prepare ourselves for the extinction of our civilization, and our resurrection in a better life, connected with the earth and the cosmos. If we succeed in that, we can consider our mission to be successful. And we have a very great chance to succeed. According to old prophecies, new sciences will sprout at the beginning of the new era. They will settle scores with the many problems we have today. Furthermore new forms of curing illness will put an end to almost all diseases. Because we know about the coming disaster in advance, I see it as our task to make these predictions of a better world come true.

24.
A NEW GOLDEN AGE

We are soon to be confronted with the greatest challenge ever in our history. Within the next several years, an indescribable super catastrophe will wipe out our civilization in a matter of one day and one night. Very few people will take measures toward surviving this gigantic geological disaster. Up until the very last moment even governments and scientist will send their strong messages of denial into the world. Millions will wonder desperately whom to believe—until it is too late.

The New Civilizers

People that want to survive will have to rely on their own resources. They will also have to have a firm faith in the objective they want to reach. It will be you, some others and me. There will not be many more, but that doesn't make a difference as long as there are a few thousand. We will end up being the only people left in a destroyed world, a remnant of what was once the most unique and most highly developed civilization in the whole universe. Together we will form an organized group that will be the foundation for a new civilization. We will support and encourage each other as much as possible. Together, through sheer hard work, we will take care of the many problems that will confront us. We will face the most precarious challenge of all time, to defeat an untold number of obstacles in an unequalled fight against nature's forces run riot.

We will have in our possession a mini-library containing priceless books written about our advanced technological knowledge. Taking such a precaution, we equal the cleverness of the inhabitants of Aha-Men-Ptah who had two hundred years to prepare themselves for the previous polar shift. They, too, brought with them scripts containing their best, most important discoveries and knowledge. It is for that reason that we now have such a high-tech civilization. Without the knowledge that they saved, we might still be living in the Stone Age.

Because of their foresight, they knew it would be very important to pass on information about the source of their progress to their descendants. Thanks to our library, future generations will enjoy the benefits of our technological discoveries. Otherwise, what use is it to survive? If you're not able to perform life-saving operations or do other more or less complicated things, life will become an unbearable burden. For example, if not for modern

medical technology, I would have been dead for eighteen years now because I suffered a fatal accident when I was thirty. If I had died then, nobody would know about the decoding of the deepest secrets of the previous civilization, let alone receive one last warning about the forthcoming catastrophe...

A Bridgehead to the Future

Due to the cataclysm a lot of what we know now will be lost forever. Such a profound loss is simply the consequence of such extreme global disaster. Because we now know and realize that this will be the outcome, we have no illusions whatsoever: the destruction will be almost total. Only a few of us will survive. Some of us will be adrift in unsinkable boats loaded with food, liquid and knowledge. Others of us will be trying to survive in the high mountains. There will be some fortunate people not of our group who will survive the forces of nature such as the earthquakes, the volcanic eruptions and the rising of the waters, however, it will not be because they were prepared. This happened in the old days, and it will be undoubtedly so in 2012. They will have almost nothing and, therefore, little chance of continued survival. Some of them will attack us in order to steal our resources. If negotiations lead to nothing, we must then be able to defend ourselves. If necessary, it might come down to using weapons, but everything will depend on the circumstances.

I am prepared to allow others into our group, but not at the cost of our lives. However difficult, we may have no other choice but to take rigorous measures. My heart already breaks at the thought of such possible scenarios. I dream about them almost every day, but my resolve is more than firm: every emerging civilization in the past began to flourish after it had built up a well-organized defense. We will need to do the same.

Our main goal is the preservation of knowledge, at whatever cost. After the disaster we must therefore protect, with our lives, the essence of our ingenuity collected into compact works. In that way we can restart our civilization, like a phoenix rising again from its ashes. We must warn the next generations that they will one day face a similar cataclysm.

To some of you this may sound hard and imperialistic, but unfortunately, it is our only option. If we want to give our descendants a dignified existence we will need to develop exemplary military abilities. Should our knowledge become lost, very dark times will befall humanity. Our average life expectancy will decrease drastically. Even more probable is that humanity will revert to barbarism and slowly die out.

I am probably scaring a lot of readers with the above text,

but it is simply a fact that hungry people are capable of doing anything to get what they desire. A well-organized group can wipe us away, just like that. You only have to read our history books to know that this is the truth. Many cultures were wiped out by barbarians and that is a risk we cannot take; human nature is too cruel. Even though we are only eating vegetarian food, I insist that we should not neglect our military strategy.

So you see that our choices and options are very restricted. Our world will be filled with many pitfalls, impossible missions, unexpected setbacks, attacks from outside, illnesses, hunger and pain. Our hearts will be torn apart when we have to make difficult decisions. Exhausted children will die in our arms, adults will suffer from grief. Our minds will be tortured with sorrow and many of us will succumb to nervous breakdowns; crying, wailing and lamenting such a horrible fate. And yet we will go for it despite the difficult circumstances because we took this task, this great responsibility, upon our shoulders. However unbelievable this all may sound the fact remains that, if *we* don't do this, nobody will.

A Heroic Battle for our Wisdom Cult

Our fight will be more heroic than any previous to our time, not only because of our world's sophistication but also, the earth has never been so crowded before. We will be in a worse situation than uncivilized peoples. Uncivilized people can recuperate more quickly and adapt more easily to new circumstances. We, on the other hand, are too cultured and find it very difficult to live without comfort. Not only will we mourn our dead, but we will also mourn the disappearance of our infrastructure, the destruction of our technology and our luxurious lives. We will witness an almost unimaginable collapse. You need to realize this! Everything, and I repeat, *everything*, will be wiped away leaving a polluted global mess. Yet we should not let this deter us. The following legend about the rainbow warriors will serve to keep our morale high in the dark times that lie ahead of us:

> Under the symbol of the rainbow all races and all religions of the world will unite. Together they will proclaim the great wisdom of living in harmony with each other and with all the creations of the Earth. The ones who are teaching this will become known as 'the rainbow warriors.' Although they are warriors, they will have loving hearts and carry the spiritual way of living and knowledge of the "Old Ones" with them. And they will not do any harm to any living creature.

The legend tells that after a great battle in which only the force of peace will be used, these rainbow warriors will finally bring an end to the destruction and desecration of Mother Earth. Peace, and more than that, will then reign for a long period of time: a joyful, peaceful Golden Age.

A Vision for Success

This old prophecy is clear. We will conquer. We simply have to. However, due to the short period of time that lies between the warning and the disaster, we should not give in to too many illusions. Only we, with a well-organized vision, will be able to re-establish civilization. For this to happen, we need to have knowledge of ecology, architecture and construction, cartography, mathematics, diverse sciences, technology, electricity and medicines. We will have to restrict ourselves to basic knowledge in these subjects because of the complexity of everything. We will teach everyone and make the light of our knowledge triumph in the world. Future generations will be able to study the texts that we bring with us, work them out and restore knowledge of whatever has been lost.

Our present civilization doesn't realize that everything is finite. In our universe nothing lasts forever. Stars can live for billions of years, but even their light extinguishes over time. Oil reserves will eventually reach a point of exhaustion. A human life has only a certain period of time. Everyone dies eventually. The same goes for civilizations. They flourish, reach a high point and then die. You can find the skeletons of these civilizations all over the world. If we continue the way in which we are living now, the present cycle for humanity will end forever. Due to the existing greed for money and the ecologically unsound industries it fosters, the earth will be incredibly contaminated after the disaster. Our survival will be hanging on a thin thread. Should we be able to turn the tide in time, we will be able to survive the massive amounts of chemical and petrol pollution that will coat the earth, and we will triumph in our goals. In order to prevent a recurrence of such ruinous practices in the future, we will have to emphasize this issue as an important part of our message to future generations.

If our imaginations fall under the spell of rebuilding a more ecologically sensible civilization, we will conquer. Rational belief in this offers us a way to deal with our feelings, our hopes and our fears. In this way our mental energies will be directed toward meaningful goals. Such goals will offer up rules by which our way of living will result in a sort of a flow condition. Through this methodology, we will realize our future goals much more easily.

For this to happen, we will need to use our scientific knowledge concerning the fate of humanity and pole shifts. Without that knowledge we would remain divided. Only an integrated interpretation of all knowledge will help us. Through this vision we are confronted with the following fact: pole shifts have an overpowering influence on humanity and its fate. Important questions will be answered, such as: How strong is our connection with the magnetic field of the sun? What are the consequences of a pole shift? To what phenomena will we be subjected? Once we understand, we will need to teach others.

Immortal "Information Buildings"

Every earthling, as it were, will be immersed in our scientific findings about this mega disaster. For this purpose we need to construct huge buildings, as the Maya and the Old Egyptians once did. In the process of reconstruction, we should try to prevent making crucial mistakes like the one the early "Masters of the Numbers" made. These masters of the "Mathematical Celestial Combinations" left us difficult-to-decipher coded messages in their buildings. Therefore, it is only after hundreds of years that we finally understand their message. Now, we only have a few years left to prepare and it may end up being too late. In the buildings that we construct in the future, we will need to try to prevent such confusion. We will need to reflect our universal message containing the years of the previous catastrophes and the date of the next. Our theory on the basis of the information, as well as the exact astronomical data, should be depicted extensively in the stones. Our messages should not be confusing, and should leave no doubt whatsoever. In this way, our desire to warn future generations of an equal Armageddon can become reality.

Because the situation after the disaster will be extremely serious, not to mention precarious, some of us will fail or only obtain limited success. And yet a well-organized group with sufficient perseverance can create a stable bridgehead from which everything can begin again. Although we will be with just a few hundred survivors, the surviving scientific knowledge will be considerable. Once we have rebuilt our civilization, we will be able to spread our new wisdom cult over the earth. The force of faith still moves mountains! In the past as well as in the future this remains an undisputed truth. With the help of the correct motivational techniques, we will make ourselves, our knowledge, immortal.

An Ecological Civilization

Thousands of years or even tens of thousands of years ahead,

future generations will remember us and will be thankful for our achievements. In short, our holy goal becomes keeping as much knowledge as possible alive and passing it on to a well-motivated future civilization. When this happens we can quickly reclaim the earth in a short period of time and leave the mark of an ecologically responsible civilization to its survivors. Nothing is more important. With the passing of time our recognition of many problems such as overpopulation, massive pollution and exhaustion of raw materials, can be set right. If we accept a cooperative position instead of the role of rulers of the earth, we will feel like an exile who comes home after many years. Once individual goals unite with the universal laws of the sky and the earth, the problem of our "giving meaning to *life*" will be solved.

The crucial message that our civilization will spread is living in harmony with nature. If this is not to be our goal, we can spare ourselves the trouble of furthering human existence. We need to see to it that woodlands, wild animals and an abundant variety of plants will be waiting for our descendents long into the future. Who wouldn't want to espouse that dream?

I would like to end with the words of Seneca: "The fierce violence of flames will make the whole frame of the earth's crust burst."

Furthermore he wrote:

> One day will see the funeral of humanity. Everything that brought forth the long-lasting indulgence of fortune, everything that rose to sublimity, everything that is famous and beautiful, big thrones, big nations, it will all go down in one abyss, it will be thrown down in one hour.

In conclusion, I would like to offer a riposte, my personal mission statement for the new world:

> And like a phoenix we will arise from our ashes, ruling the world in an ecological way with an essential message for all future generations.

PART V

ASTRONOMICAL AND
MATHEMATICAL PROOF

25.
MATHEMATICAL PROOF

Super Numbers Predict the Catastrophe
The code has been broken. As I promised, I will give you the decoding of the exact date through a mathematical game with numbers. However, before you tackle the following sections, I strongly recommend that you re-read attentively the chapter on this subject in my first book, *The Orion Prophecy*. Much of the reasoning and methodology used below are described there more fully.

You have to start with 1,366,560, which is the Mayan super number. This number contains twenty cycles of 68,328 days, which contain 117 cycles of 584 Venus years. With the help of this number (117) and the number 227, which represents the number of cycles of fifty-two years between the previous and forthcoming catastrophe, you will find the first code:
117 x 227 = 26,559.

Divide the number of years between the catastrophes by this number:
9792 + 2012 = 11,804 years between cataclysms
11,804 ÷ 26,559 = 0.444444.

The time period between the catastrophes of 21,312 and 9,792 BC, lasted 11,520 years. At that time the precession number (25,920) was the main code (see my previous book *The World Cataclysm in 2012*). To find out that this code 0.44444 is correct you have to calculate as follows:
11,520 ÷ 25,920 = 0.444444.

Number eight was Egypt's Holy Number, the number of the Celestial College. Eight was the number of perfection. Series of eight were extremely important in Egypt (see Albert Slosman's *Le Grand Cataclysme*).

The Holy Number Eight
11.11111 x 11.11111 = 123.456790123456790 (the numeral eight is missing in this sequence; see my previous book)

```
1 x 9 x  123.45679012345679  = 1,111.11111
2 x 9 x  123.45679012345679  = 2,222.22222
3 x 9 x  123.45679012345679  = 3,3333.3333
```

$$0 \times 9 + 8 = 8$$
$$9 \times 9 + 7 = 88$$
$$98 \times 9 + 6 = 888$$
$$987 \times 9 + 5 = 8888$$
$$9876 \times 9 + 4 = 88888$$
$$98765 \times 9 + 3 = 888888$$
$$987654 \times 9 + 2 = 8888888$$
$$9876543 \times 9 + 1 = 88888888$$
$$98765432 \times 9 + 0 = 888888888$$
$$987654321 \times 9 - 1 = 8888888888$$

The next decoding shows that you are tracing something very important:

$$227 \times 0.444444 = 100.888888888888888888$$

Further decipherings prove that we can use these numbers. Multiply 11,804 (the time period between the last crash and the coming one) by the several time periods with which the Maya marked a year:

$$11,804 \times 365.25 = 4,311,411$$
$$11,804 \times 365.0 = 4,308,460$$
$$11.804 \times 360 = 4,249,440$$

Divide these numbers by the above found number (26,559) and you will find important code numbers which I calculated in exactly the same way during the cracking of the computer program of the previous crash (see my previous book):

$$4,311,411 \div 26,559 = 162.333333$$
$$4,308,460 \div 26,559 = 162.222222$$
$$4,249,440 \div 26,559 = 160$$

Study this code cracking extremely well and compare it with the results I found earlier. Undoubtedly you will have to conclude that the end date is indeed in 2012! There is no other possibility. The proof for this will be shown more extensively in the next section.

Divide the Maya numbers that show a fifty-two year cycle by these calculated values and you will find 117:

$$18,993 \div 162.33333 = 117$$
$$18,980 \div 162.22222 = 117$$
$$18,720 \div 160 = 117$$

Three times the number 117 gives: $117 \times 3 = 351$. You will find this number again later and it will lead you to the solution. Remember that you will encounter the number 351 several times in the deciphering of the Dresden Codex. It is a primary number to decipher this code!

Furthermore: $11,804 \div 117 = 100.8888888888$

This is the same number we have found before and therefore appears to be a recurring code number. Multiplying 0.8888888 by 117 results in:
$0.888888 \times 117 = 104$

You can also calculate in another way:
$100.8888 - 0.8888 = 100$
$$11,804 - 104 = 11,700$$
or $11,804 - 11,700 = 104$

This is the same as writing it this way:
$$11,804 = 100.888$$
and $104 = 0.888$

Now we are getting close to the way they mathematically calculated the destruction with the help of Holy Numbers.

The period between the catastrophes is: 11,804 years. In order to produce the exact outcome you have to subtract a certain number. But you have to know the correct number of days in a year. This is not 365.25 but 365.2422 days. When you multiply this by the number of years your result will be 4,311,319 days for 11,804 years. This number is a bit too large. If you want to know the correct number of days between the crash of the 27th of July 9792 BC and the expected catastrophe on the 21st of December 2012, you need to subtract 220 days from 4,311,319 days. This results in 4,311,099 days and shows the exact number of days between both disasters. Besides, the number can be divided by 117 and 227:
$4,311,099 \div 117 = 36,847$
$4,311,099 \div 227 = 18,991.625555$

4,311,099 is the correct number of days between the crashes. Subtract this number from the number of days existing from 11,804 years of 365.25 days:
$4,311,411 - 4,311,099 = 312$

A connection with code number 351 exists:
$312 \div 351 = 0.88888$

Then I decided to divide the days between the catastrophes by the code number 351 :
$4,311,411 \div 351 = 12,283,22222$ = correlate with 11,804 years = 100.8888
$4,311,099 \div 351 = 12,282,33333$ = correct number of days between the crashes = 100%!

When I subtracted one number from the other it resulted in:
12,283.22222 − 12,282.33333 = 0.888888
Or, with another mathematical pattern of thinking, in:
100.8888 - 100 = 0.8888888

Immediately I knew this was the solution! I had found:
11,804 − 11,700 = 104
You need to multiply this number by three, because there are three calendar rounds (365.25, 365 and 360 days). Your result will be:
11,804 x 3 = 35,412
11,700 x 3 = 35,100

And: 35,412 − 35,100 = 312 = higher value found
When you divide the before mentioned numbers by 351, your result will be:
35,412 ÷ 351 = 100.88888
35,100 ÷ 351 = 100
312 ÷ 351 = 0.88888
100.88888888 - 100 = 0.888888888888888

Conclusion: If your calculation begins on the 27th of July 9792 BC, then the day for the next catastrophe is the 21st of December 2012!

Code Numbers that Confirm the
Countdown to the End of Times in 2012

In the previous section you have discovered the numbers 160, 162.222 and 162.333—the same numbers I showed in my book *The World Cataclysm in 2012*, in the chapter "The Computer Program of the Previous Crash." For that reason there had to be more information. The Maya must have found those numbers somewhere. The Maya profoundly respected numbers. With their help they decoded countless things. I searched further in a structured manner. Was it possible that I could find it in their past? I probably would.

I studied the period between the first two crashes of 29,808 and 21,312 BC, which lasted 8,496 years. I divided this period by seventy-two, the same number I used when cracking the time period of 11,520 years:
8,496 ÷ 72 = 118

Then I multiplied the time period between the crashes with the respective calendar rounds:
8,496 x 360 = 3,058,560

8,496 x 365 = 3,101,040
8,496 x 365.25 = 3,103,164

This outcome I divided by 118 and as expected I found:
3,058,560 ÷ 118 = 25,920
3,101,040 ÷ 118 = 26,280
3,103,164 ÷ 118 = 26,298

From this point on, I had to use the identical principle I used in the previous decipherings, which is as follows:
Time period between crashes: code number = 0.44444444
This produced:
8,496 ÷ 0.4444444444 = 19,116
19,116 ÷ 118 = 162

From my previous decipherings I knew that a relation existed between the precession number and the numbers 160 and 162:
25,920 = 162 x 160

When I divided the calendar rounds by 162 this resulted in:
3,058,560 ÷ 162 = 18,880
3,101,040 ÷ 162 = 19,142,222
3,103,164 ÷ 162 = 19,155,333

Further division by 118 gave me the long searched for code numbers:
18,880 ÷ 118 = 160
19,142,222 ÷ 118 = 162.222
19,155.333 ÷ 118 = 162.333

Immediately I saw the origin of the Maya numbers for the fifty-two year cycle:
18,880 - 160 = 18,720 = Mayan 52 year cycle
19,142.222 – 162.222 = 18,980 = Mayan 52 year cycle
19,155.333 – 162.333 = 18,993 = Mayan 52 year cycle

These deductions confirmed what I had suspected for a long time. They gave me the direct relation between the code numbers and the Mayan fifty-two year cycle!
These numbers also prove that 2012 shows the end of the cycle! The previous time the precession number indicated this. The time period between the crashes amounted to 11,520 years. The several calendar rounds show therefore the following number of days:
4,207,680
4,204,800
4,147,200

When you divide these numbers by the precession cycle you also retrieve the above-found values:

4,207,680 ÷ 25,920 = 162.333333
4,204,800 ÷ 25,920 = 162.222222
4,147,200 ÷ 25,920 = 160

The present cycle shows the same result:

4,311,411 ÷ 26,559 = 162.333333
4,308,460 ÷ 26,559 = 162.222222
4,249,440 ÷ 26,559 = 160

Conclusions
1) The numbers 160, 162, 222 and 162.33 originate from the time period between the first two crashes. They confirm my research more than spectacularly!
2) Once more there appears to exist an irrefutable relationship between the earlier events that took place in Aha-Men-Ptah and its famous descendents, the Maya.
3) *Without any doubt these sensational decodings prove that 2012 is the date of the next cataclysm!*

The Sunspot Cycle Theoretically Calculated
With the help of a simple integral, a theoretical sunspot cycle of eleven years can be replicated as will be seen in this section.

The polar magnetic field of the sun rotates (theoretically) in about 37.2 days; the equatorial field in 25.75 days (the average of the last 75 years: see "Long Term Variations of the Torsional Oscillations of the Sun," *Solar Physics* 170: 373/388, 1977, by Dirk K. Callebaut). Because it is rotating faster, at a certain moment, the equatorial field overtakes the polar field. Therefore we can only investigate the relationship between the field of the sun and an independent observer by measuring each take-over moment. Through this we always compare only two variants: the converging positions of the fields in relation to the shifted point of observation. In fact we are doing nothing more than calculating the winding process of the magnetic field of the sun. At this moment we can calculate the numbers of the fields together with the position of convergence:

360 ÷ 25.75 = 13.9805825 degrees
360 ÷ 37.19 = 9.6800215 degrees
The difference is: 13.9805825 − 9.6800215 = 4.30055848 degrees

The polar field is overtaken by the equatorial field after the following number of days:

360 ÷ 4.30055848 = 83.710058 days = 1 bit of the sunspot cycle

The number of circles traveled by the equatorial field during this time is:

83.710058 ÷ 25.75 = 3.25087545

The number of circles traveled by the polar field is:

83.710058 ÷ 37.19 = 2.25087545

0.25087545 circle forms a bit and will be used as a basic unit in the calculation.

When you calculate and subtract both graphics, the result will be the difference between the magnetic field of the sun and an independent observer. Filling in the previous numbers in the Excel file I have developed to study the sunspot cycle (see my previous book) and changing the 365.25 days into 360 days (see further) results in a sunspot cycle of 54.5 bits. 54.5 x 83.710058 days = 4,562.2 days = 12.49 years.

Note: Variations in the speed of the equatorial and polar fields were not taken into account.

Second example:

We change the hypothetical speed of the polar field to 37.16 days:

360 ÷ 25.75 = 13.9805825 degrees
360 ÷ 37.16 = 9.68783638 degrees
Difference = 4.292746117 degrees

360 ÷ 4.292746117 = 83.86240187 days = 1 bit

83.86240187 ÷ 25.75 = 3.2567923

0.2567923 circle = 1 bit

When you put these numbers in the Excel file the result is a sunspot cycle of 42 bits.

42 x 83.86240187 = 3,522.2 days = 9.64 years.

Conclusions

1) Even a small change in the speed of the polar or equatorial field can result in a considerable prolongation or deceleration of the sunspot cycle.

2) From a mathematical point of view there has to exist a very close correlation between the equatorial and polar fields.

3) The sunspot cycle together with the polar reversal of the magnetic field of the sun lasts longer when the polar field rotates somewhat slower. A difference of only 0.0807 percent causes the cycle to increase from 9.64 to 12.49 years!

Third example, resulting in the cycle of 11 years:
Change the speed of the polar field to 37.176 days:

$360 \div 37.176 = 9.683666882$ degrees
$360 \div 25.75 = 13.9805825$ degrees
Difference: 4.296915618 degrees

$360 \div 4.296915618 = 83.7810262$ days = 1 bit

$83.7810262 \div 25.75 = 3.25363208$ circle
0.25363208 circle = 1 bit

When you put these data in the Excel file, the result is a sunspot cycle of 48.0 bits.
$48.0 \times 83.7810 = 4,021.5$ days = 11.01 years.

The Magnetic Field Reversal at an Orbit Speed of 360 Days
A Recalculation of the Sunspot Cycle

After I had found the turning point in the Mayan sunspot cycle, I made countless new calculations with their formula, until the moment I stumbled upon a mistake I had constantly overlooked. In order to calculate the sunspot cycle I had used the orbit speed of the earth around the sun; however, when you use the orbit period of Venus or Mars the resulting graph appeared quite different. Of course, this is impossible, because the cycle of the sun has to be independent of a planet's movement. And yet the Maya had used the theory of the solar year in all their calculations! My decodings pointed more than clearly in that direction. Besides I had found an irrefutable turning point in it. For that reason I had overlooked this mistake many times, so there had to be more! But where did I have to search?

Again I thoroughly went through all my calculations. Painfully slowly I studied them, until a bell started to ring. Besides the solar year the Maya also used a year of 360 days. The solution had to be hiding there! A 360-day orbit around the sun results in one degree per day. With this calculation I found a connection between the converging points of the magnetic fields of the sun and a circle existing of 360 degrees with an independent observer. This had to be the correct theory! After exactly 360 days you will land on your starting point and you have traveled a precise complete circle, exactly 360 degrees. This theory is universally valid and bridges the connection between the sun and the outside observer who is independent of its position in space.

Another explanation: An independent observer travels the

mean of the polar and equatorial fields in one day.
Total length equatorial field = 4,370,880 km
Total length polar field = 700,000 km
Mean = 2,560,000

This is about equal to the speed of an object that travels 360 days around the sun in one year.

When you recalculate the sunspot cycle theory with an orbit speed of 360 days, you encounter the field reversal after 1,980 bits = 474 years. This seems a bit rapid, though. When you change the parameters slightly, the reversal shifts spectacularly to higher values. Because of the fact that the Maya had chosen the theory of 365.25 days as a main code, we can almost be sure that the calculated value of 3,848 years comes very close to the real value. It could also concern an accumulation of several cycles that converge after a long period. I consider it the task of future generations of scientists to closely follow the future behavior of the sun and to adjust the theory to the reality. For the time being I do not have enough data to be of help in this matter.

The reversal on bit 1,980 yields the following values for the surrounding bits:
1,980 = 0
1,981 = 1,979 = 43.45
1,982 = 1,978 = 86.90
1,983 = 1,977 = 229.63
1,984 = 1,976 = 186.18
1,985 = 1,975 = 217.27
1,986 = 1,974 = 99.27
1,987 = 1,973 = 55.18
1,988 = 1,972 = 12.36
1,989 = 1,971 = 31.09
1,990 = 1,970 = 74.54 (74 and 54 are main code numbers for the Dresden Codex)

Another Calculation of the Time Period of the Polar Reversal of the Magnetic Field of the Sun

A small difference in the rotation speed of the polar and equatorial fields of the sun produces huge differences in the polar reversal of the magnetic field of the sun. For practical reasons the sunspot cycle of 365.25 was used here because it shows a clear turning point. After almost twelve thousand years the difference can easily amount to 300 years or more. The examples below illustrate this:

The rotation speed of the equatorial field is 26.05 days instead of 26.

The rotation speed of the polar field is 36.95 days instead of 37.

These speeds correlate with the following numbers of degrees per day:

$360 \div 26.05 = 13.81957774$

$360 \div 36.95 = 9.742895805$

Difference in number of degrees: $13.81957774 - 9.742895805 = 4.076681935$

One bit will then be reached after the following number of days:

$360 \div 4.076681935 = 88.30711$ days

Another example:

Equatorial field: 25.95 days

Polar field: 37.05 days

These speeds correlate with the following numbers of degrees per day:

$360 \div 25.95 = 13.87283237$

$360 \div 37.05 = 9.71659919$

Difference in number of degrees: $13.87283237 - 9.71659919 = 4.15623318$

One bit will then be reached after the following number of days:

$360 \div 4.15623318 = 86.61689$ days

The difference between these cycles is: $88.30711 - 86.61689 = 1.69022$ days. The average turning point of the magnetic field of the earth is after approximately 11,700 years. This correlates with approximately 49,000 cycles of the sunspot cycle of 87.454545 days. After 49,000 bits the difference between above calculations is:

$49,000 \times 1.69022 = 82,821$ days. This equals 227 years!

Another calculation:

Equatorial field: 26 days

Polar field: 36.7 days

$360 \div 26 = 13.84615385$ degrees

$360 \div 36.7 = 9.809264305$ degrees

Difference: $13.84615385 - 9.809264305 = 4.036889545$ degrees

$360 \div 4.036889545 = 89.17757$ days

Difference with sunspot cycle: $89.177 - 87.4545 = 1.7231$ days

Number of cycles in a year = $365.25 \div 89.177 = 4.096$

Descending difference per year = $4.096 \times 1.7231 = 7.06$ days

Difference after 11,804 years = $7.06 \times 11,804 = 83,308$ days = 228 years

The Turning Point on Bit 16,071

In my previous book I found that, after exactly 3,848 years, the turning point of the magnetic field of the sun falls on bit 16,071. When you decelerate the speed of the polar and the equatorial fields by a proportional factor (26 to 25.5 and 37 to 36.28846) the turning point falls on bit 16,071 after 3,774 years.

Equatorial field: 25.5 days
Polar field: 36.28846 days
$360 \div 25.5 = 14.11764706$ degrees
$360 \div 36.7 = 9.920509165$ degrees
Difference: $14.11764706 - 9.920509165 = 4.197137895$ degrees
$360 \div 4.197137895 = 85.77273585$ days

Turning point = $16,071 \times 85.7727 = 3,774$ years

When you accelerate the speed of the polar and equatorial fields (26 and 37, respectively) by a proportional factor giving 26.25 and 37.355769, the turning point falls on bit 16,071 after 3,885 years.

Equatorial field: 26.25 days
Polar field: 37.355769 days
$360 \div 26.25 = 13.7142857$ degrees
$360 \div 37.355769 = 9.637065697$ degrees
Difference: $13.7142857 - 9.637065697 = 4.07722000$ degrees
$360 \div 4.077220000 = 88.295456$ days

Turning point = $16,071 \times 88.295456 = 3,885$ years

Conclusions

1) When you decelerate the speed of the polar and equatorial fields by a proportional factor to give the results of 25.5 and 36.28846 days respectively, the turning point falls on bit 16,071 after 3,774 years. When you accelerate the speed of both fields to 26.25 and 37.35569 days respectively, the turning point of the magnetic field of the sun falls on bit 16,071 after 3,885 years. This results in a difference of 101 years. After three cycles this amounts to 303 years.

2) Using the same formula, although with slightly declining numbers (the difference of the rotation speed of both fields is max. 0.4%!), after 11,700 years again differences can show up of almost 300 years!

3) The time period between the previous crashes was 11,520 years. The interval between the last crash and the coming one is almost 11,804 years—284 years more. From this we may

hypothesize the following: in relation to the previous time, both fields are now probably rotating somewhat slower. It is also possible that the polar field now rotates a bit quicker than during the previous time period.

Mathematical Correlations Between the
Sunspot Cycle and the Shifting of the Zodiac

In *The Orion Prophecy* I showed that a direct relation exists between the precession of the zodiac and the sunspot cycle. Below I repeat the resulting values for the sunspot cycle:

$68,302 \div 37 = 1,846$

$68,302 \div 26 = 2,627$

For the precession you found:

$25,920 \div 13.84615385 = 1,872$ $(360 \div 26 = 13.84615385)$

$25,920 \div 9.729729730 = 2,664$ $(360 \div 37 = 9.729729729)$

There is a connection between the differences of the time periods. For the sunspot cycle this amounts to $2,627 - 1,846 = 781$. For the precession this is $2,664 - 1,872 = 792$. When you subtract these numbers the result is: $792 - 781 = 11$. When you divide 781 by 11 the result is 71. Again you produce this proof: $26 \times 37 = 962$ and $71 \times 962 = 68,302 =$ period of one sunspot cycle. Well, it cannot be more beautiful. But why these darned Atlanteans needed to make everything so terribly complicated will remain an eternal secret to me. It is indeed a fact that knowledge is power and they were more than able to camouflage that. Without my perseverance and obsessive research this would have remained lost forever. And it doesn't stop here.

Multiply eleven by 360: $11 \times 360 = 3,960$.

Divide the precession number by this: $25,920 \div 3,960 = 6.454545$

Here we find a correlation with another number:

$11 \times 6.454545 = 71$

Even the worst skeptics cannot assert that this is all a coincidence. In order to quiet them forever, I will give another correlation one cannot deny.

When I divided the precession number by 792 I found the following strange series: $25,920 \div 792 = 32.727272$.

Conclusions

1) When you subtract two basic numbers of the precession and the sunspot cycle, you obtain the result of eleven: $792 - 781 = 11$. When you divide the numbers by eleven, the result is code numbers:

$792 \div 11 = 72;\ 781 \div 11 = 71$. When you divide 360 by 11, the result is 32.727272. This shows the code values of the sunspot cycle.

2) Number eleven is the basic number of the sunspot cycle. Every eleven years a cycle travels up and down. Here you produce a connection between both phenomena.

3) In the Mayan essential calculations of the sunspot cycle, number eleven shows up several times. Without this number you cannot make decodings.

4) In one year the inner core of the earth shifts 1.1 degree in relation to the outer core (see Chapter 3: The Inner Core of the Earth). This relates to an extra rotation after 327.2727 years. A more than clear relationship exists with the sunspot cycle, in which rotations or degrees relate to 32.727272 (see further). Only the speed differs. You know from previous calculations that units don't count.

You have found before: $25{,}920 \div 792 = 32.727272$.

The endless repetition of 72 seemed an Atlantean starting point to me. So I started to search again. Follow in my way of thinking and you will derive the same results.

Multiply the number of degrees that the magnetic fields traverse in one day, reversed with their traveled circles after 87.4545 days. That calculation utilizes the degrees in a circle. Change this to days and the result is:

$$13.84615385 \times 2.363636 = 32.727272$$
$$9.729729729 \times 3.363636 = 32.727272$$

Explanation: after 2.363636 and 3.363636 days the fields of the sun have traveled 32.727272 degrees of a circle. Yes you are reading this right! This much coincidence cannot be considered coincidence anymore. Real sleuths like you and me don't give up that easily. And look, here is another clue: $360 \div 32.727272 = 11$. Here we have to think a bit further and the unveiling continues as follows: $3.3636 \times 2.3636 = 7.9504132 \times 11 = 87.4545$. Of course there had to be more. Those brilliant mathematicians of millennia ago were too clever to not have incorporated more codes:

$$7.9504132 \times 13.8461538 = 110.0826439$$
$$7.9504132 \times 9.72972930 = \underline{77.35536587}$$
$$32.72727272$$

Explanation: after 7.9504132 days, there is a difference of 32.727272 degrees. I hope you are just as eager as I am to unravel one of the biggest secrets of this lost civilization. The forthcoming world catastrophe is so big that you have to stimulate all of your senses to their highest point. Earlier, you have read that

after 87.4545 days one field overtakes the other. You prove this mathematically as follows:

87.4545 x 13.8461538 = 1,210.9090909
87.4545 x 9.72972930 = 850.9090909
 360

Conclusion

After 87.4545 days, the equatorial field has traveled one complete rotation (360 degrees) more than the polar field. When you divide the number of degrees by eleven, it results in familiar numbers:

1,210.90909 x 11 = 13,320
 850.90909 x 11 = 9,360
 3,960

The difference of 3,960 degrees is the number you have calculated before in the zodiacal cycle! Besides, you see a multitude of the much-used number 936, which simply cannot be overlooked. With that we have sufficiently proven the correlation between the precession and the sunspot cycle.

How Did They Code the Orbit Period of the Earth?

In my previous book, *The World Cataclysm in 2012*, I came to the astounding conclusion that the Maya knew the time period of a solar year up to at least twelve digits after the decimal point! Since then I have kept on investigating the possibilities for more codes. The Mayan orbit period of the earth around the sun amounted to 365.242 days. Was this indicating a code, I wondered? By using a value with three digits after the decimal point, thereby expressing the number in "thousandths," were they hinting that we should calculate the exact orbit period of the earth after a thousand years? I made the calculation for the thousand years for the *correct* value of a solar year and found:

365.2422 x 1,000 = 365,242.2 days

Behind the decimal point you see 0.2 days. Convert this into the number of seconds:

0.2 day = 4.8 hours = 17,280 seconds (1,728 = code number Egyptian Zodiac; furthermore the difference between a Mayan year and the present value is 17.28 seconds per year).

Continue to convert: you can split up 4.8 hours into the following:

4 hours = 14,400 seconds
0.8 hours = 2,880 seconds
Both are Egyptian code numbers (see my previous book)!

After a thousand years a sidereal year (in relation to the stars) contains the following number of days: 365.2564 x 1,000 = 365,256.4 days.

The difference with the Mayan year is:

365,256.4 – 365,242 = 14.4 days

The difference with the normal year is:

365,256.4 – 365,242.2 = 14.2 days

This results in the following number of seconds:

86,400 x 14.4 = 1,244,160
86,400 x 14.2 = 1,226,880
 ‾‾‾‾‾‾‾‾‾‾
 17,280

You have now arrived at the correlation with the precession cycle as shown in my previous book:

17,280 ÷ 25,920 = 0.666666 = code number
1,244,160 ÷ 25,920 = 48
1,226,880 ÷ 25,920 = 47.33333

This leads to the following result:

48 – 47.3333 = 0.666666

As found in my previous book, the real value is not 0.2 days, but indeed 0.199074074074. Multiply this number by the number of seconds in one day:

0.199074074074 x 86,400 = 17,200 seconds.

The difference with the above-mentioned value is:

17,280 –17,200 = 80 seconds. Divide this by the number of seconds in a minute and the result is a code number: 80 ÷ 60 = 1.3333333

Earlier I had proved the connection with the codes of number 1,728:

108 –1.33333 = 106.66666
1.3333 = 80 seconds
Divide the other numbers by 1.33333:
108 ÷ 1.33333 = 81
106.66666 ÷ 1.3333 = 80

Multiply both outcomes by 80:

81 x 80 = 6,480 seconds = anagram for 86,400 (the number of seconds in a day)

80 x 80 = 6,400 seconds = code number

The correlation with 108:

17,280 – 6,480 = 10,800 = code number
17,200 – 6,400 = 10,800

The following calculations produce more correlations:
$864 \div 648 = 1.33333$
$64 \div 864 = 0.074074074 = $ code number

Conclusion
This deciphering shows that they were able to calculate precisely the orbit period of the earth around the sun after a time period of one thousand years. How? That is still not completely clear to me.

An Absolutely Certain Coding
Multiply the number of seconds in one day with the different orbit periods of the earth around the sun:
$86,400 \times 360 = 31,104,000$
$86,400 \times 365 = 31,536,000$
$86,400 \times 365.25 = 31,557,600$

Also multiply by the exact value:
$86,400 \times 365.2422 = 31,556,926.08$
Difference with the value of 365.25:
$31,557,600 - 31,556,926.08 = 673.92$
Leave out the decimal point:
$67,392 = $ code number Egyptian Zodiac
In my previous book I had found the following:
$67,392 + 936 = 68,328 = $ value Mayan sunspot cycle

Also multiply by the value of a Mayan year:
$86,400 \times 365.242 = 31,556,908.8$
Difference with the value of 365.25:
$31,557,600 - 31,556,908.8 = 691.2 = $ code number
Enlarge the number into the units used above:
$= 69,120$
Subtract the Mayan sunspot cycle:
$69,120 - 68,328 = 792 = $ code number Dresden Codex

Add up the outcomes:
$936 + 792 = 1,728 = $ Mayan code number for the time difference of a solar year!

Conclusion
This deciphering is absolute proof that all of my previous findings are correct.

Other Possible Proof
The orbit period of the earth around the sun is 365.2422 days. Split the number after the decimal point into two: $0.2422 = 24$ and 22.

The number of seconds in one day is 86,400, but here we only use the first three numbers (864 is also a code number you regularly run into):

24 x 864 = 20,736 = 144 x 144
22 x 864 = 19,008

We know that: 20,736 + 5,184 = 25,920
Add 5,184 and 19,008:
19,008 + 5,184 = 24,192

Here you produce two code numbers:
25,920 – 24,192 = 1,728 = code number
25,920 – 19,008 = 6,912 = code number

The following striking calculations prove that there are more correlations between our time calculation (86,400 seconds per day) and the Mayan sunspot cycles (68,328 and 68,302 days respectively):

86,400 – 68,328 = 18,072 = anagram for 18,720
86,400 – 68,302 = 18,098 = anagram for 18,980

Multiply the numbers in between:
18 x 72 = 1,476
18 x 98 = 1,764 = results are anagrams of one another!

Add the results:
1,476 + 1,764 = 3,240 = code number

Multiply the code numbers of the Dresden Codex by 864:
74 x 864 = 63,936
54 x 864 = 46,656
52 x 864 = 44,928
22 x 864 = 19,008
The last shows number 8 standing alone! This is extraordinary!

Add the other three numbers:
63,936 + 46,656 + 44,928 = 155,520
Subtract the number of seconds in one day:
155,520 – 86,400 = 69,120 (= code number!)

Subtract the above products from the Mayan sunspot cycle:
68,328 – 63,936 = 4,392
68,328 – 46,656 = 21,672
68,328 – 44,928 = 23,400
68,328 - 19.008 = 49,320 = anagram for first number 4,392

Add the first three numbers:
4,392 + 21,672 + 23,400 = 49,464
Subtract the last two results:
49,464 – 49,320 = 144 = code number
Add: 49,464 + 19,008 = 68,472
Subtract the code number 144:
68,472 - 144 = 68,328 = Mayan sunspot cycle

APPENDIX

At the end of 2012, a pole shift that will destroy everything is destined for us. It is one of the thousands that have already taken place in the history of the earth, however, this time it will be completely different. Our ancestors from a distant past had calculated and knew in advance when the previous cataclysm would occur and escaped with their knowledge; we are now living in a highly-advanced civilization because of this. It is likely that it will be turned to dust in 2012 unless, of course, we take the necessary precautionary measures to preserve it.

I urge everyone to visit my website at: http://www.howtosurvive2012.com to keep apprised of the latest developments in our survival plans. I want to use this website to help me prepare for the biggest rescue operation ever. Someone has to take the responsibility for the preparations, and plan for the continuation and restoration of all the knowledge and standards that we know now. I have made the decision to be that responsible person.

How to Survive 2012

A couple of years before 2012, the survival strategy as outlined in *How to Survive 2012* will be published on this website. However, you have to take into account that you will need at least US$12,000 (10,000 euros) to have a reasonable chance for survival; US$18,000 (15,000 euros) is a more realistic estimate. You will need this money to buy the following:

- Enough survival material
- Food for at least a year
- Seeds of vegetables, grains, rice and seed-potatoes
- Essential equipment to start a mini-civilization
- Books

Furthermore, part of this money will be used for building bunkers. This deserves some explanation. Our place of survival will be in the Drakensberg Mountains in Southern Africa. As we will be in high mountains, we will be tormented by super storms as well as by intense solar radiation. The only way to survive is to live in concrete bunkers or in pits with good shored-up walls. Only small quantities of iron can be used in the construction because it attracts lightning. And, we will probably have to plead forcefully with the authorities in order to get the necessary permits, which will also cost more money.

In order to withstand the tidal waves, we will have to be at

least three kilometers above the current sea level. I wish the central group to be located in the most suitable place, in order to create a stable bridgehead. From that point, civilization can be restarted. Who wants to chart the best places in these mountains?

Europe

Several persons have asked me if it would be wise to build bunkers in Europe. I do not think anyplace would be suitable, except for the high mountains of Spain and Turkey. In the lower lands bunkers would have to withstand super earthquakes. One crack is sufficient to succumb to the immense tidal wave. The pressure of a tidal wave one kilometer high is phenomenal. Besides, it is possible that a lot of places will be flooded for days, so you will suffocate quickly. Finally, you need to know that after the pole shift the biggest part of Europe will be bitterly cold.

America and South America

As described comprehensively in *How to Survive 2012?*, the actual chances of surviving in either North or South America are very slim. The reason is that the earth's axis in these parts of the world will undergo the biggest shift, resulting in incredible earthquakes and volcanic eruptions. So we will encounter a real doomsday scenario here.

Other Survival Places

Unfortunately, you need money in order obtain the materials you will need in order to survive; without money to back you right now, your chances can be pretty slim. If this is your case, you will find a list of additional places where you might be able to survive. You can go there before the cataclysm. Of course, your chances of survival in these places will be a lot smaller than if you were with a well-organized group. But doing something proactive is always better than doing nothing.

Understand, though, it will be impossible to enter our central group if you have few materials or nothing at all to offer in the way of your own support. The situation during and after the cataclysm will be so precarious that we won't be able to provide for other survivors. We will hardly be self-sufficient! Please take that as definite! Do not have any illusions! Without your own effort your chances of survival are terribly small!

Regrouping

Depending on the magnitude of the earth's crust shift, several starting places for a new civilization will be pointed out in advance. Should you want to go there, you need to be able to interpret

charts in order to determine the latitude on earth. You can find this information in *The Golden Thread of Time* by Chrichton E. M. Miller. This book is a must for all of you who want to survive!

Unsinkable Boats

Special attention will be given to surviving the tidal wave with the help of unsinkable boats. These boats are very expensive and only a group of people could afford to pay for one. If we are able to convince some of the present and future owners to cooperate, thousands of people will certainly survive. Count for yourself: 6,000 boats in total were built in 2002. In 2012 there will be about 10,000. If we are allowed to use a quarter of them (i.e., 2,500) with an average of 4 persons aboard, then about 10,000 people would be able to escape from the tidal wave. That is more than enough to start a new civilization. Much will depend on the cooperation of ETAP in order to get the addresses of the boat owners. Furthermore, boat owners will have to be convinced to participate. It is possible most of them will make an effort to survive, and will be in their boats on the ocean on that particular date. In case they are not interested, we could possibly borrow their boats. I am counting on some captains who will motivate their colleagues to be a part of this plan. Without any doubt, this is the most likely way to survive.

Who is going to coordinate this?

Internet: http://www.etapyachting.com

The Survivors of 2012

With this website, I want to start off the biggest survival and restoration operation ever. Few will believe what is ahead of us. However, I sorely need every man or woman who does believe. A lot depends on the right attitude and motivation of those who want to survive. The stronger your desire to survive, the greater your chances are of surviving. Let's join our efforts and strive for a better world, which is our final objective.

In the cataclysm of the pole shift in 2012, all existing structures and services will be destroyed. There is the strong possibility that most of humanity will also die. I therefore need a lot of people who also want to survive to work with us on the rescue operation following the pole shift. Do not underestimate what awaits us, because we have quite a lot to do. I do not need people who are eager to do something, but do not know what. If you have read my books intently, it will not be too difficult to focus on some aspect of surviving 2012. For instance, you may choose to gather extensive knowledge about any of the following subjects:

• The most efficient survival material

- Essential equipment to start a mini civilization
- Mountain bikes and motor cycles for the transport
- Food
- Seeds of vegetables, grains and rice. Seed-potatoes
- Unsinkable boats

You might want to start to assemble a mini library with books on the following subjects:

- Principles of mathematics (algebra, space-geometry, and so on)
- Elementary physics
- Elementary chemistry (general and carbon chemistry)
- Basic electricity
- Basic electronics
- Basics of anesthesia, equipment and methods
- Basics of dentistry and necessary material
- Biological growing of vegetables and fruit
- Basics of architecture/building (raw materials to make cement, and so on)
- The production of paper and ink
- The production of glass
- The production of soaps
- Alloys
- Plastics
- Treatment and manufacturing of leather and other natural products
- Pottery
- Simple looms and sewing machines
- Cooling installations
- The production of bio-diesel for diesel engines
- The construction of fuel engines
- The measurement of radioactivity
- Radio and telephone equipment
- Wooden abacuses
- Windmills for the production of electricity
- Detailed maps of the whole world
- Maps to locate minerals, oils and so on
- Accurate mechanical clocks
- Lenses and corrective optometry for glasses
- Paints and coatings
- Welding techniques
- Blueprints for building boats
- Musical instruments and musical compositions
- Ammunition powder and explosives

The above-mentioned items are essential, and a new civilization can be reconstructed from them. If you find other important items, you can always bring the corresponding works about them. However, as we can just transport a somewhat restricted quantity, I strongly advise you to restrict yourself to the most essential information. Only in that way can we save our scientific knowledge, and pass it on to our descendants in a distant and insecure future.

Finally

We, the survivors of 2012, will be able to compensate for the mistakes that have been made, like those in the area of ecology. You, a follower of an ecological wisdom paradigm, can surely identify with this. You will have at your disposal an ambitious construction project together with all the relevant scientific information. As a result of that, a paradisiacal civilization can rule on earth within a few hundreds or thousands of years.

So read my books again attentively. Note down all the important points and start to devise a survival strategy for yourself. Besides your survival, the continuity of our knowledge pool is central. Keeping that in mind, together we can withstand the biggest challenge ever facing humanity: the continued existence of our civilization. It will not be easy; it will be terribly difficult. However, that should not scare us. We have a goal and we will reach it in one way or another. Tons of blood, sweat and tears will be shed, until our final target is reached: a new "Golden Age" on our renewed earth.